The Exhibition

A Moral Compass:
Seventeenth and Eighteenth Century Painting
in the Netherlands

and accompanying catalogue

are made possible by the grand patronage of the

Jay and Betty Van Andel Foundation

and major patronage of the

Richard and Helen DeVos Foundation

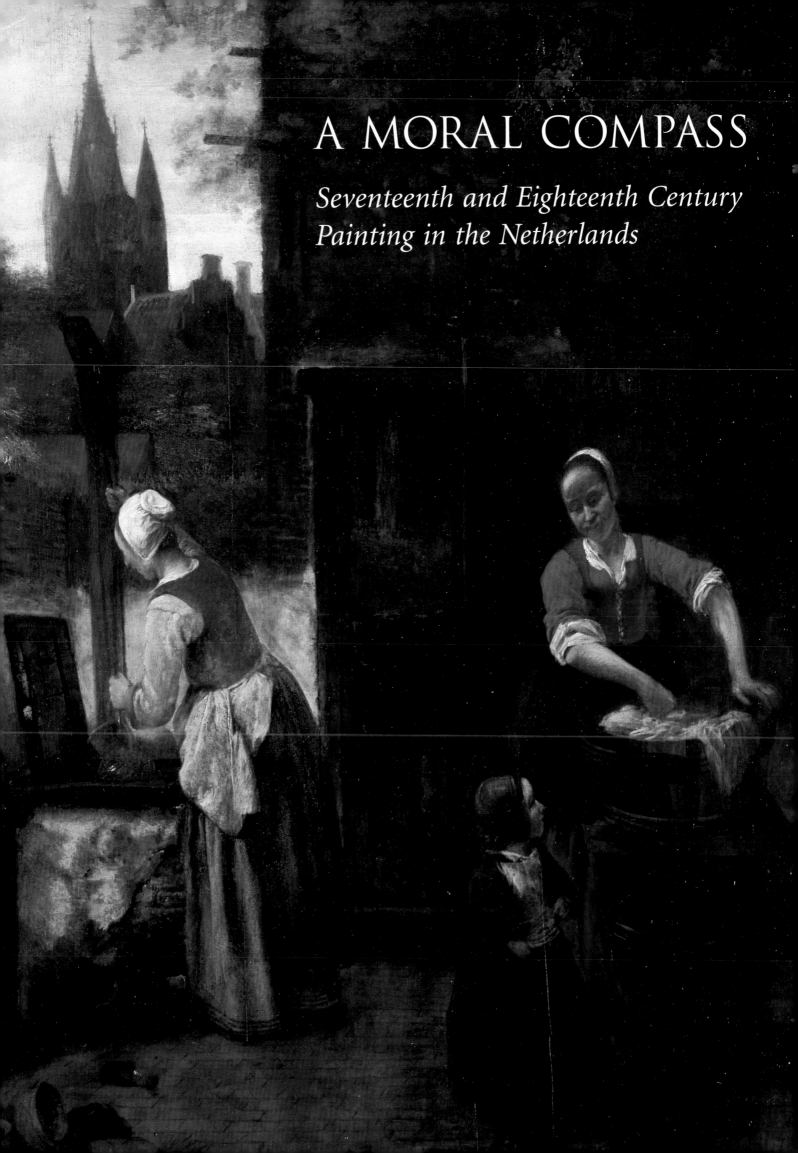

A MORAL COMPASS

*Seventeenth and Eighteenth Century
Painting in the Netherlands*

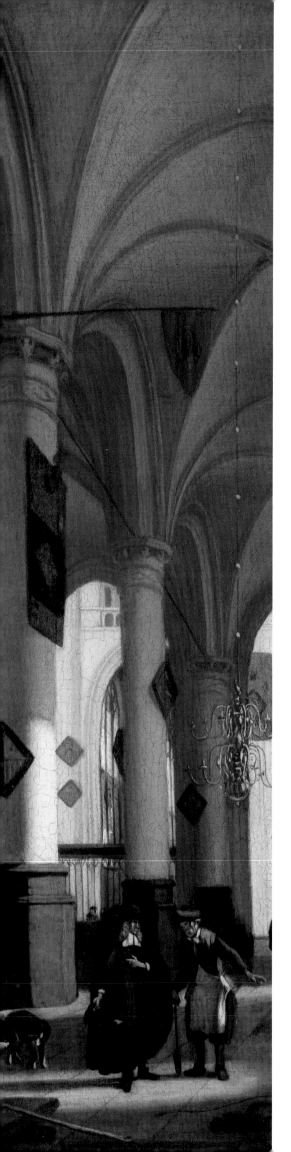

A MORAL

Seventeenth and
Painting in

Contributions by

Introduction by

GRAND RAPIDS ART MUSEUM
GRAND RAPIDS, MICHIGAN

COMPASS

Eighteenth Century the Netherlands

Arthur K. Wheelock Jr.

Lawrence O. Goedde

Mariët Westermann

Henry M. Luttikhuizen

Peter C. Sutton

RIZZOLI INTERNATIONAL PUBLICATIONS, INC.
NEW YORK

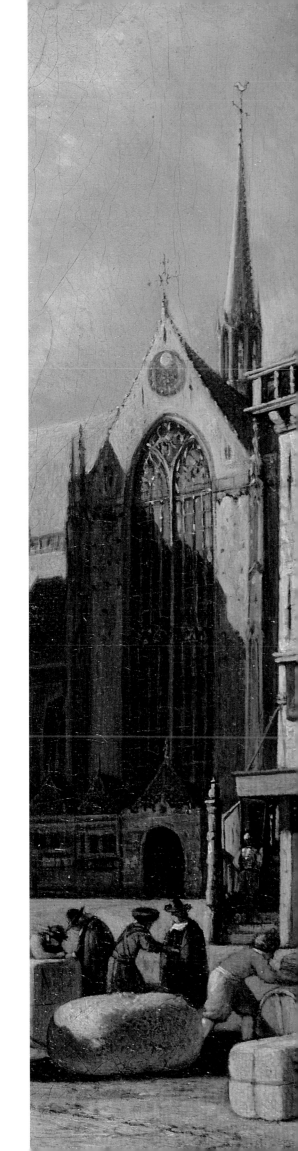

Illustrations in the front matter:

page III: Pieter de Hooch, *Courtyard, Delft*, detail (cat. 12)

page IV: Emanuel de Witte, *Interior of the Oude Kerk, Amsterdam*, detail (cat. 26)

page V: Gerrit Berckheyde, *The Town Hall on the Dam, Amsterdam*, detail (cat. 2)

This catalogue has been published in conjunction with the exhibition
A Moral Compass: Seventeenth and Eighteenth Century Painting in the Netherlands
organized by the Grand Rapids Art Museum and held at the museum
from April 16 to August 15, 1999.

Published jointly in 1999 by
Grand Rapids Art Museum
155 Division North, Grand Rapids, Michigan 49503
and by
Rizzoli International Publications, Inc.
300 Park Avenue South, New York, NY 10010

Printed in the United States of America

04 03 02 01 00 99 7 6 5 4 3 2 1

Library of Congress Cataloging-in-Publication Data

A moral compass: Seventeenth and eighteenth century painting in the Netherlands.
 p. cm.
 Catalog of an exhibition held at the Grand Rapids Art Museum in 1999.
 Includes bibliographical references.
 ISBN 0-942159-23-3 (cloth: alk. paper)
 1. Painting, Dutch — Exhibitions. 2. Painting, Modern —
17th-18th centuries — Netherlands — Exhibitions.
 I. Grand Rapids Art Museum.
 ND646.M65 1999
 759.9492′09′03207477456 — dc21 98-49889
 CIP

A Moral Compass: Seventeenth and Eighteenth Century Painting in the Netherlands was produced by
William B. Eerdmans Publishing Company (Grand Rapids, Michigan / Cambridge, U.K.).

Project Director: Celeste Adams, Grand Rapids Art Museum
Project Editor: Jon Pott, Wm. B. Eerdmans Publishing Co.
Design: Klaas Wolterstorff, Wm. B. Eerdmans Publishing Co.
Filmwork: Advanced Litho Systems, Grand Rapids, Michigan
Printing: Custom Printers, Grand Rapids, Michigan
Binding: Dekker Bookbinding, Grand Rapids, Michigan

Honorary Committee

James W. F. and Donna K. Brooks

Lewis Chamberlin III

Peter C. Cook

Samuel M. Cummings, *Campaign Co-Chair*

Pamella G. DeVos, *Campaign Co-Chair*

Charles E. McCallum

Gordon J. Van Wylen

Henry I. Witte

Casey Wondergem

Contents

Donors

Grand Patron

Jay and Betty Van Andel Foundation

Major Patron

Richard and Helen DeVos Foundation

Underwriter

The Keeler Foundation

Benefactors

Jim and Donna Brooks

Peter C. and Pat Cook

Frey Foundation

Meijer

Edgar and Elsa Prince Foundation

Wege Foundation

Sponsors

Calvin College

Daniel and Pamella DeVos Foundation

Milliken Fabric

John and Judy Spoelhof

Lenders of the Exhibition

RIJKSMUSEUM, *Amsterdam*

DETROIT INSTITUTE OF ARTS, *Detroit*

METROPOLITAN MUSEUM OF ART, *New York*

MUSEUM BOIJMANS VAN BEUNINGEN, *Rotterdam*

ST. LOUIS ART MUSEUM, *St. Louis*

TOLEDO MUSEUM OF ART, *Toledo*

NATIONAL GALLERY OF ART, *Washington D.C.*

PRIVATE COLLECTIONS, *Michigan*

Dedication

A Moral Compass: Seventeenth and Eighteenth Century Painting in the Netherlands reaffirms the special relationship between the Netherlands and West Michigan. Since the late nineteenth century, more Dutch immigrants and their children have called West Michigan home than anywhere else in the United States. Dutch-Americans in West Michigan continue to appreciate their cultural heritage and have preserved close ties to the Netherlands. After World War II and the devastating floods of 1953, residents of West Michigan provided special aid to the Netherlands. In addition, the City of Holland continues to celebrate Tulip Time, a festival which commemorates Dutch culture in America. Consequently, it is no surprise that an exhibition of Dutch art is being organized in West Michigan.

The Kingdom of the Netherlands has maintained diplomatic relations with the United States longer than any other country. The close friendship between our two nations has been strengthened over the years by the achievements of those living in West Michigan. Hence, with deep appreciation, I dedicate this exhibition and catalogue to the people of West Michigan, for helping Americans understand and appreciate Dutch art and culture.

THE HONORABLE CYNTHIA P. SCHNEIDER
Ambassador of the United States of America
to the Kingdom of the Netherlands

Foreword

THE INVISIBLE intersection between personal and social conscience might seem an unlikely subject for the visual arts, yet seventeenth-century Dutch painting marked the intersection of one's relationship to God and to other men with a moral compass of exceptional sensitivity. This exhibition on the art of the Netherlands during the seventeenth and eighteenth centuries sets forth a visual record of the shared beliefs and values of a culture in the midst of a Golden Age. In this comprehensive yet select group of paintings, even the most concisely realistic and simply straightforward evoke a gentle contradiction. Lurking beneath the visual clarity and technical finesse of these works are subtle questions that give us pause. These are paintings that embrace the world and fret over its delights, pursue grandeur and repent pride, and seek the true meaning of what confronts the eye. Art is the instrument that measures the depth of human experience and the nature of human character.

As guardians of art, museums feel particular reverence for the works of art they preserve and present in exhibitions and particular gratitude to all those who have shared works from their own collections to create an opportunity for everyone. *A Moral Compass: Seventeenth and Eighteenth Century Painting in the Netherlands* is a unique exhibition because of the unprecedented quality of the works lent to this museum and the recognition by lenders that our community has a special interest in this subject.

The distinguished museums and private collectors who extended loans of primary importance from their collections and are listed in this catalogue have been gracious partners. Arthur Wheelock, Curator of Northern Baroque Painting at the National Gallery of Art, Washington; Jan Piet Filedt Kok, Director of Collections at the Rijksmuseum, Amsterdam; Jeroen Giltaij, Chief Curator of

Paintings, Museum Boijmans van Beuningen, Rotterdam; Walter Liedtke, Curator of European Paintings, The Metropolitan Museum of Art, New York; and George Keyes, Curator of European Paintings, The Detroit Institute of Arts have been particularly generous and willingly shared their time and advice. James Burke, Director of the St. Louis Art Museum, and Judith Mann, Curator of Early European Art, David Steadman, Director of the Toledo Museum of Art, and Lawrence Nichols, Curator of European Painting and Sculpture before 1900, have affirmed the merit of this project by their obliging and thoughtful commitment.

Members of the museum Honorary Committee, whose names appear in this catalogue, have worked effectively to bring together the necessary community support required for an international exhibition. On behalf of the committee, it is a pleasure to recognize and thank United States Ambassador to the Netherlands, Cynthia Schneider, an art historian specializing in Dutch art, for her interest in this exhibition and her dedication statement to this catalogue. We are honored by the contributions of scholars, Arthur Wheelock, Lawrence Goedde, and Mariët Westermann for their essays and Peter Sutton for his introduction to this publication. Guest Curator Henry Luttikhuizen, Associate Professor of Art History at Calvin College, wrote the catalogue and brought outstanding professional skill, youthful vigor, and immense goodwill to the entire exhibition project. Alfred Ackerman, Head of Paintings Conservation at the Detroit Institute of Arts, worked with us as conservator for the exhibition.

Grand Rapids Art Museum staff have worked diligently on all aspects of this exhibition. Linda Thompson, Assistant Director for Education and Public Programs; Kathleen Ferris, Registrar; Amy Braun Heiney, Exhibition Designer and Assistant Curator; Steven Ferres, Assistant Curator and Chief Preparator; Anne Armitage, Director of Development; and Pamela Gallina, Director of Community Relations, have been devoted to this project.

The attribute of Dutch culture during the era of this exhibition which remains both remarkable and admirable is the scope of artistic patronage. Our own community is also fortunate in its patronage of the arts. The Jay and Betty Van Andel Foundation has had an international vision in its support of museum projects and provided the splendid lead gift that launched this exhibition. The Richard and Helen DeVos Foundation is a major patron sponsoring this superb catalogue and *The DeVos Lectures on Dutch Art,* a special lecture series organized in conjunction with the exhibition. The Keeler Foundation, Jim and Donna Brooks, Peter C. and Pat Cook, the Frey Foundation, Meijer, the Edgar and Elsa Prince Foundation, the Wege Foundation, Calvin College, the Daniel and Pamella G. DeVos Foundation, Milliken Fabric, and John and Judy Spoelhof have also provided essential sponsorship. To these and all foundations, companies, and individuals whose friendship and patronage have made this exhibition possible, the museum offers profound gratitude.

A Moral Compass: Seventeenth and Eighteenth Century Painting in the Netherlands has united the Grand Rapids/Holland community of West Michigan in a celebration of Dutch art and culture, a heritage that is valued and perpetuated throughout this region. It is fitting that this exhibition is organized and presented here as a measure of commitment to the quality of life in this community.

CELESTE MARIE ADAMS
Director, Grand Rapids Art Museum

Curatorial Statement

I N MANY WAYS, Grand Rapids is the ideal location for an exhibition of seventeenth- and eighteenth-century Dutch painting. The city, after all, has been and remains the home of several generations of Dutch immigrants and their descendants. Some readers may find it surprising, however, that most of the collectors of seventeenth- and eighteenth-century Dutch art in this country are not of Dutch heritage.

The American fascination with Dutch art and culture is nothing new. In fact, it played a role in shaping our national identity. The United Provinces provided a model nation for the new republic of the United States to imitate. Already in the late eighteenth century, Americans admired seventeenth-century Dutch society for its affluence and tolerance. In 1780 John Adams, who would later become the second president of the United States, praised Dutch culture. In a letter to his wife Abigail, he writes: "I doubt much whether there is any nation of Europe more estimable than the Dutch in proportion. Their industry and economy ought to be examples to the world. They have less ambition, I mean that of conquest and military glory, than their neighbors, but I do not perceive that they have more avarice. And they carry learning and arts, I think, to greater extent."[1] Benjamin Franklin echoed Adams's sentiments. As he put it, "In love of liberty and in defense of it, Holland has been our example."[2] With patriotic zeal, John Adams, Benjamin Franklin, and other Americans closely associated Dutch art and culture with political democracy and personal freedom, national characteristics they hoped to develop in the United States.

Throughout the eighteenth and nineteenth centuries, Americans not only appreciated Dutch politics, but they also held the Dutch in high regard for their middle-class virtues and religious tolerance. Dutch painting was also esteemed, for such art, it was believed, reflected the noble qualities of Dutch culture. The il-

lusionary qualities of Dutch painting were not described primarily in terms of deceit or trickery but were often praised for being faithful to appearances. For many Americans, Dutch painting, unlike the art of other European countries, seemed to lack embellishment and to disclose the simple truth.[3]

Today, many of the attributes once associated with Dutch art and culture of the Golden Age have been called into question. Historians have effectively shown that Dutch society was neither as democratic nor as tolerant as previously believed, and that the search for morality did not always translate into moral deeds.[4] In addition, art historians have revealed that Dutch paintings are not simple records of everyday life. The use of optical naturalism in Dutch art is highly selective and rhetorical. It constructs a plausible fiction, encouraging viewers to believe that what they see is true. In other words, these paintings are not passive illustrations of seventeenth- and eighteenth-century life. On the contrary, they are agents of persuasion, enticing observers to search for personal morality and the common good as they delight in the poetics of seeing.[5]

This exhibition of Dutch art is entitled *A Moral Compass*. As instruments of navigation, compasses help us to find our way; they guide us toward our proper destination. This international exhibition encompasses numerous genres of seventeenth- and eighteenth-century Dutch painting. We have brought this exhibit together to show some of the ways in which these works can steer viewers in a moral direction.

Dutch paintings are sophisticated and should not be viewed merely as visual sermons or didactic lessons. Contemporary viewers deeply appreciated artistic skill and took great pleasure in the subtleties and nuances of presentation.[6] Most of the paintings in this exhibition do not elicit a single meaning; rather, they invite a variety of plausible interpretations. Although these works differ in degree of ambiguity, they often place observers in a moral dilemma, encouraging viewers to make imaginative choices.[7] Dutch paintings evoke a variety of responses and can foster further contemplation concerning the nature of representation. They can stimulate beholders to reconsider the experience of viewing. By calling greater attention to the reception of images, such works invite observers to engage the faculties of memory and imagination. These paintings seem to imply that a moral compass is not simply something out there waiting to be uncovered; on the contrary, it is something produced internally, fashioned within each of us, as we respond to the challenges of life.

As curator of this exhibition, I have received the generous support and guidance of others. Harry Boonstra and Kathleen Struck of the Hekman Library of Calvin College and Lorenza Amico of the Fiske Kimball Fine Arts Library of the University of Virginia helped me to discover bibliographic materials I might otherwise have missed. At Calvin College, Lisa De Boer, Anna Greidanus-Probes, Clarence Joldersma, Cornelis van Nuis, Chris Stoffel Overvoorde, James Vanden Bosch, Charles Young, and Lambert Zuidervaart patiently listened to my ideas,

read parts of my manuscript, and offered much-needed criticism. Lawrence Goedde of the University of Virginia, Donald McColl of Washington College, and Larry Silver of the University of Pennsylvania also made significant contributions to this text. Their wisdom and friendship continued to guide me throughout this venture. To all those who helped bring this exhibition catalogue to completion, I extend my deepest gratitude and warmest regards.

<div align="center">

HENRY M. LUTTIKHUIZEN
Guest Curator

</div>

NOTES

1. John Adams's letter to Abigail was written in Amsterdam, during a diplomatic mission to the United Provinces, and is dated 15 September 1780. This quotation is cited in Peter C. Sutton, *Guide to Dutch Art in America* (Grand Rapids, 1986), p. xiii.

2. This quotation is cited in *The Great Dutch Paintings in America,* ed. Ben P. J. Broos et al. (exhib. cat., The Hague, 1990), p. 8.

3. Ibid., pp. 14-59.

4. For more on the history of the Netherlands, see Simon Schama, *The Embarrassment of Riches: An Interpretation of Dutch Culture in the Golden Age* (New York, 1987); Arie Theodorus van Deursen, *Het kopergeld van de Gouden Eeuw,* trans. Maarten Ultee as *Plain Lives in the Golden Age: Popular Culture, Religion, and Society in Seventeenth-Century Holland* (Cambridge, 1991); and Jonathan Israel, *The Dutch Republic: Its Rise, Greatness, and Fall, 1477-1806* (Oxford, 1995).

5. For more on the rhetorical nature of seventeenth-century Dutch painting, see Lawrence O. Goedde, *Tempest and Shipwreck in Dutch and Flemish Art: Convention, Rhetoric, and Interpretation* (University Park, PA, 1989; Goedde, "A Little World Made Cunningly: Dutch Still Life and *Ekphrasis,*" in *Still Lifes of the Golden Age: Northern European Paintings from the Heinz Family Collection,* ed. Arthur K. Wheelock Jr. (exhib. cat., Washington, 1989), pp. 35-46; Goedde, "Seascape as History and Metaphor," in *Praise of Ships and the Sea: The Dutch Marine Painters of the Seventeenth Century,* ed. Jeroen Giltaij and Jan Kelch (exhib. cat., Rotterdam 1996), pp. 59-73; and Goedde, "Naturalism as Convention: Subject, Style, and Artistic Self-Consciousness in Dutch Landscape," in *Looking at Seventeenth-Century Dutch Art: Realism Reconsidered,* ed. Wayne Franits (Cambridge, 1997), pp. 129-43.

6. Eric Jan Sluijter, "Didactic and Disguised Meanings? Several Seventeenth-Century Texts on Painting and the Iconological Approach to Dutch Paintings of This Period," in *Art in History, History in Art: Studies in Seventeenth-Century Dutch Culture,* ed. David Freedberg and Jan de Vries (Santa Monica, 1991), pp. 175-207. Reprinted with minor revisions in *Looking at Seventeenth-Century Dutch Art: Realism Reconsidered,* pp. 78-87.

7. Anne W. Lowenthal, "The Debate on Symbol and Meaning in Dutch Art: Response to Peter Hecht," *Simiolus* 16 (1986): 188-90; and Lowenthal, "Contemplating Kalf," in *The Object as Subject: Studies in the Interpretation of Still Life,* ed. Anne W. Lowenthal (Princeton, 1996), pp. 29-39.

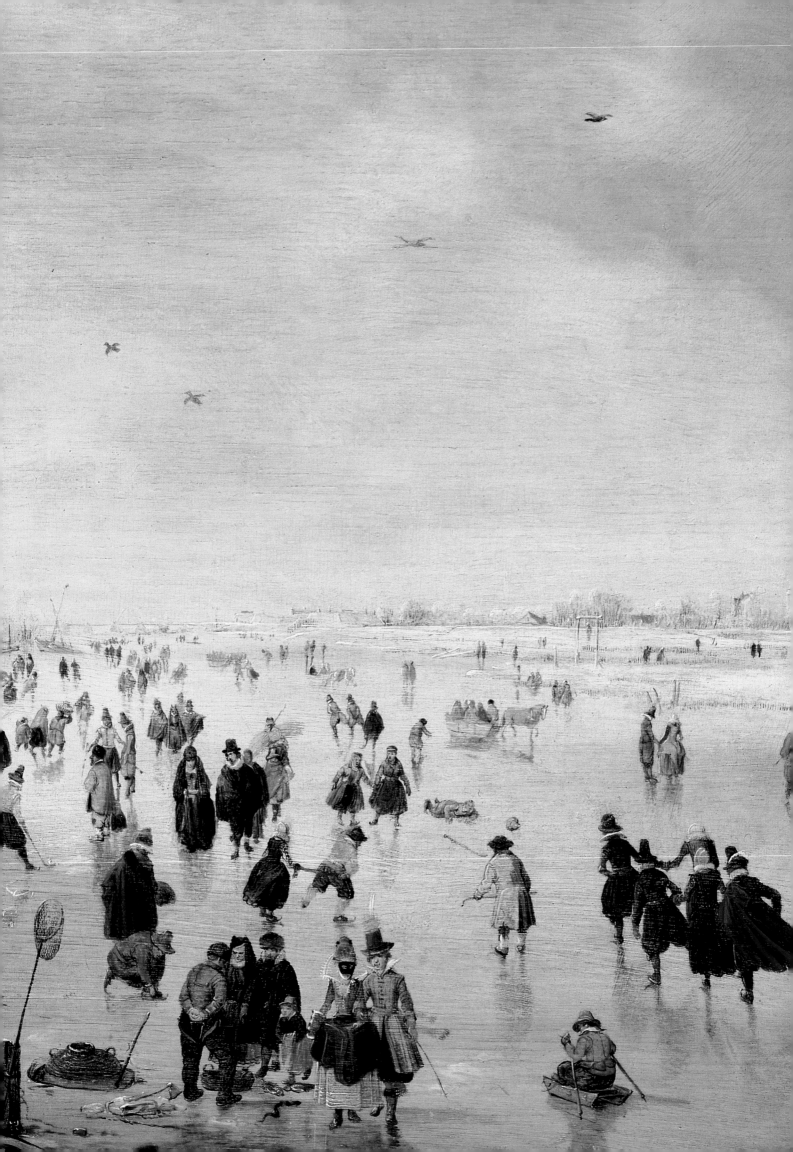

Introduction

PETER C. SUTTON

"It is better to do one thing excellently than many things only passably. He who cannot become a lutenist can learn to play the pipes."

PHILIPS ANGEL, 1641.[1]

IN THE seventeenth century the Dutch were the richest people per capita in all of Christendom. The global reach of their trading empire and the boundless enterprise of their merchants brought staples and treasures from throughout Europe and the wider world to the doorstep of this tiny country. No single edifice embodied Holland's prosperity and its sources in foreign trade more clearly than the majestic new *Stadhuis* or Town Hall in Amsterdam designed by Jacob van Campen. Celebrated as the "eighth wonder of the world" and a source of great pride for the citizenry who had financed it with their taxes, its classical facade featured high on its tympanums personifications of the Maid of Amsterdam receiving the bounty of the world's oceans and continents. The Netherlands' bustling commerce and relative political and religious tolerance attracted many immigrants who swelled its cities, where more than 60 percent of the population lived.

Judging from seventeenth-century inventories as well as the many paintings that survive today, Holland's wealthy urban populations developed a robust appetite for art that supported legions of painters. A few privileged artists received commissions from public and private patrons, but most worked for a highly competitive open market. Sales prices and appraisals suggest that profit margins for paintings were small; one survey of inventories in Delft determined that the average price of a painting attributed to an artist was fl. 16.6, or about two weeks'

OPPOSITE:

Hendrick Averkamp,
*Winter Landscape with
Figures Skating on a
Frozen River,* detail (cat. 1)

1

wages for a skilled worker, and a mere fl. 7.2 for unattributed paintings.[2] These economic pressures encouraged artists to specialize, since a painter would be loath to abandon a subject once it proved successful. This exhibition attests to the Dutch penchant for specialization, whether in portraiture, landscape, still life, genre, or architectural painting. It also illustrates their delight in a naturalistic record of their surroundings — the land, people, customs, and possessions.

The influential nineteenth-century art historian Eugène Fromentin promoted the notion that all Dutch art, regardless of subject matter, was a form of portraiture.[3] For Fromentin the insistent probity of the Dutchman's naturalism was the art's most revolutionary feature. Since all art involves some editorializing, his suggestion that the Dutch recorded their surroundings with the literalness of a camera lens is at best only a poetic truth. However, the Dutch portrayed their society, countryside and cities, flora and fauna, foods and furnishings more faithfully and comprehensively than any people who preceded them, indeed set standards for naturalistic observation for the centuries of painters who followed.

As citizens of a country that had only recently achieved its independence from Spain and the Spanish Southern Netherlands, the Dutch took special pride in images of their countryside, indeed fashioned their own sense of national identity in part through these works, whether panoramic views of the mottled plain, farmlands, or the bosky forests in the east of the country. As a nation that vied with much larger neighbors for the mastery of the globe's oceans and saw as much as one-tenth of its male population at sea at any given moment, the Netherlands scarcely neglected seascape painting. Allied to landscape as a painting type, Dutch marines portrayed dramatic tempests, shipwrecks, and sea battles but also more quotidian moments with vessels lying at anchor in calm harbors.

In the area of still-life painting, the Dutch shared many interests with their Flemish cousins. Paintings that express a taste for luxury, abundance, and ostentation are defined in the untranslatable Dutch term *pronck stilleven*. Although more readily associated with Flemish than Dutch painting, a taste for greater elegance and luxury arose among Holland's privileged classes, especially after the mid-seventeenth century. Among the most distinguished paintings in this exhibition are the genre scenes, a term that refers to scenes of everyday life. Northern European and especially Dutch painters invented and codified this painting type in the sixteenth and seventeenth centuries. Calvinist *predikants* and authors of moralizing social commentary were often harshly critical of entertainment. Inscriptions on emblematic prints of merry company subjects reinforced their arguments. The moral compass of Dutch art could at times be as censorious as its most pious observers, but among the providers and consumers of genre paintings there was clearly a full spectrum of points of view. This should not suggest, however, that these scenes are merely pictorial sermons. On the contrary, many paintings convey delight in the gaiety of their subjects without hectoring moral

commentary. Moreover, the moral point of view expressed by Dutch genre paintings might be exemplary as well as admonitory. Pieter de Hooch's domestic scenes, for instance, often express an ideal of domestic virtue championed in seventeenth-century domestic conduct books; for in the Protestant Republic of the Netherlands, the home and hearth were as important forums for moral instruction as the church.

The paintings in this exhibition were produced for Dutch homes. Their intimate scale and subtle details encourage close attention and provided seventeenth-century viewers with both enjoyment and edification.

NOTES

1. Philips Angel, *Lof der Schilder-Konst* (Leiden, 1642), pp. 49-50.

2. John Michael Montias, *Artists and Artisans in Delft in the Seventeenth Century: A Socio-Economic Study of the Seventeenth Century* (Princeton, NJ, 1982), p. 259.

3. Eugène Fromentin, *The Old Masters of Belgium and Holland* (New York, 1963; first published as "Les Maîtres d'autrefois: Belgique-Hollande," in *Revue des deux-mondes*, 1875), p. 131.

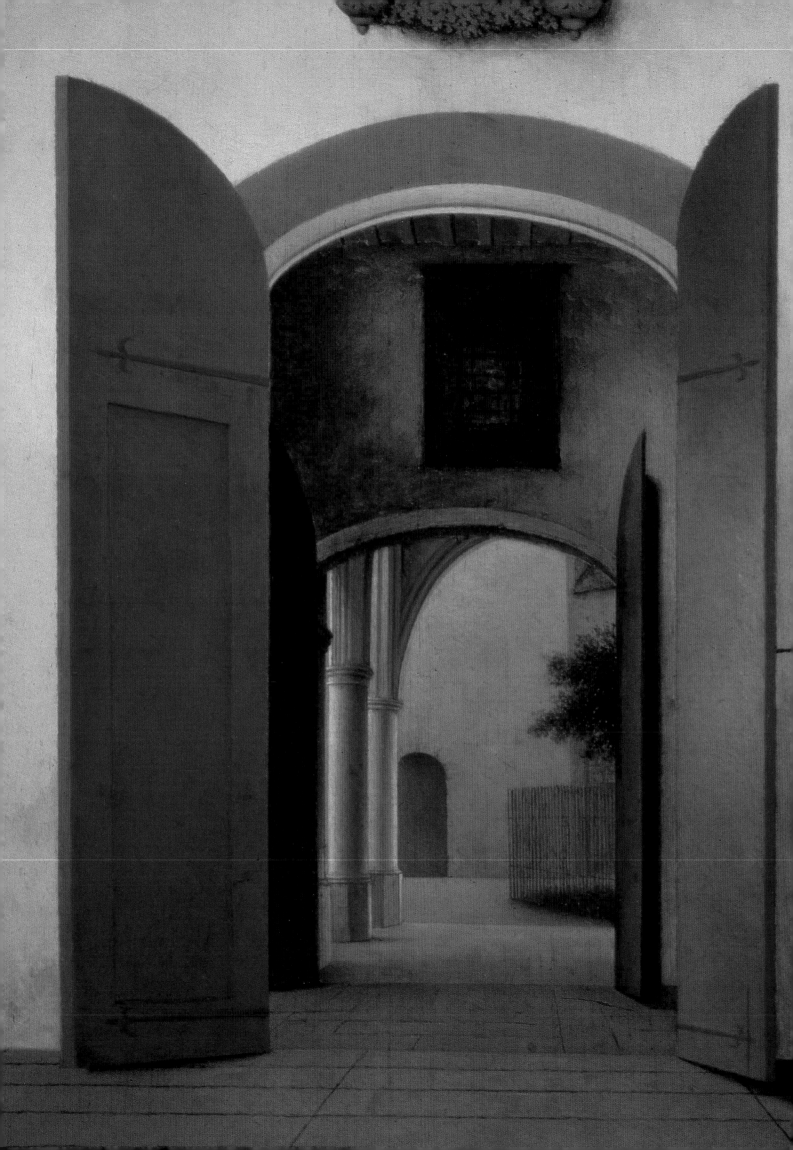

A Moral Compass: Public and Private Domains in Dutch Art

ARTHUR K. WHEELOCK JR.

T HE MASSIVE salmon-red doors leading from the St. Laurenskerk have been swung open, and the viewer, slowly at first, but with an increasing sense of urgency, is drawn to what appears to be a quiet and peaceful private realm, devoid of human presence (cat. 21).[1] Just enough of the light-filled exterior is visible beyond the double sets of doors to indicate that a lush garden lies beyond our sight, but Pieter Saenredam has been careful not to reveal its character. Indeed, the view offers no logical visual culmination for the imposing architectural enframement, and we are left to wonder about the implications of the tall iron fence around the treed garden or the off-center arched doorway on the opposite wall.

As with many of Saenredam's finest works, it is a painting constructed with utmost clarity but also with a profound sense of enigma that leaves many questions about his intent.[2] What motivated him to paint this view, an open and beckoning passageway leading from the church's southern ambulatory through the darkened alcove of the library to the arcade beyond?[3] Why did he alter the appearance of a large public square adjacent to the church so that it takes on the character of a private cloister?[4] Did he introduce the fenced-in garden, which did not exist in that public space, as a conscious allusion to the Garden of Paradise?[5] Although Saenredam provides us with no answers to these questions, the journey he encourages us to make is both physical and spiritual. In passing through these doorways to the serene realm beyond, we are not only compelled to consider our physical surroundings, but also, in the darkened alcove of the library, the limits of human understanding in confronting the ultimate mystery of the religious experience.

OPPOSITE:

Pieter Jansz. Saenredam,
*View from the Aisle of Sint
Laurenskerk, Alkmaar,*
detail (cat. 21)

5

Saenredam's painting of the St. Laurenskerk, Alkmaar, introduces a fascinating and perplexing aspect of Dutch art: its insistence that insignificant and unexpected views of everyday reality may reveal the greatness of God's creation and offer insights about moral issues affecting our own lives. Such themes occur in numerous depictions of daily life. As with Saenredam, most Dutch artists selectively adapted reality for aesthetic and thematic reasons, whether the subject be a graceful vase of flowers (cat. 23), an elegant woman absentmindedly toying with her ring while standing in the midst of luxury (cat. 3), or travelers wandering past a craggy, dead tree rising among windswept dunes (cat. 17). Each of these images engages the viewer through its sense of realism, but each also provides a spiritual, emotional, or moral context for our own experiences. Jan van Thielen's still life celebrates God's extraordinary bounty; Gerard ter Borch's genre scene intimates the psychological complexity of human relationships; and Pieter Molijn's landscape reminds us to remain aware of the transience of earthly existence.

While many Dutch paintings focus on such private spiritual and moral concerns, others raise broader, more public issues. For example, Gerrit Berckheyde's intimately scaled painting, *The Town Hall on the Dam, Amsterdam*, 1672 (cat. 2), conveys a communal sense of economic well-being.[6] Rising behind the traders,

Gerrit Berckheyde,
*The Town Hall on the
Dam, Amsterdam*,
detail (cat. 2)

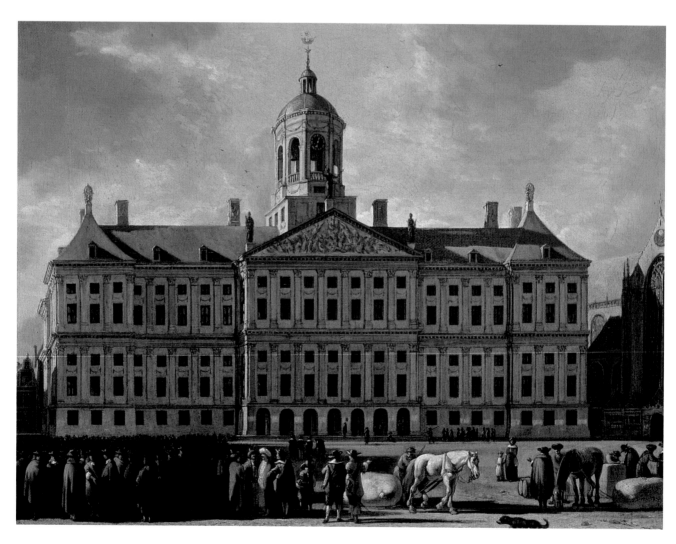

6

merchants, and aristocrats who have congregated on this large and imposing public space is Amsterdam's magnificent Town Hall, a building renowned in its day as the "eighth wonder of the world."[7] While this symbol of political might was Berckheyde's central focus, he also included segments of two other buildings on the Dam Square, the Nieuwe Kerk and the Weigh House, edifices that symbolize Amsterdam's spiritual and commercial strength.

On the basis of this image, one would never guess that all was not well in the Dutch Republic. However, this celebration of Amsterdam's power and might is dated 1672, the "Rampjaar," when besieging French troops invaded the Netherlands while pillaging its towns and cities and raping its citizens. Against this historical background Berckheyde's small painting cannot be seen neutrally. Beyond being a careful depiction of an important public space at the center of Amsterdam, it is a political statement of the artist's unshakable belief in the greatness of his country and its people.[8]

Berckheyde's public statement, where the viewer participates in a shared sense of communal pride, and Saenredam's very private image, where the viewer is encouraged to explore an inner space, both actually and metaphorically, are both outgrowths of the character of Dutch society as it developed at the very beginning of the seventeenth century. To understand how these concerns became so fundamental to Dutch art, it would help to look briefly at the political, religious, and social circumstances that lay at the core of the Dutch Republic.

As a country that had only recently become a political entity and was still suffering from the effects of a long and arduous war against Spain, the Netherlands would hardly seem to have had adequate resources to nourish and sustain a distinguished artistic tradition. Nonetheless, in every respect, the Dutch seem to have drawn strength from adversity: they profited in terms of trade, political awareness, religious tolerance, wealth, and, above all, self-esteem. They were proud of their achievements and were determined to provide for themselves a broad and lasting foundation that would ensure their unique social and cultural heritage.

The groundwork for the Republic of the United Netherlands was established in the second half of the sixteenth century during the Dutch revolt against Spanish domination. The Republic was formed when a loose federation of the seven northern provinces, Holland, Zeeland, Utrecht, Gelderland, Overijssel, Friesland, and Groningen, agreed to act together as one entity to maintain their rights against foreign tyranny. Each province sent a representative to the States General, the legislative body in The Hague responsible for the economic and social welfare of the Republic. The Stadholders, who were responsible for military affairs, were all descendants of Prince Willem of Orange (William the Silent), the leader of the Dutch revolt until his assassination in 1584.

The political separation of powers that evolved in the seventeenth century created an effective form of checks and balances for determining national policy.

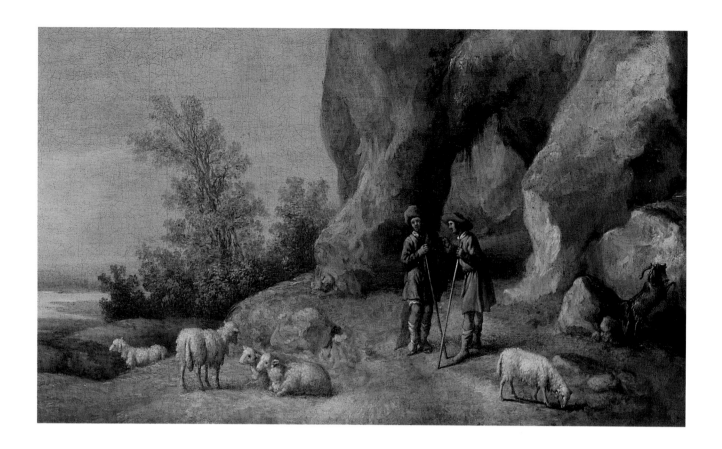

Aelbert Cuyp, *Shepherds in a Rocky Landscape*, detail (cat. 4)

The States General, which was dominated by the most powerful province, Holland, and its most important city, Amsterdam, advocated a course of peace that would enhance trade, and hence the economic prosperity of the bourgeoisie. However, the Stadholders Maurits, Frederik Hendrik, and Willem II were all capable leaders who possessed great military abilities. Since their role in state affairs was clearly augmented during periods of military conflict, they advocated a policy of military intervention. Their desires, however, were often stymied by debate in the States General. Thus, unlike the absolute monarchies in other countries of the period, the Dutch determined their national policy through a body that represented many segments of their society.

An essential ingredient in the political and social structure of the country was Calvinism. The revolt against Spain was waged for a variety of reasons, not the least of which was religion. The North resented the intrusion of Spanish Catholicism and favored Protestant beliefs, epitomized by the writings of John Calvin. Protestantism, however, was manifest in many forms. Strict Calvinists, who advocated authority in religious affairs, were supporters of a strong central government and sided with the House of Orange. Those who sought a milder form of Calvinism, one that tolerated other sects and was more humanistic in its approach, sided with the States General. Tension existed among the various factions, and religious strife, with direct political ramifications, occasionally surfaced.

The political events and religious attitudes of the period are not readily apparent in the wealth of visual material produced by Dutch artists. The still lifes,

portraits, landscapes, seascapes, and genre scenes that characterized this school of painting are surprisingly devoid of information on the major occurrences of the day. Nevertheless, the philosophical bases from which artists worked are clearly the same as those governing decisions in contemporary political, military, and religious spheres of activity. This ideology was essentially threefold: that God's work is evident in the world itself; that, although things in this world are mortal and transitory, no facet of God's creation is too insubstantial to be noticed, valued, or represented; and that the Dutch, like the ancient Israelites, were a chosen people, favored and blessed by God's protection. This last analogy, based on the fact that the Dutch, like the Israelites, had fought for their existence against a powerful oppressor, lent their struggle against Spain a legitimacy based on historic and heroic precedent.

The seventeenth-century Dutch, in fact, found numerous similarities between great historical, literary, and political events and their own experiences that became important components of their national mythology. Aside from the struggle of the Israelites, the Dutch also drew direct parallels between their political situation and the revolt of the ancient forefathers of the Dutch, the Batavians, against the Romans. In fact, the story of the Batavians' brave struggle was the subject of a series of large-scale paintings within the Amsterdam Town Hall.[9] Dutch viewers of Berckheyde's 1672 painting (cat. 2) would have recalled the valor of their heroic forefathers while contemplating their own dire circumstances resulting from the French invasion of their country.[10]

Many of the paintings dealing with shared national mythologies were large works commissioned for public buildings. Thus, they fall outside the parameters of this exhibition, which focuses on realistically conceived, small-scale works suitable for a private home. Nevertheless, even here, in the absence of narrative paintings, particularly those with religious, historical, or mythological subject matter, intimations of these shared political and social ideals can be discovered. The most important of these works, other than Berckheyde's *Town Hall on the Dam, Amsterdam,* is Aelbert Cuyp's *Shepherds in a Rocky Landscape* (cat. 4). This serene world, where carefully tended cows and sheep quietly graze on fertile fields, reflects two other related myths central to contemporary thought, the existence of the "Dutch Arcadia" and the "Dutch Golden Age."

Today, when we use the term the "Golden Age" to refer back to the Dutch seventeenth century, we have before our mind's eye primarily the extraordinary achievements of its artists. Nevertheless, we could also celebrate its architects, poets, scientists, universities, unique political structure, tolerant attitudes toward different religious sects, maritime fleet, economic power, and prosperous way of life. However, before all of this came to pass, before Rembrandt first picked up his brush, the Dutch already understood that they were entering into a "Golden Age." Mannerist artists delighted in allegorical images of "The Golden Age," in which sensuous and evocative gods and goddesses living in a world of

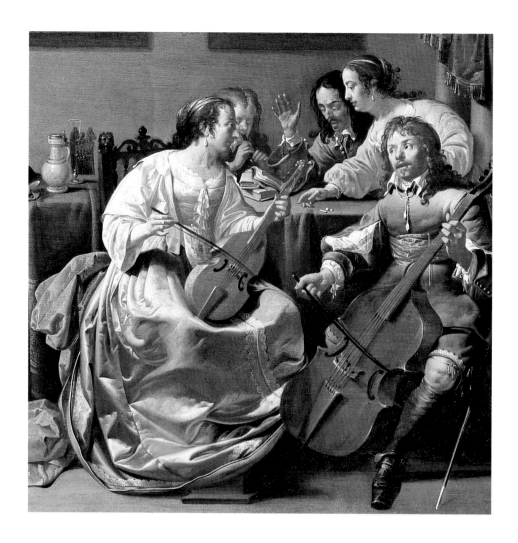

peace, harmony, and prosperity lounged gracefully around banquet tables.[11] Johannes Pontanus, in his 1611 city history of Amsterdam, wrote that Amsterdam was embarking on its "Golden Age," while, at the same time, numerous poets eulogized the pastoral beauty of the "Dutch Arcadia."[12]

The Twelve Years Truce, which lasted from 1609 to 1621, gave immediate credence to this already existing myth of the "Dutch Golden Age." After so many years of war and strife, hunger and hardship, the freedom to travel without fear of military encounter, as well as the influx of talented artists and craftsmen from the Southern Netherlands, gave new promise and hope to the Dutch people. The sense of wealth was enhanced by the untold riches from distant lands — spices, exotic flowers and plants, rare shells, and even unknown types of animals and birds — that Dutch traders brought to their shores. Finally, reclamation projects added fertile new lands for crops and grazing, while improved waterways allowed commerce to pass easily from city to city and from town to town.

By the mid-1640s, when Cuyp painted this pastoral idyll of Dutch shepherds and herders lazily tending their sheep and cows under the billowing clouds of a summer's day, both the threat of war and life's cares seemed far removed.[13] Although Cuyp's arcadian landscape is largely fanciful — no such rocky out-

growths exist in the Dutch countryside — the peaceful world he portrayed had become a very real phenomenon in Dutch life.

The self-conscious evocation of a "Dutch Arcadia," however, is not limited to the idealized pastoral paintings by Aelbert Cuyp. The concept also underlies the extremely positive view of the Netherlands presented by artists who portrayed the specific realities of Dutch life. Most Dutch landscapes and seascapes emphasize the essential harmony of humanity and nature, whether it be the festive atmosphere of skaters enjoying the ice on a cold winter's day (cat. 1), the daily activities of fishermen and herdsmen along inland waterways (cat. 7), or the diligence of sailors caring for the hulls of the imposing ships that were the backbone of the Dutch maritime empire (cat. 25). This sense of harmony also extended to the carefully measured courtyards of Dutch burghers, where domestic life unfolded in peaceful rhythms (cat. 12), or to the easy rapport of revellers playing backgammon or musical instruments (cat. 6).

The ideals underlying the "Dutch Arcadia" were not far removed from the biblical notion of the Promised Land, and thus the Dutch, the modern-day Israelites, brought to this classical concept a theological and moral component. The bounty they so richly deserved had been provided by God, and every celebration of nature, be it a painting or a discovery through a telescope or microscope, was an act of homage to his greatness. For example, when the church fathers in Delft wrote in 1677 to the Royal Society in London on behalf of the famed Delft microscopist Anthony van Leeuwenhoek, they asserted that "nothing contributes more to the honour of God, the Creator of everything, or incites us more to the admiration of Him who alone is Goodness, Wisdom, and Power, than the exact observation of creation."[14]

This theological approach to the world was felt as strongly in the Southern Netherlands as in the Northern Netherlands. Flemish still lifes, ranging from Joris van Son's lush tabletop filled with fruit and oysters (cat. 22) to Jan van Kessel's precise rendering of insects and berries (cat. 13) to van Thielen's floral

Gerrit Berckheyde,
*The Town Hall on the
Dam, Amsterdam,*
detail (cat. 2)

11

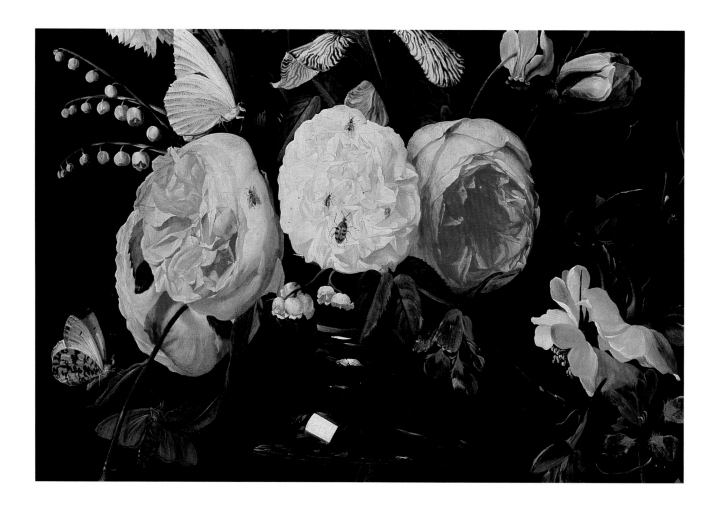

Jan Philips van Thielen, *Bouquet in a Glass Vase,* detail (cat. 23)

bouquet, were every bit as accurately observed as Leeuwenhoek's microscopic studies. An excellent insight into the prevailing attitude toward nature is provided by the Flemish art theorist Cornelis de Bie, who, in 1661, wrote that nature is perfect beauty, without blemish.[15] According to de Bie, human understanding of nature was obscured after the Fall of humanity, even though nature itself remained untainted. Rediscovery of nature was possible only through the effort and industry of the enlightened mind, which is granted by God's grace. An artist's careful depiction of nature could thus help reveal the essence of God's greatness.[16] De Bie, for example, wrote about the Dutch landscape painter Jan Both in the following manner: "When we perceive the power of nature in the green growth of the earth, daily nourished by the grace of God, we are reminded of the origin of life. Jan Both painted this with such talent that the heart of the observer of his work is inspired with virtue."[17] A similar attitude underlies contemporary appreciation of flower paintings. De Bie marveled that "Life seems to dwell" in the paintings of van Thielen's teacher, Daniel Seghers.[18]

Dutch society's moral compass for human behavior must be understood within this broad theological approach to the world. The most visible manifestation of this compass is the emblem book, a fascinating literary and pictorial genre that flourished in the seventeenth-century Netherlands. Emblems, which consist of an epigram, an image, and an accompanying verse, provide guidance

on all aspects of human endeavor, whether love, child rearing, commercial ac-
tivity, social responsibility, or Christian ideals. Part of the appeal of the emblem
was the challenge of puzzling through the multiple layers of meaning and allu-
sion in images and texts, for, as these writers delighted in reminding their read-
ers, life's choices are not always self-evident.

The Dutch sometimes adopted allegorical images from Italian and French em-
blematic traditions, but, to an extraordinary degree, they selected their motifs
from objects and situations found in daily life. Similar motifs occurring in Dutch
paintings appear to have had comparable moral or allegorical connotations.[19] In-
deed, artists, no less than emblem writers, often obscured their paintings' mean-
ings as a means to present life's moral ambiguities. Viewers of ter Borch's *Lady at
Her Toilet* (cat. 3), for example, have to decide whether the centrally placed
snuffed-out candle merely indicates that the scene transpires during daylight
hours or whether it also refers to the vanity of worldly possessions.[20]

The character of the moral compass for private and public images, thus, differs
in Dutch art. Ambiguous meanings do not occur in paintings with a public focus,
those works infused with broad, cultural messages built on society's underlying
myths. Primary among these are paintings instilled with the idea that the Nether-
lands, under the enlightened rule of the House of Orange and the States General,
was a promised land, a prosperous and peaceful Arcadia. The message of such im-

Gerard ter Borch,
Lady at Her Toilet,
detail (cat. 3)

ages is invariably self-evident and positive. The moral compass for private images is more varied and more complicated. In these works Dutch artists sought to engage their viewers in ways that reveal God's beneficence as well as the complexity of life's moral choices. Some, like Saenredam, constructed evocative spaces for viewers to enter and explore; others, like van Thielen, created extraordinarily lifelike renderings of nature for the observer to admire and reflect upon; while many, like ter Borch, focused on the human drama. Nevertheless, despite such differences in the character of the private and public images they created, Dutch artists believed fully in the allegorical implications of the physical world, convinced that these provided the proper framework for understanding both the nature of their society and the moral issues confronting one's life.

NOTES

1. I would like to thank Quint Gregory and Lynn Russell for their thoughtful comments on this essay.

2. As is normal with Saenredam, the artist composed his painting on the basis of drawings made from life. Although these are now lost, Saenredam almost always made subtle adjustments in the building's proportions in his paintings for both aesthetic and iconographic reasons. One can imagine that, in this instance, he enlarged the double doorway leading from the aisle of the church.

3. *Pieter Jansz. Saenredam* (exhib. cat., Centraal Museum, Utrecht, 1961), pp. 42-43, correctly notes that Saenredam depicted a view through the library, which was built between the first traverse of the southern ambulatory and the southern transept arm of the church in 1594 for the benefit of its Latin School. For a history of this important library, see G. I. Plenckers-Keyser and C. Streefkerk, "De Librije van Alkmaar," in *Glans en Glorie van de Grote Kerk: Het interieur van de Alkmaarse Sint Laurens*, Alkmaarse historische Reeks 10 (Hilversum, 1996), pp. 263-74. I would like to thank Quint Gregory for calling my attention to this article.

4. G. Schwartz and M. J. Bok, *Pieter Jansz. Saenredam: The Painter and His Times* (New York, 1989), pp. xxx, 232, and Jeroen Giltaij and Guido Jansen, *Perspectives: Saenredam and the Architectural Painters of the 17th Century* (exhib. cat., Museum Boijmans van Beuningen, Rotterdam, 1991), p. 157, describe the space as a "cloister." However, as is evident from A. Rademaker's print showing the exterior of the church, which was published in 1736, the view through these doors is of a large public space. For an image of Rademaker's print, see Plenckers-Keyser and Streefkerk in *Glans en Glorie*, p. 264, fig. 1.

5. Rademaker's print of this area (see n. 4) indicates that a garden surrounded by a brick wall existed behind the south transept. However, this garden would not have been visible from Saenredam's viewpoint. For a discussion of the Paradise iconography of the enclosed garden, see Virginia Tuttle Clayton, *Gardens on Paper: Prints and Drawings, 1200-1900* (exhib. cat., National Gallery of Art, Washington D.C., 1990), pp. 23-24.

6. For Berckheyde's paintings of the Dam Square, the earliest of which dates 1668, see Cynthia Lawrence, *Gerrit Adriaensz. Berckheyde (1638-1698): Haarlem Cityscape Painter* (Doornspijk, 1991), pp. 55-56.

7. For a synopsis of the Town Hall's symbolism, see Mariët Westermann, *A Worldly Art: The Dutch Republic 1585-1718* (New York, 1996), p. 155.

8. Berckheyde's carefully constructed composition is conceived far differently from Isaac Ouwater, *View of the Spui at Delft Bridge, The Hague* (cat. 18). This eighteenth-century topographic artist, who likewise painted marvelously luminous and detailed cityscapes, exercised little selectivity in the types of buildings and canals he depicted.

9. For the story of the Batavian Revolt and an assessment of this complex commission, see H. van de Waal, "The Iconographical Background to Rembrandt's *Civilis*," in H. van de Waal, *Steps*

Towards Rembrandt: Collected Articles 1937-1972, ed. R. H. Fuchs (Amsterdam and London, 1974), pp. 28-43.

10. Indeed, such historic allusions became as intrinsic to the Dutch mythology as were the assassination of William the Silent or the heroic defense of Haarlem against the Spanish invaders in 1573. The Dutch also viewed dramas surrounding heroes and heroines, whether mythological or biblical, as allusions to the moral dilemmas inherent in human nature. Thus, while contemporary political, military, and religious events were rarely portrayed in Dutch painting, parallel themes rendered in allegorical dress were commonly depicted.

11. See Eric Jan Sluijter, *De 'Heydensche Fabulen' in de Noordnederlandse schilderkunst circa 1590-1670* (The Hague, 1986).

12. Johannes Pontanus, *Historische beschrijvinge der seer wijt, beroemde coopstadt Amsterdam* (Amsterdam, 1614), p. 105, notes that the city is entering "een guilden tijt." Portanus also writes about the expansion of Amsterdam that will occur during "die selve jaren als onder een gouden tijt stellen" (the same years as the period of the Golden Age). I would like to thank Professor Eco Haitsma Mulier from the Universiteit van Amsterdam for providing me with this reference. For the pastoral beauty of the "Dutch Arcadia," see Alison McNeil Kettering, *The Dutch Arcadia: Pastoral Art and Its Audience in the Golden Age* (Montclair, NJ, 1983).

13. Preparations already underway in the mid-1640s for ending all hostilities with Spanish forces culminated with the signing of the Treaty of Münster in 1648.

14. A. van Leeuwenhoek, *Collected Letters* (Amsterdam, 1952), vol. 4, p. 257.

15. The following analysis is taken from E. S. de Villiers, "Flemish Art Theory in the Second Half of the 17th Century — An Investigation of an Unexplored Source," *South African Journal of Art History* 2 (1987): I-II.

16. Cornelis de Bie, *Het Gulden Cabinet van de edele vrij Schilderconst* (Antwerp, 1661), p. 66: "het leven wijst den wegh van perfectie en gheeft den sin van Godt's Mogentheydt." He continues: "Het leven (dat alleen van Godt voorcompt) leert alle dinghen. Ergo soo moet de Const van *Pictura* (die naer het leven uytghewerckt is ende het leven afschaduwende) onghelijck meerder cracht hebben als het gene gecopieert wordt naer den schijn van het leven."

17. De Bie, *Gulden Cabinet*, p. 156, as quoted by De Villiers, "Flemish Art Theory," p. 2. The original text reads: "Dat is het soet ghewas t'gen' doegh'lijckx wordt ghegheven/Door Godes zeghen uyt de groen en vruchtbaer aert./Dit wist *Both* met t'pinceel soo wonder af te malen/Dat al sijn maelery door haere geesticheyt/Den Mensch (die Const bemindt) met jever can bestraelen/En menichmael het hert tot haere deught verleyt."

18. De Bie, *Gulden Cabinet*, p. 215.

19. See Eddy de Jongh, *Tot Lering en Vermaak* (exhib. cat., Rijksmuseum, Amsterdam, 1976).

20. For an account of this dilemma, see Peter Sutton, *Masters of Seventeenth-Century Dutch Genre Painting* (exhib. cat., Philadelphia Museum of Art, 1984), pp. 150-51, cat. 13.

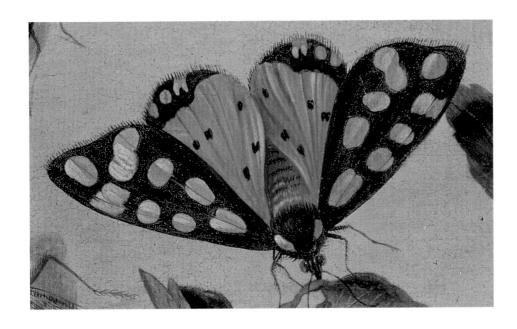

Jan van Kessel I, *Study of Butterflies and Insects*, detail (cat. 13)

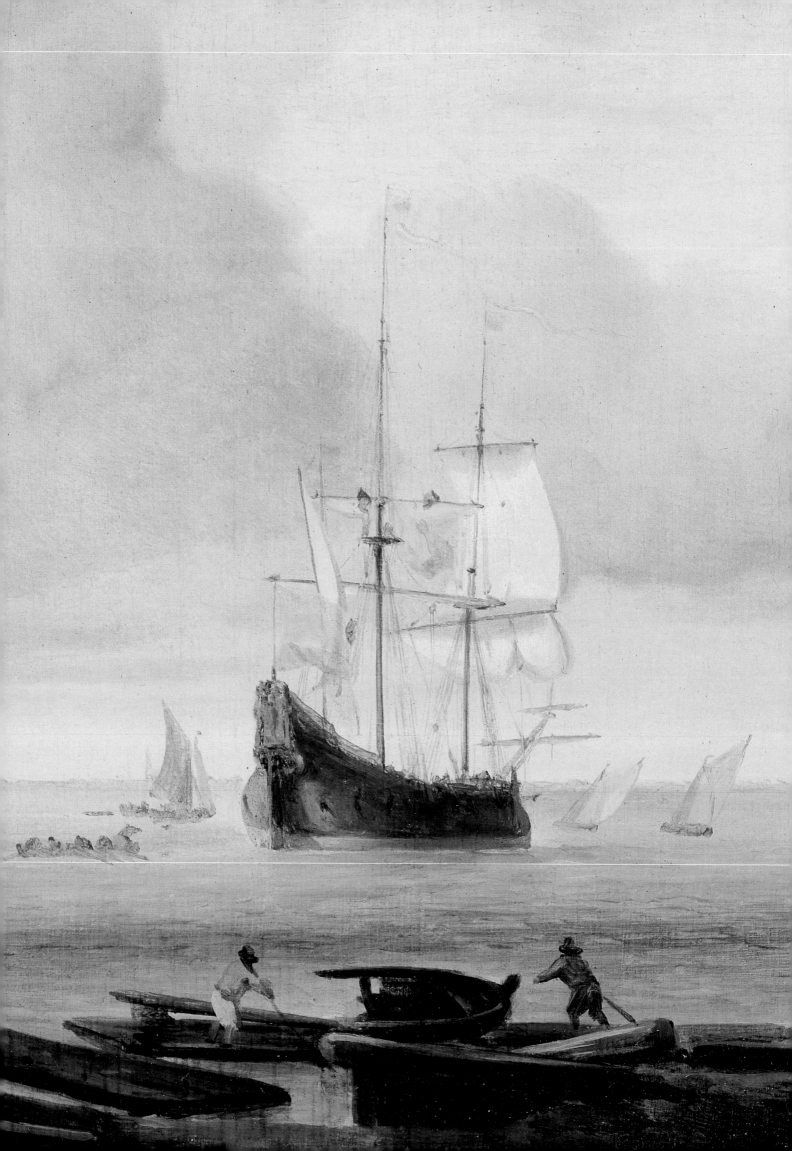

Seafaring and Dutch Art

LAWRENCE O. GOEDDE

THE EXPERIENCE of the sea and seafaring profoundly affected Dutch history and Dutch communal identity in the seventeenth century.[1] Seafaring was critical to the military and economic power of the Dutch Republic; but even more, the existence of the Republic as an independent state depended upon both its naval and its merchant shipping. Success in the prolonged struggle for independence from Spain and, after 1648, in the repeated conflicts, first with England and then with France, rested firmly on Dutch military and economic accomplishments at sea. Seafaring left its mark, too, in seascape painting, which has long been recognized as one of the distinctive inventions of the Dutch Golden Age.[2] There can be little doubt that the development of marine art and the continuing demand for it depended upon the widespread awareness in Dutch society of the maritime prowess of the United Provinces.

The heroism and audacity of the Dutch fleet in the Eighty Years War with Spain was embodied in the great naval victories of such celebrated admirals as Jacob van Heemskerck at Gibraltar in 1607 and Maarten Harpertsz. Tromp over the second Spanish Armada in 1639, as well as in such feats of daring as Piet Heyn's capture of the Spanish silver fleet in 1628, an event still sung in a children's rhyme.[3] The three wars with England (1652-54, 1665-67, 1672-73) involved humiliating losses and astonishing victories for the Dutch, including such celebrated events as the burning of the English fleet at anchor in the Medway in 1667. So successful were the Dutch in harassing the English in the summer of that year that the Surveyor of the English navy, Sir William Batten, exclaimed, "By God! I think the Devil shits Dutchmen," as the diarist Samuel Pepys records.[4] In 1673, with the Dutch Republic at the lowest ebb of its fortunes and most of the Netherlands conquered by a vastly larger French army, the Dutch navy under the

17

command of Michiel Adriaensz. de Ruyter fought the combined fleets of England and France to a standoff in three epic battles.[5] This was effectively a victory in the circumstances, saving the nation from what seemed certain ruin.

The victories and losses of the Dutch navy were consequently a part of people's lives and identities — indeed, some of the battles in the English Channel were witnessed at a distance by crowds that gathered on the dunes. This popular awareness of seafaring was not limited to naval exploits, however, for people were keenly interested as well in the extraordinary achievements of entrepreneurial daring that saw Dutchmen for the first time circumnavigating the globe and exploring remote corners of the earth.[6] In the 1590s the Dutch sailed for the first time to India, the East Indies, and the Far East. By 1650 Dutch traders were everywhere, from Russia to Brazil, from North America to Japan, and they had founded a commercial empire that stretched across the Indian Ocean to the Spice Islands of what is now Indonesia and beyond that to Japan. It is not often remembered that the Dutch controlled much of Brazil from 1630 to 1645 and did not give up their colony there until 1654. The wealth that poured into the small land of the Netherlands was unprecedented as the Dutch not only continued to dominate the carrying trade in such bulk goods as timber, grain, metal, salt, wine, cloth, and even marble but also gained control of the "rich trades" in spices, silks, porcelain, and other Eastern luxuries. Jonathan Israel has argued that from about 1590 the Dutch Republic became a "world emporium," the central entrepôt or clearing house for storage and transshipment of not just the bulk trade of Europe but of luxury goods produced around the world.[7] In the process the Dutch gained control as well of enormous amounts of capital, and Amsterdam became the center of world finance.

The astonishing rise of the Dutch to this prosperity and power depended upon seafaring and the entrepreneurial energy of the maritime towns of Holland and Zeeland. Few inhabitants of relatively small towns like Enkhuizen, Hoorn, Vlissingen, and Dordrecht were not touched in some way by nautical activities, but even the 200,000 inhabitants of Amsterdam must have been made aware of seafaring on a daily basis. In addition, the Dutch were highly innovative in such related fields as ship design and construction. Nicolaes Witsen's treatise on shipbuilding is one of the earliest and most important works of its kind and documents the Dutch awareness of their extraordinary success in ship construction.[8] Dutch shipyards produced hundreds of vessels a year and produced them more quickly and cheaply than any other country in Europe. This was due in part to the prevailing low interest rates in the Republic, but also to vast stockpiles of raw materials, the ingenious use of machines like wind-driven sawmills and large cranes, and the careful organization of materials in the shipyards.[9] Jan Jansz. Liorne, a shipbuilder in Hoorn, introduced the *fluit* or flute in 1595.[10] This oceangoing ship was distinguished by an exaggeratedly rounded hull of relatively shallow draft, ideally suited to the shallow waters of the Netherlands and

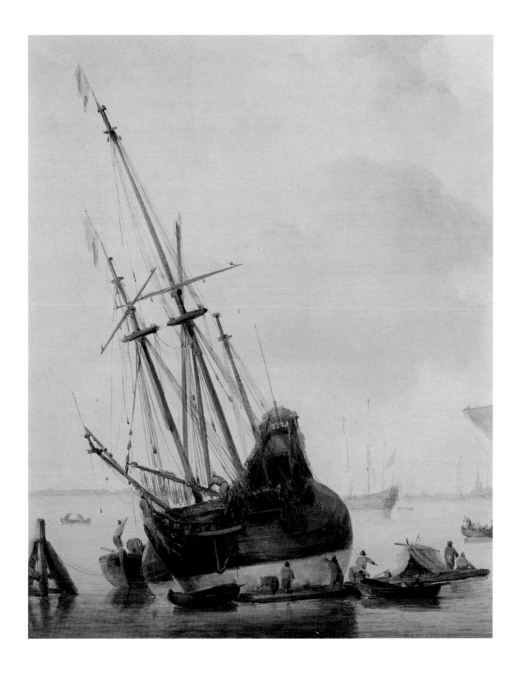

Willem van de Velde II,
Ships in a Harbor
(Marine Painting Pair),
detail (cat. 25)

to carrying larger loads of cargo than ordinary hull forms. That the *fluit* could also be operated with fewer crewmen was one factor in the operating economies that permitted the Dutch to undersell their competitors and gain control of the carrying trade of Europe. The Dutch also took the lead in cartography and navigation. Lucas Jansz. Waghenaer published sea charts in 1584-85 that became so well known that English seamen continued to refer to books of charts as "wagoners" until the nineteenth century.[11]

The Dutch were keenly aware of these developments and of the role of seaborne trade in the prosperity that financed their revolt against Spain and made possible the constant expenditures needed to protect their commercial networks against the envy of England and France. A number of institutions enhanced this awareness of seafaring within Dutch culture. One was the decentralized system of five admiralty "colleges," which were responsible for administering the navy.

They built, outfitted, and repaired ships, recruited sailors, collected tolls, and regulated fisheries.[12] Located in Amsterdam, South Holland (Rotterdam), the North Quarter, Zeeland, and Friesland, these representative bodies answered to the States General but comprised members from all the provinces of the Republic. Another important maritime institution was the *rederij,* or system of part ownership of vessels that prevailed in the Republic.[13] Individuals, often of relatively modest means, bought shares in ships as investments, a diffusion of ownership that spread both risks and an interest in seafaring. Further stimulating a concern with seafaring and enhancing its penetration into the fabric of Dutch society was the extensive body of travel literature published in Holland, most notably the accounts of the Dutch voyagers, which began to appear in print with the *Itinerario* of Jan Huygen van Linschoten in 1596, telling of his voyage to the Portuguese Indies.[14] Numerous accounts of voyages, often published in cheap pamphlet form, made the exploits and dangers of seafaring vivid for a wide public. Some, like Willem Ijsbrandtsz. Bontekoe's tale of his voyage to the East Indies, remain well known in the Netherlands to this day.[15]

Perhaps the most fundamental reason for Dutch awareness of the sea and seafaring was geographical: it is still a land literally permeated by water, consisting in large part of the deltas of the great rivers Rhine, Maas, and Schelde flowing into the North Sea.[16] Then as now great barrier dunes facing the sea protected a low-lying land of fields and bogs, crisscrossed by numerous natural and manmade watercourses. It was also a land of numerous islands, small lakes and marshes, and great inland seas like the Haarlemmermeer and the Zuiderzee, now fully or partially drained and tamed; but on seventeenth-century maps these bodies of water give the land a decidedly dissolved appearance. Even the great reclamation projects that began in the seventeenth century only served to heighten the awareness of the sea, which sometimes took back in disastrous floods the lands the Dutch had pumped dry.[17] The shortage of arable land and a location at a natural crossroads of European trade encouraged Netherlanders to look to the sea. Fishing was one of the foundations of the Dutch economy and the Dutch diet; and from an early date the Dutch were actively engaged in shipping and trading. Indeed, the province of Holland had already gained control of bulk shipping in the Baltic in the sixteenth century.[18]

Seen in the context of geography, history, and culture, it is perhaps not surprising that the Dutch were the first to develop seascape as an independent category of painting. This development seems less inevitable, however, if we reflect upon the many maritime cultures of early modern Europe — Venice, Genoa, Portugal, Spain, Lübeck and other German Hansa towns, and England, for instance — that did not give birth to seascape painting. Simply the existence of a thriving tradition of seafaring was clearly not enough in itself to give rise to a tradition of imagery. This depended in the Netherlands on a number of factors, not the least of which was the development through two centuries of a tradition

of naturalism in art and a culture that tended to value the depiction of the familiar and everyday.[19] This tradition of realism, as it is called, is marked, however, by another feature that seems in some respects contradictory to its naturalism, that is, a pronounced tendency to conventionality in choice of subjects, compositions, and expressive effects.

Dutch art in general abides by a surprisingly selective approach to depicting the world. For all its wonderfully convincing verisimilitude, it is a realistic art in which only some aspects of reality find a place.[20] This selectivity is especially evident in the fact that, with few exceptions like the Brazilian paintings of Frans Post and Albert Eckhout, the great voyages of exploration, the distant places where the Dutch fought, traded, and settled, and the fabulous wealth that they brought to the Netherlands are for the most part represented only indirectly in Dutch painting.[21] What this indicates is that Dutch art, including seascape, itself contradicts its reputation as a document of the visible world as seventeenth-century Netherlanders experienced it, for it illustrates that world only in part. It is highly naturalistic and believable — and in many cases accurate as well as plausible — but also selective, conventionalized, and interpretive. Rather than seeing Dutch marine pictures as illustrations of the great adventure of Dutch seafaring, it is better to understand them as interpretations or as fictions that select, structure, and clarify certain aspects of that story.[22] The reasons for the selection are not always immediately apparent, but it is clear that what is chosen, however conventionalized the subject may be, gives visual form to shared values, outlooks, and beliefs.

Dutch seascapes fall into a fairly limited number of categories of function and subject. One of the most important comprises images made for public places. It is not often appreciated that a considerable number of Dutch seascapes were public monuments, commissioned by institutions like town councils, admiralty colleges, and harbor authorities and either hung in public places or presented as official gifts to foreign rulers or dignitaries or to distinguished individual citizens.[23] Such pictures are frequently of monumental scale, vastly larger than the paintings in the present exhibition, and comparable to history paintings in size and function. Battle scenes, ceremonial arrivals of dignitaries in Dutch harbors, and "portraits" of harbors filled with shipping typify the subject matter of these paintings, which are consequently laden with national and civic connotations. They memorialize the past, assert civic or national pride and identity, and serve as models for the present.

As I have discussed elsewhere, there is abundant evidence that such images gave shape to communal and personal pride in victory, prosperity, and civic greatness.[24] That they are marine paintings evinces the broader Dutch awareness of the role of seafaring in achieving abundance and security. The bold red, white, and blue flags so prominent in these paintings reinforce this identification of the nation with maritime enterprise of all kinds.[25] There are, however, numerous

images of battles and harbors that were not made for public places. While some were no doubt commissioned to commemorate the careers and successes of specific masters and captains, we lack provenances to establish this. Many more seascapes possess few features that allow a precise identification of a specific event or location. These pictures were surely made for display in private homes, something the scale of diminutive pictures like those by Jan van Goyen and van de Velde the Younger in this show also indicates.[26] Pictures like these are not literally documents or illustrations of Dutch seafaring or of life on Dutch inland waters in the sense of providing a comprehensive historical survey of events and life on the water. They do, however, allude to this widely shared experience, history, and culture, and the scenes they depict possess an emphatically Dutch identity. The tricolor flag is one way this identity is strikingly confirmed in all three pictures. Its presence on the careened vessel that van de Velde depicts is notable; and the flag on the small boat at the left in the van Goyen provides one of the few notes of local color in the muted palette of ochres, greys, and greens typical of the monochrome or tonal style.

This use of the flag is typical of Dutch marine painting in general, as are the recognizably Netherlandish vistas in all three pictures. Van Goyen's view of streams merging into a larger watercourse at the left, set in a low, boggy pastureland with farmhouses and different types of windmills and the spire of a village church on the horizon, is instantly identifiable as Dutch.[27] As is characteristic of the tonal style, the apparent modesty of the scene masks its subtle artistry.[28]

Jan van Goyen,
A River Landscape with
Fisherman Mooring a
Rowing Boat,
detail (cat. 7)

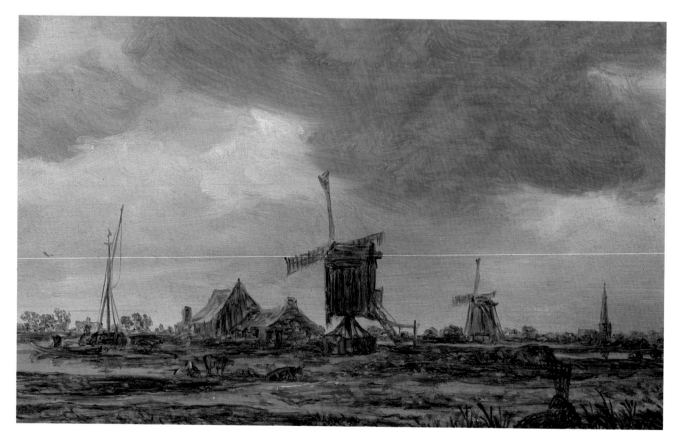

The reduced color and broad, fluid handling of the paint capture the windswept yet moisture-laden atmosphere and homely earthiness of this familiar landscape. The little van de Velde panels, too, evoke the waters of the Netherlands, but here the atmosphere of the coast on a bright day. The tall formats of the pair suggest the wonderful height of the clouds overhead as opposed to the evocation of the flat, broad landscapes of Holland and Zeeland in the van Goyen. Van de Velde depicts the equally characteristic shallow waters off the Dutch coast, filled with boats and ships, and in the picture with the careened *fluit* he includes the towers of a harbor town on the low horizon. Indeed, the familiarity of these scenes is such that their Dutch identity seems scarcely in need of mention, except that it is exactly this familiarity and identifiability that is significant.

The Dutch identity of these apparently modest pictures is one of a variety of motifs that links them to the great historical events and large-scale economic developments of the seventeenth-century Netherlands. The van Goyen, for example, recalls the importance of the extensive system of inland rivers, streams, and canals in the Dutch Republic, which allowed for the efficient and safe transport of goods and people through the entire country, including regular passenger barge *(trekschuit)* services linking the major cities.[29] Van de Velde's pictures likewise echo in small vaster social, economic, and historical developments. Both depict *fluitschepen*, the famous flutes already mentioned, with their bulging hulls and strikingly narrow poop decks. In one painting the vessel appears to be setting sail in a fresh breeze. In the other, the ship (not the same one since she lacks gun ports) is careened for caulking or other repairs to the hull, a standard part of shore life, and suggesting the extensive support network of trades required to keep the enormous Dutch fleet of merchant and naval vessels seaworthy. The warship at anchor in the middle distance of the same painting must have evoked at some level of awareness the recurrent need in the Golden Age for a formidable navy to protect Dutch commerce from a variety of foes. The enemy changed through the century, but their depredations on the relatively defenseless *fluiten* and other Dutch fishing and merchant vessels had to be resisted by an ever increasing expenditure on the war fleet. It is revealing that despite the existence of a large and expensive land army, it was the navy and its exploits that captured public attention and sympathy in the Republic. The tombs of naval heroes comprise the only extensive body of publicly commissioned sculpture in the Golden Age; and paintings of Dutch naval victories vastly outnumber the rare depictions of victories ashore.[30] Any number of literary sources demonstrate the tendency to identify the entire nation with the hardy sailors of the Netherlands.[31]

It is clear that Dutch marine pictures, like most Dutch realistic art, encouraged an identification between the viewer and the scenes depicted; but did this realistic art also have a symbolic level? Could van de Velde's little pictures, for instance, have been understood in the seventeenth century as allegories of the ship of state

or the ship of life or the ship of love or any of a dozen other nautical metaphors? These questions, as I have argued elsewhere, cannot be answered simply.[32] The tradition of nautical metaphors was extensive and ancient, widely familiar from scripture, proverbs, and the classics, so that it is difficult to decide which metaphor to use.[33] In addition, while many marine metaphors remain familiar to the present day, in a number of cases they have become obscure to us. A still more fundamental problem is that the pictures are not symbolic diagrams. They do not possess a structure of reinforcing symbolic details that would indicate which metaphor to choose — in other words, their realism, while selective, is yet too thoroughgoing and convincing to yield a single symbolic meaning. In general, I would argue that it is preferable to look at an entire image — what is happening in it, the location it depicts, the weather, and the expressive visual qualities of the picture — and interpret it in terms of the value system implicit in the image rather than by applying one symbolic meaning to the picture.[34]

In pictures like those painted by van Goyen and van de Velde, that value sys-

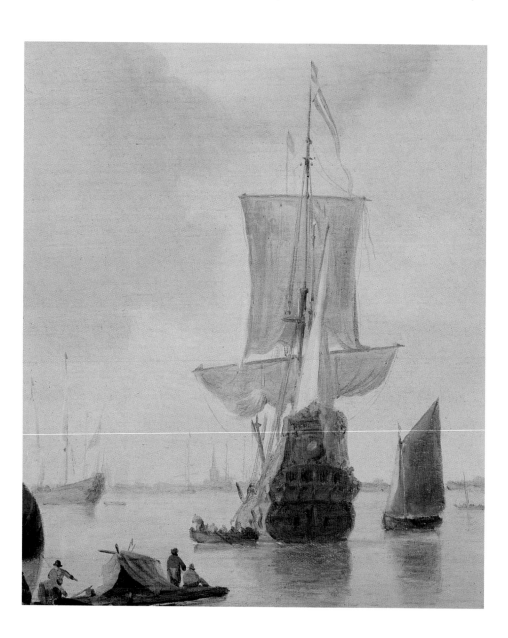

Willem van de Velde II,
Ships in a Harbor
(Marine Painting Pair),
detail (cat. 25)

24

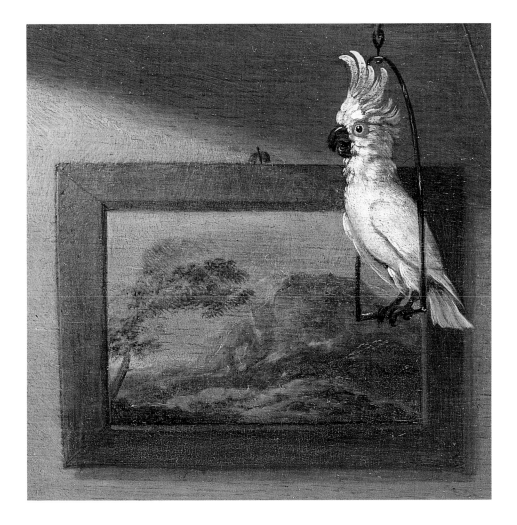

Jacob Duck,
Musical Ensemble
with Cockatoo,
detail (cat. 6)

tem seems to reside in large measure in their calm and order and in the peace
and abundance that is surely implicit in their depiction of the Dutch busy at
their workaday lives on the waters and shores of their homeland. In this regard
these pictures conform to one of the most widespread of Dutch pictorial con-
ventions in seascape and landscape, the choice of incidents and compositional
forms that emphasize the harmony of human labor and human ingenuity with
the movements of the natural world. This pictorial concord between human be-
ings, their vessels, and the larger order of nature is significant in that it expresses
human harmony with the fundamental cosmological forces that most seven-
teenth-century observers understood as the sources of weather, that is, the "love
and strife" of the four elements — earth, water, air, and fire — that constituted
the universe.[35] Meteorological phenomena were manifestations of elemental
conflict and harmony and thus signs of the larger structure and purposes of the
cosmos. This cosmos was divinely ordered, and its divine structure and pattern
could serve for human instruction in what was generally understood to be an-
other scripture, the Book of Nature, a divine revelation parallel to the Bible.[36]
The harmonious interaction of human beings and their vessels with nature, ex-
pressed in the compositional congruence of vessels with sea, clouds, and shore
and their simplicity and unassuming modesty, functions as a positive metaphor

of human accord with divine providence as well as a depiction of contemporary reality. That viewers were expected to gaze at and contemplate this order and harmony is implicit in the compositional coherence of the images, and it is made explicit in a few pictures that depict townsfolk standing on the dunes contemplating the quintessentially Dutch scene spread below them and us.[37]

This imagery of abundance, fullness, order, and coherence is not limited to seascape or to landscape but is characteristic of many Dutch pictures, including daily-life genre scenes and still lifes like those in this exhibition.[38] In these subjects, too, we find details and motifs that allude to the abundance and wealth brought to the Netherlands by the great enterprise of seafaring. The tulips in the flower piece by Jan Philips van Thielen, for example, now seem obviously Dutch and thoroughly domestic, but in the Golden Age they still retained strong connotations of foreign rarity. First brought from Turkey to Europe in the 1560s and to the Netherlands in the 1590s, tulips remained relatively exotic and expensive, quite apart from the *Tulpenwoede,* or tulipomania, which reached its apogee of speculative frenzy in 1637 when single tulip bulbs sold for hundreds and even thousands of guilders.[39] Despite its simplicity, van Thielen's flower still life resonates with the keen interest taken in flowers from distant places in the Dutch Republic. Another foreign luxury is evident in the *Musical Ensemble with Cockatoo* by Jacob Duck, which includes a cockatoo perched above the singers. This bird could have been brought only at great expense from the distant East Indies. Its presence here is an indication of indulgence in luxury, which the satin dress suggests as well, providing a foretaste of the much more

Jan Philips van Thielen,
Bouquet in a Glass Vase,
detail (cat. 23)

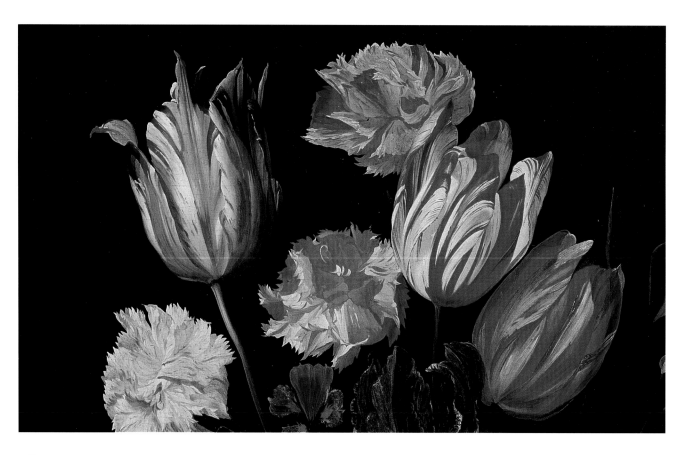

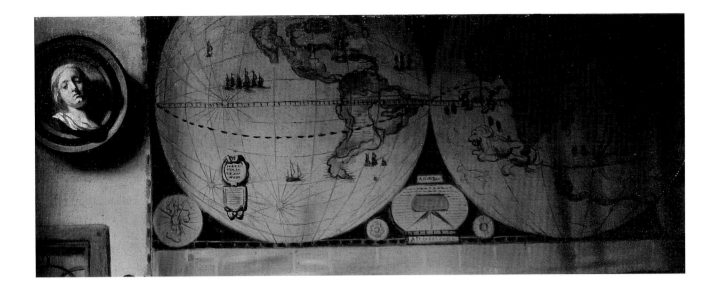

prodigal display of fine fabrics and luxurious fashions in genre pictures painted after 1650. In the paintings by Gerard ter Borch and Gabriel Metsu in this exhibition, the opulence of clothing and furnishings, including a Turkish carpet, bespeaks the wealth that had accumulated in the Republic by the second half of the seventeenth century, an affluence founded on Dutch seafaring. Even these scenes set in domestic interiors, pictures focused on behavior and fashion, possess resonant echoes of the vast world into which the Dutch had so boldly sailed. It is to that expansive world that the map behind the sleeping old lady in Nicolaes Maes's painting alludes and so brings into this cozy, private interior some sense of the enormously expanded horizons that the great adventure of seafaring brought to the Dutch of the Golden Age.

Nicolaes Maes,
The Account Keeper
(The Housekeeper),
detail (cat. 14)

NOTES

1. On the role of seafaring in Dutch history and culture, see Jonathan Israel, *The Dutch Republic: Its Rise, Greatness, and Fall 1477-1806* (Oxford, 1995), pp. 307-27, 713-22, 766-74, 812-13; Simon Schama, *The Embarrassment of Riches: An Interpretation of Dutch Culture in the Golden Age* (Berkeley, 1987), pp. 25-34, 220-57; C. R. Boxer, *The Dutch Seaborne Empire, 1600-1800* (New York, 1965), pp. 1-30; Charles K. Wilson, "A New Republic," in George S. Keyes, *Mirror of Empire: Dutch Marine Art of the Seventeenth Century* (exhib. cat., Minneapolis Institute of Arts, 1990), pp. 37-50; and Cynthia Lawrence, "Hendrick de Keyser's Heemskerk Monument: The Origins of the Cult and Iconography of Dutch Naval Heroes," *Simiolus* 21 (1992): 265-95. See also the texts cited in Lawrence O. Goedde, *Tempest and Shipwreck in Dutch and Flemish Art: Convention, Rhetoric, and Interpretation* (University Park, PA, and London, 1989), p. 211, n. 57.

2. For surveys of Dutch marine art, see, among others, Laurens J. Bol, *Die holländische Marinemalerei des 17. Jahrhunderts* (Braunschweig, 1973); Keyes, *Mirror of Empire;* Jeroen Giltaij and Jan Kelch, *Praise of Ships and the Sea: The Dutch Marine Painters of the 17th Century* (exhib. cat., Rotterdam: Museum Boijmans van Beuningen, 1996); Margarita Russell, *Visions of the Sea: Hendrick C. Vroom and the Origins of Dutch Marine Painting* (Leiden, 1983); and Goedde, *Tempest and Shipwreck*.

3. For the Dutch navy, see the literature cited in n. 1 above, and S. W. P. C. Braunius, "Oorlogsvaart," in G. Asaert et al., eds., *Maritieme geschiedenis der Nederlanden*, II, *Zeventiende eeuw, van 1585 tot ca. 1680* (Bussum, 1977), pp. 316-54; and F. L. Diekerhoff, *De oorlogsvloot in de zeventiende eeuw* (Bussum, 1967).

4. *The Diary of Samuel Pepys,* ed. Robert Latham and William Matthews (Berkeley and Los Angeles, 1974, entry for 19 July 1667), vol. 8, pp. 344-45.

5. Israel, *Dutch Republic,* pp. 812-13.

6. For Dutch trade, shipping, and overseas expansion, see Violet Barbour, "Dutch Merchant Shipping in the Seventeenth Century," *Economic History Review* 2 (1930): 261-90; Boxer, *The Dutch Seaborne Empire;* Asaert, *Maritieme geschiedenis,* vol. 2, esp. pp. 200-288; D. W. Davies, *A Primer of Dutch Seventeenth-Century Overseas Trade* (The Hague, 1962); Jonathan Israel, *Dutch Primacy in World Trade, 1585-1740* (Oxford, 1989).

7. Israel, *Dutch Primacy,* esp. pp. 1-79.

8. Nicolaes Witsen, *Aeloude en hedendaegsche scheeps-bouw en bestier* (Amsterdam, 1671).

9. On the economics and organization of Dutch shipbuilding, see Barbour, "Dutch Merchant Shipping," pp. 261-90; and S. Hart, "Scheepsbouw," in Asaert, *Maritieme geschiedenis,* vol. 2, pp. 72-77, 359-60.

10. Boxer, *Dutch Seaborne Empire,* p. 20; J. van Beylen, "Scheepstypen," in Asaert, *Maritieme geschiedenis,* vol. 2, pp. 28-32; Barbour, "Dutch Merchant Shipping," pp. 279-82.

11. G. Schilder and W. F. J. Mörzer Bruyns, "Navigatie," in Asaert, *Maritieme geschiedenis,* vol. 2, pp. 159-99; Dirk de Vries, "'Chartmaking Is the Power and Glory of the Country': Dutch Marine Cartography in the Seventeenth Century," in Keyes, *Mirror of Empire,* pp. 60-76.

12. On the admiralty colleges, see Israel, *Dutch Republic,* pp. 295-97; and Braunius, "Oorlogs-vaart," in Asaert, *Maritieme geschiedenis,* vol. 2, pp. 316-21.

13. On the *rederij,* see S. Hart, "Rederij," in Asaert, *Maritieme geschiedenis,* vol. 2, pp. 106-11; Israel, *Dutch Primacy,* pp. 21-22; Boxer, *Dutch Seaborne Empire,* pp. 6-7.

14. Jan Huygen van Linschoten, *Itinerario* (Amsterdam, 1596); ed. H. Kern and H. Terpstra (The Hague, 1957) (De Linschoten Vereeniging, no. 60). On the accounts of the Dutch voyagers, see G. A. van Es, "Reisverhalen," in F. Baur, ed., *Geschiedenis van de letterkunde der Nederlanden* ('s-Hertogenbosch and Antwerp, 1948), vol. 4, pp. 220-41; and the discussion of the voyagers within a broadly ambitious interpretation of Dutch culture in Schama, *Embarrassment of Riches,* pp. 28-34. Many of the voyagers' journals have been reprinted in modern editions by the Linschoten Vereeniging.

15. Willem Ijsbrantsz. Bontekoe, *Journael often gedenckwaerdige beschrijvinghe van de oost-indische reyse . . .* (Hoorn, 1646); ed. G. J. Hoogewerff (The Hague, 1952) (De Linschoten Vereeniging, no. 54).

16. Audrey M. Lambert, *The Making of the Dutch Landscape: A Historical Geography of the Netherlands* (2d ed., London, 1985), chap. 7; Jan de Vries, "The Dutch Rural Economy and the Landscape: 1590-1650," in Christopher Brown, *Dutch Landscape, the Early Years: Haarlem and Amsterdam 1590-1650* (exhib. cat., London: National Gallery, 1986), pp. 79-86.

17. For Dutch land reclamation, see Schama, *Embarrassment of Riches,* pp. 34-50, and the literature cited there.

18. Israel, *Dutch Republic,* 17-19, 117-19.

19. These factors include not only a distinctive Netherlandish tradition of depicting the sea but also a number of specific circumstances in Dutch society and culture in the decades around 1600 that favored a remarkable openness to artistic innovations like seascape images. See Goedde, *Tempest and Shipwreck,* pp. 21-23, 109-111.

20. On the selective nature of the Dutch seascape, see Goedde, *Tempest and Shipwreck,* pp. 1-21, 101-8, 163-206; and Goedde, "Convention, Realism, and the Interpretation of Dutch and Flemish Tempest Painting," *Simiolus* 16 (1986): 139-49. On the selective nature of Dutch painting in general, see, among others, Eric J. Sluijter, "Hoe realistisch is de Noordnederlandse schilderkunst van de zeventiende eeuw? De problemen van een vraagstelling," *Leidschrift: Historisch tijdschrift* 6.3 (1990): 5-39; Sluijter, "Schilders van 'cleyne, subtile ende curieuse dingen': Leidse 'fijnschilders' in contemporaine bronnen," in *Leidse fijnschilders: van Gerrit Dou tot Frans van Mieris de Jonge 1630-1760* (Leiden: de Lakenhal, 1988), pp. 19-23; David Freedberg, *Dutch Landscape Prints of the Seventeenth Century* (London, 1980), pp. 9-18; and Ann Jensen Adams, "Competing Communities in the 'Great Bog of Europe': Identity and Seventeenth-Century Dutch Landscape Painting," in W. J. T. Mitchell, ed., *Landscape and Power* (Chicago, 1994), pp. 35-40.

21. On the identification of foreign settings in Dutch storm paintings, see Goedde, *Tempest and Shipwreck,* pp. 102-8. For Frans Post, see Frits J. Duparc, "Frans Post and Brazil," *Burlington Magazine*

124 (1982): 761-72; and Erik Larsen, *Frans Post, interprète du Brésil* (Amsterdam, 1962). For Albert Eckhout, see T. Thomsen, *Albert Eckhout: Ein niederländischer Maler* (Copenhagen, 1938); and Hugh Honour, *The New Golden Land: European Images of America from the Discoveries to the Present Time* (New York, 1975), pp. 48-51, 78-83.

22. Lawrence O. Goedde, "Seascape as History and Metaphor," in Giltaij and Kelch, *Praise of Ships and the Sea,* pp. 59-73.

23. Goedde, "Seascape as History," pp. 64-66.

24. Ibid., pp. 67-69.

25. On flags in Dutch marine painting, see J. van Beylen, in Asaert, *Maritieme geschiedenis,* vol. 2, pp. 69-71, 358 (with further bibliography); M. S. Robinson, *Van de Velde Drawings: A Catalogue of Drawings in the National Maritime Museum* (Cambridge, 1958), vol. 1, pp. 28-29, 227-31; and Rupert Preston, *The Seventeenth-Century Marine Painters of the Netherlands* (Leigh-on-Sea, 1974), pp. 88-93.

26. The picture by van Goyen is not a seascape, but because it depicts a typical inland waterway with characteristic vessels, it is closely related to more explicitly maritime scenes, which often include identical boats.

27. Simon Schama emphasizes this identifiability as one of the key innovations of the tonal landscape. See "Dutch Landscapes: Culture as Foreground," in Peter C. Sutton, *Masters of 17th-Century Dutch Landscape Painting* (exhib. cat., Amsterdam, 1987), pp. 64-83, esp. pp. 72-73.

28. For the artistry of the tonal style, see Lawrence O. Goedde, "Naturalism as Convention: Subject, Style, and Artistic Self-Consciousness in Dutch Landscape," in Wayne Franits, ed., *Looking at Seventeenth-Century Dutch Art: Realism Reconsidered* (Cambridge, 1997), pp. 142-43, and the literature cited there, esp. the work of Melanie Gifford cited in n. 80.

29. Jan de Vries, *Barges and Capitalism: Passenger Transportation in the Dutch Economy, 1632-1839* (Utrecht, 1981).

30. Lawrence, "De Keyser's Heemskerk Monument," pp. 265-95; Schama, *Embarrassment of Riches,* pp. 246-50.

31. Goedde, "Seascape as History," p. 68.

32. Goedde, *Tempest and Shipwreck,* pp. 5-21, 130-47. See as well the critique of the iconographic method in Wayne Franits, "Between Positivism and Nihilism: Some Thoughts on the Interpretation of Seventeenth-Century Dutch Paintings," *Theoretische geschiedenis* 21 (1994): 129-34; Peter C. Sutton, *Masters of 17th-Century Dutch Landscape Painting* (Amsterdam: Rijksmuseum, 1987), pp. 12-13; and Eric J. Sluijter, "Didactic and Disguised Meanings? Several Seventeenth-Century Texts on Painting and the Iconological Approach to Northern Dutch Paintings of This Period," in Franits, *Looking at Seventeenth-Century Dutch Art,* pp. 78-87.

33. Concerning marine metaphors, see Goedde, *Tempest and Shipwreck,* esp. pp. 25-45, 130-94, and the literature cited there.

34. For a fuller discussion of this approach to interpretation, see Goedde, *Tempest and Shipwreck,* pp. 15-21, 116-56.

35. For cosmology, meteorology, and the elements, see S. K. Heninger, *The Cosmographical Glass: Renaissance Drawings of the Universe* (San Marino, CA, 1977), esp. pp. 106-15; S. K. Heninger, *A Handbook of Renaissance Meteorology* (Durham, NC, 1960); Gerhard Frey, "Elemente," in *Reallexikon zur deutschen Kunstgeschichte,* vol. 4, pp. 1256-61; and Marjorie Hope Nicolson, *The Breaking of the Circle* (rev. ed., New York and London, 1962). For the relation of these concepts to landscape and seascape, see Lisa Vergara, *Rubens and the Poetics of Landscape* (New Haven and London, 1982), pp. 48-55; and Goedde, *Tempest and Shipwreck,* pp. 31-35, 193-96.

36. For the Book of Nature, see Hans Blumenberg, *Die Lesbarkeit der Welt* (Frankfurt am Main, 1981); the materials collected in Erich Rothacker, *Das "Buch der Natur": Materialien und Grundsätzliches zur Metapherngeschichte,* ed. Wilhelm Perpeet (Bonn, 1979); and Ernst Robert Curtius, *European Literature and the Latin Middle Ages,* trans. Willard R. Trask (New York and Evanston, 1963), pp. 319-26.

37. For this type of beach scene, see Goedde, "Seascape as History," p. 71; for the painting in the Mauritshuis by de Vlieger, see Bol, *Die holländische Marinemalerei,* p. 183.

38. I owe this idea to Arthur Wheelock.

39. On the tulipomania, see Schama, *Embarrassment of Riches,* pp. 350-65.

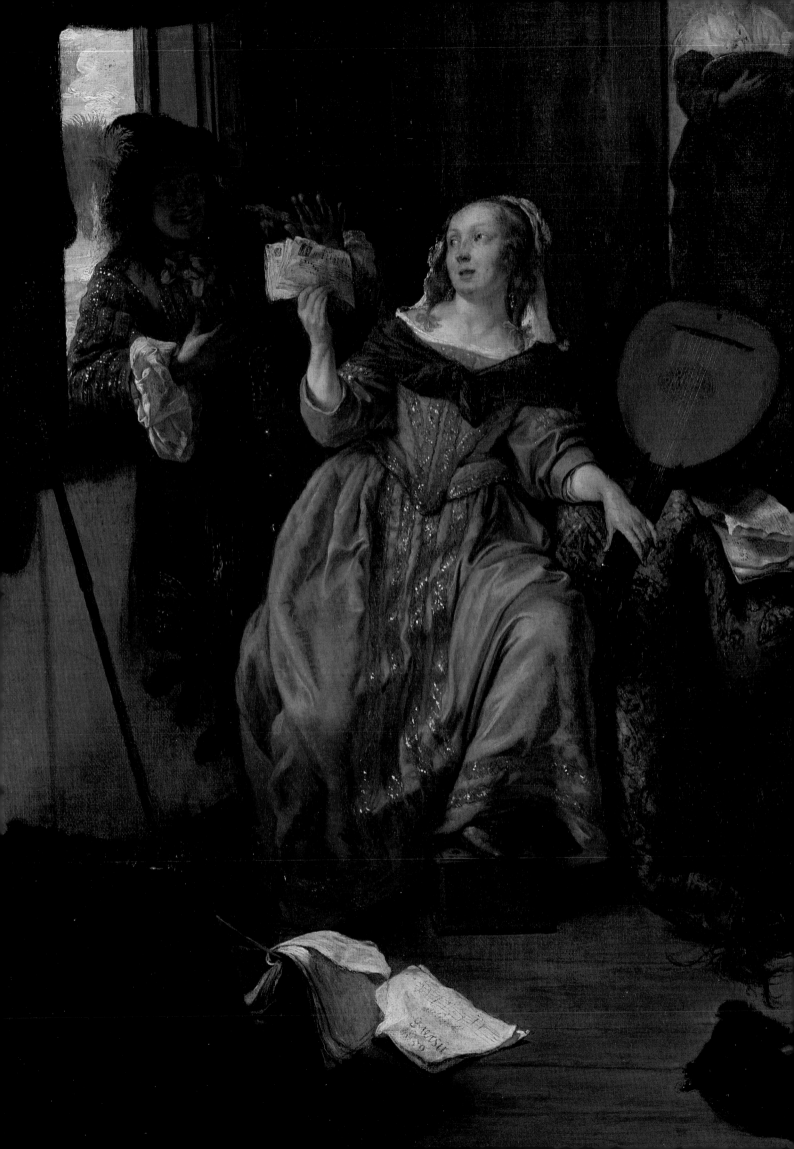

Subject and Value in Seventeenth-Century Dutch Painting

MARIËT WESTERMANN

"ONE THING strikes you when you study the moral basis of Dutch art — the total absence of what we call today a *subject*."[1] This famous nineteenth-century description of Dutch seventeenth-century painting, written by the French painter and art critic Eugène Fromentin (1820-76), is baffling today. People making music, a young woman at her toilet, cows and their keepers, a pristine church interior, a carefully selected bouquet, men mooring a dinghy: Dutch painting appears rife with subject, if a subject is defined as something that can be named. What did Fromentin mean?

Like his contemporaries, Fromentin identified a subject as a narrative from "history, mythology, the Christian legends." Reared on the new Realist painting of the mid-nineteenth century, Fromentin saw Dutch painting as protomodern in its concern for the local landscape, the everyday home, the average person. For almost a century, he claimed, "the great Dutch school seemed to think of nothing but of painting well." Notwithstanding the perspicacity of his vision, Fromentin's celebration of the exclusively artistic interests of the Dutch "masters of old time," as he called them, is closer to his own preoccupations than to the complex content of their art. Most obviously Rembrandt (1606-69), the finest seventeenth-century Dutch artist, was an extremely innovative and effective painter of religious and mythological narratives. Although he was one of many Dutch painters who specialized in such classic "subjects," Fromentin was compelled to consider him "the least Dutch of the Dutch painters, ... not altogether

of his time." In his view, the true Dutch artists, a Metsu, a ter Borch, a van Goyen, ask the viewer only to relish their miraculous skill in crafting the look of satin, metal, clouds, light itself. But even the paintings Fromentin found quintessentially Dutch — the portraits of Hals and the interiors of de Hooch, the landscapes of van Ruisdael and the cows of Cuyp — offer the viewer other pleasures and challenges. They sketch characters and tell stories, invite contemplation and propose what we might call values. To gain some understanding of how these pictures do so, we must consider the economic and religious climate that shaped them.

Fromentin's championing of the subjectless nature of Dutch seventeenth-century painting can yet be understood when we compare the totality of this art against that produced in Catholic areas of Europe, including the Northern Netherlands itself before the Reformation took hold in the course of the sixteenth century. In Italy, France, and the Southern Netherlands, the Catholic Church remained one of the most stimulating patrons, providing commissions for huge altarpieces and cycles of religious painting to artists such as Peter Paul Rubens (1577-1640). Since the Reformed Church strictly opposed the use of paintings in religious worship, such patronage was virtually unavailable in the overwhelmingly Calvinist climate of the Dutch Republic. Jean Calvin had not proscribed all artistic production, however. He specifically sanctioned images for decoration, commemoration, and teaching, as long as they were kept out of the church.

The decline of religious patronage was an important factor stimulating the development of new types of painting during the sixteenth century, intended primarily for display at home. Painters began to specialize in biblical scenes with a strong moral message, landscape paintings, portraits, social scenes of peasants and burghers, and still life. As the Republic enjoyed spectacular economic growth between 1585 and 1620 and a broad middle class could afford to spend income on art, this process of artistic specialization gained momentum. Thus many of the painters represented in the exhibition concentrated almost all their efforts on one genre: Frans Hals on portraiture, Jacob Duck, Dirck Hals, Pieter de Hooch, and Gerard ter Borch on scenes of social life, and Jan Davidsz. de Heem on still life. Landscape painting, one of the most popular genres, was divided further into subspecialties. While Jan van Goyen opted mostly for atmospheric renderings of the local lowlands, Jacob van Ruisdael dramatized the same scenery with towering clouds, rock formations, waterfalls, or broken trees. Albert Cuyp's landscapes are dotted with cows; Hendrick Averkamp's are almost invariably frozen. Gerrit Berckheyde took the expanding Dutch cities for his theme, celebrating landmarks of Dutch economic success such as the impressive new Town Hall of Amsterdam. Late in the century, Willem van de Velde the Younger became the foremost European painter of marines.

The Calvinist stance on images even occasioned a novel specialty of Dutch Reformed church interiors, perfected by Pieter Saenredam and Emanuel de

Witte. Most of the churches they represented are whitewashed and virtually devoid of decoration. Both painters relished the light streaming into these churches through unstained windows, and at their expert hands it appears a metaphor for religious purity. Saenredam's rare church interiors with altarpieces were most likely made for Catholic collectors. The striking emptiness of his *View from the Aisle of the Sint Laurenskerk, Alkmaar* (cat. 21) is offset by a finely carved and painted sixteenth-century organ case and a gilded instrument of two pipes that would yield a sonorous roll.[2] The console below it is decorated with a startlingly lifelike bearded head. Although such a head stands in the medieval and Renaissance tradition of ornamenting church furnishings with whimsical grotesques, to a seventeenth-century viewer it could also evoke the head of the giant Goliath, who fell at David's hand. King David was the author of the Psalms, which constituted the preeminent source for Reformed church music. As the use of the organ in Calvinist services was a bone of contention, Saenredam's prominent representation of the wind instruments suggests that he made it at the behest of a proponent of organ music. Saenredam's seemingly accidental view in the Church of Sint Laurens is carefully structured in another way. The mellow color scheme of creamy white, grey, and pinkish brown and the two sets of opened doors invite contemplation of the churchyard behind, where the cemetery was located.

Paintings of church interiors frequently offer less subtle hints of life after

Pieter Jansz. Saenredam, *View from the Aisle of Sint Laurenskerk, Alkmaar,* detail (cat. 21)

death. De Witte favored the motif of the freshly dug grave and digging tools, placed in the foreground of his *Interior of the Oude Kerk, Amsterdam* (cat. 26). The grave digger has interrupted his task to speak with a well-dressed gentleman, whose earnest gesture indicates the gravity of the otherworldly matter they are discussing.[3] Yet by including other figures going about their business off to the side, both Saenredam and de Witte suggested that individual human death is but a part of life, insignificant in the grand divine scheme.

Calvinist doctrine did not prescribe the quiet contemplation stimulated by paintings of church interiors — indeed, it said very little about positive uses of pictures — but it did encourage analogous practices, such as private Bible study and direct prayer to God. Such religious exercises should not be mediated by priests or saints, as they had been in the Catholic tradition. Gerard Dou's painting of an unidentified hermit in fervent prayer (cat. 5) may offer a model of such a personal relationship between the worshiper and God. Dou had been Rembrandt's first pupil from 1628 to 1631, when his master was developing the theme of hermit saints as well as the precise manner of painting here perfected by Dou. An etching by Rembrandt of *St. Jerome in Prayer* may have stimulated Dou's career-long interest in the subject.[4] Although the hermit's monastic habit and intense gaze at a crucifix seem unexpectedly Catholic in tone, Dou's emphasis on

Gerard Dou,
The Hermit,
detail (cat. 5)

the brightly illuminated Bible in the center of the composition recalls the Protestant requirement that all Christians study the Word of God.[5] It also makes the hermit resemble St. Jerome (340?-420), the scholarly hermit saint responsible for the authoritative Latin Bible known as the Vulgate. Paradoxically, Dou's miraculous mimicry of different material textures — from wrinkled skin to thinning hair, from gnarled bark to crumpled cloth — asks the viewer to savor not just the religious message but also the painter's worldly skill.

The most tantalizing Netherlandish still-life paintings, produced both in the Republic and in Flanders, share in this irony. Heaps of seafood and ripe fruit, fertile bouquets of exotic flowers, elegant if improbable arrangements of the latest porcelain, pewter, and glassware, all of it painted to capture the sheen and sparkle of stuff: seventeenth-century still life tempts us to lose ourselves in material abundance. But still life never merely encourages the viewer to celebrate its seductive offerings. Jan Philips van Thielen's *Bouquet in a Glass Vase* (cat. 23), made in the Southern Netherlands, gathers a miniature collection of specimens, all turned and twisted to give the beholder an opportunity to identify each species: roses, carnations, peonies, lilies of the valley, irises, and several different tulips. These striped varietals were cultivated to perfection in the Republic and had been the object of frantic, even disastrous financial speculation in the 1630s. Van Thielen's painting observes powerful seventeenth-century conventions of floral still life: the unobtrusively symmetrical arrangement is centered against a dark background. Most of its flowers are at their peak, but some have begun to wilt, and few of them would in real life be blooming in the same weeks. Butterflies heighten the coloristic splendor; a few other insects have alighted on petals and on the ledge below. All of these pictorial elements helped floral still life perform its functions. Most obviously, the painted bouquet could be a substitute for the enjoyment of actual flowers during the cold months.[6] Collectors of botanical specimens and more ordinary garden lovers would relish the near-scientific display of different species. The stark, centralized isolation of the bouquet and the exhilarating variety of the flowers and insects also encouraged more profound contemplation of each individual stem and each tiny creature as the special creation of God, the divine artist. The different states of the flowers would inevitably signal the short-lived nature of earthly life, and perhaps prompt further thoughts of the wondrous way in which the artist was able to freeze it in his paintings. That the idea of art outlasting life was never far from the still-life painter's mind is suggested by the evident display of artistic skill in so many of these works. Van Thielen re-created silken petals, gossamer wings, and stems distorted by glass; some of his insects throw translucent shadows onto the flowers of their choice.

While paintings of church interiors, hermits, and nature's bounty make fairly obvious statements of moral and social value, it would seem more difficult to claim such significance for portraits, which are meant to be accurate like-

nesses of individual human beings. By careful selection of poses, costumes, and attributes, however, portrait painters managed to convey specific information about the sitter and his or her familial, professional, and moral identity. Portraits were produced in great quantity and variety, for people of vastly different means. Their purposes, although never stated explicitly, can be gleaned from poetry and occasional comments about portraits. People expected portraits to offer a likeness that would almost substitute for the sitter in his or her absence, before and after death. They wished portraits to give an indication not only of the outer but also of the inner person, and it was understood that these two aspects of personal identity should chime with each other. Many portraits include motifs that clarify the sitter's name, age, and position in life. Frans Hals inscribed his lively portraits of Hendrik Swalmius and his wife (cats. 9, 10) with their ages of 60 and 57 (something we would be loath to do today!) and with the current year, 1639.[7] Each member of the couple holds a small book, which must be a Bible in acknowledgment of Swalmius's career as a preacher in Haarlem. Swalmius and his wife wear respectable but conservative costumes: by 1639 the "millstone" ruff had largely lost favor to looser, more elegant collars draped over the shoulders. Her bonnet covers the head more fully than current at this time. The old-fashioned aspects of their dress may be explained by their considerable age, but it equally suggests their desire to avoid undue ostentation, in keeping with the precepts of Calvinism. The couple's poses are calibrated to convey their proper relationship and his professional role. In an effective pictorial statement of their union, they are turned toward each other in approximate mirror images, but in keeping with seventeenth-century portrait conventions they look at the viewer. Swalmius addresses us as a preacher might, with sparkling eyes, lips parted slightly in speech, and his right hand on his chest in a gesture of profession. His wife's countenance is more placid, and she keeps her hands folded within the outline of her body. Although it is perfectly possible that Swalmius was indeed a more dynamic person than his wife, Hals's portraits also confirm Reformed ideals of matrimony, according to which the husband should be the more active and responsible force in a companionable partnership. Even Hals's brush stroke appears to honor this convention, for it is dashing and spirited for Swalmius, restrained and tighter for her.

It is difficult to imagine a sharper contrast to the portraits of Mr. and Mrs. Swalmius than Willem van Mieris's meticulously painted likeness of a young gentleman whose concerns appear entirely secular (cat. 16). The vast difference between the impressions conveyed by Swalmius and this man can only partly be attributed to the century that separates their portraits. While the sitter's vaguely classical costume and gaze away from the viewer and the picture's lighter tonality are characteristic of much eighteenth-century portraiture, the theme of the collector in his study, surrounded by drawings and sculptures of classical subjects, had been well established since the Italian Renaissance. This gentleman is

displaying the marks of his connoisseurship. The sculpture he touches is a copy of the Belvedere Torso, a famous Hellenistic statue that was endlessly copied by artists for its heroic physique. The drawings and the white and black chalk on the table suggest that the sitter may be an amateur draftsman at the very least — an increasingly familiar phenomenon in the eighteenth century — and possibly a professional artist. Almost a quarter of the picture is given to a spectacular stone relief sculpture of the drunken Bacchus, Greek god of wine, who is barely held up by a satyr, the mythic figure of lust. It is surely appropriate that the connoisseur has turned his head away from this scene that celebrates vices condemned in the seventeenth and eighteenth century alike. But whereas the preacher Swalmius would have objected to inebriation and sexual indulgence on moral grounds, as counter to God's decrees, an eighteenth-century gentleman might also have rejected them for their subversion of reason. He might well have feared the power of the senses to wreak havoc with the rational thinking that contemporary philosophers saw as the finest achievement of the classical world. Van Mieris's persuasive rendering of the sculptures is characteristic of a tradition of extremely fine painting that had been inaugurated by Dou, who taught van Mieris's father. For centuries, oil painters had argued that their ability to capture the look of any material placed their art above that of the sculptor; van Mieris's conspicuous skill at imitating sculpture itself is a familiar reference to this position.

If the portrait by van Mieris suggests more of a narrative than most portraits do, it may be because he was primarily a painter of scenes of social life, the type of picture usually referred to as genre painting. The designation "genre" was invented in the eighteenth century by French art critics who wished to categorize a wide range of paintings of anonymous peasants and burghers engaged in domestic and public endeavors. Seventeenth-century artists and collectors referred much more specifically to such paintings, depending on the types of people and activities represented. Dirck Hals's painting of dashing young men served by two women (cat. 8) might be called a "Merry Company." Jacob Duck's and Gabriel Metsu's more elegantly painted yet rambunctious versions of the same theme (cats. 6, 15) could be referred to as "A Music-Making," to indicate the prominent role of musical entertainment as social lubricant. However lifelike these types of paintings may look (as they did to Fromentin), none of them would have been seen as straightforward records of social interaction. More likely, the upstanding and rather wealthy citizens who could afford such works would have been amused by the self-importance of the men and the easy availability of the young women. Viewers did not hang such paintings on their walls to teach them not to indulge in gambling and drink, frivolous banter and illicit amorous play — they already knew the limits of polite conviviality, and these well-painted pictures confirmed this knowledge in a most pleasurable and decorative manner. But just in case one might miss the point, Duck inserted two delightful dogs who mimic

the human game of playful tease. Seated above them, a decorously attired woman addresses us with a knowing smile, raising one finger to call us to attention and pointing another at a timepiece, a classic reminder of the ephemeral character of earthly pleasure.

Gerard ter Borch's *Lady at Her Toilet* (cat. 3) suggests a more ambiguous story. The young woman's satin skirt, bodice, and shawl were worn by the fashionable ladies of ter Borch's time. Ter Borch traveled in the highest circles of Deventer, his hometown, and would certainly have encountered such dress. Although the servant's beribboned costume appears uncommonly fanciful, a version of it may well have come to the painter's attention in the entourage of the noblemen he portrayed, not least on the occasion of the Peace of Münster in 1648. The refined mantle, canopied bed, ornate mirror frame, silver candlesticks, and Anatolian carpet were coveted furnishings of the grandest Dutch residences. It has been suggested that seventeenth-century viewers would have seen such ladies as paragons of vanity, but ter Borch's customers more likely would have admired this woman's beauty and the painter's ability to capture the scintillating light on her skirt. Ladies might have seen her as a picture of elegance, and men and women alike would have relished speculating about the story. While the page offers the young woman water or perfume and a servant fixes her dress, she touches her ring and gazes away. Her profile in the mirror does not clarify the content of her thought, nor does the lap-

dog. Dogs could lend erotic charge to a scene (as they do in Duck's *Musical Ensemble* [cat. 6]), but small spaniels were also cherished for their fidelity and elegance. Ter Borch's most riveting paintings do not spell out a story, and are memorable for their rarefied ideal of elegance.[8]

The sophistication of ter Borch's toilet ritual, painted about 1660, stands in striking, quite possibly deliberate contrast to the simplicity of the chores that had just then become the specialty of Pieter de Hooch, Johannes Vermeer's colleague in Delft. De Hooch's *Courtyard, Delft* (cat. 12) from ca. 1657 is one of his earliest paintings of such a theme. Against the backdrop of the Oude Kerk of Delft, one servant woman draws water while another agitates the laundry in a tub. A broom and other implements hint at housework ahead. The washerwoman addresses a young girl, presumably a daughter of the homeowners, who appears fascinated by the task. The two women not only fulfill their duty of keeping the house spotless, but they also serve as models for the young girl, who

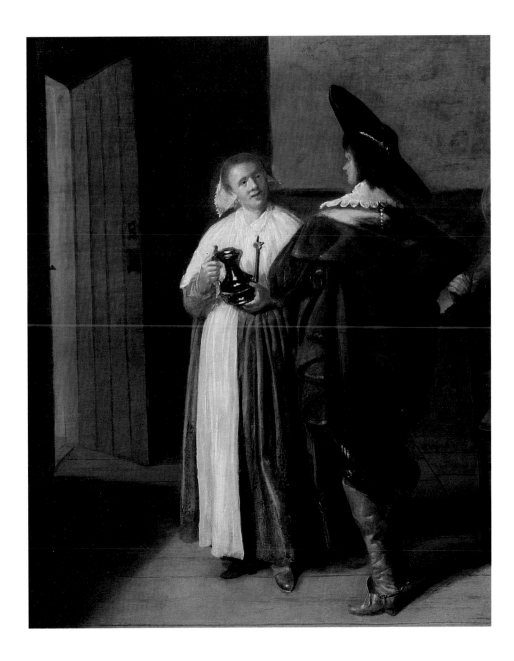

Dirck Hals,
*Cavaliers Playing
Tric-Trac in a Tavern,*
detail (cat. 8)

needs to learn the practice and value of the daily cleaning routine. Dutch writers forever emphasized the metaphoric relationship between bodily and spiritual purity, and de Hooch turned this commonplace into novel pictures.[9]

Such dedication to one's earthly tasks is the very virtue ignored by Nicolaes Maes's *Account Keeper* (cat. 14). Seated in a modestly appointed office, this woman has dozed off over the ledgers she should be keeping, thus leaving coins and keys unattended. A humorous detail specifies her transgression: a bust of Juno, the classical goddess of commerce, gazes down in displeasure. Although the neglect of financial duties might seem a worldly problem of little concern to the church, Calvinist theologians considered cautious financial management as important a human task as proper child rearing or household cleaning. The church severely censured the vices of unpaid debt and bankruptcy, and its stance was eminently suited to a society built on the twin pillars of commerce and Reformed morality.[10]

Maes's *Account Keeper* appears so thoroughly grounded in Dutch seventeenth-century circumstance that it could not have been painted anywhere else. Fromentin saw all the kinds of painting in the exhibition as uniquely Dutch and fundamentally distinct from the contemporary art of the Southern Netherlands, which he equated with the international vigor of Rubens and the grace of Van Dyck. Yet many of the genres in which Dutch painters specialized, including landscape, social scenes, architectural painting, and still life, had been developed

Nicolaes Maes,
The Account Keeper
(The Housekeeper),
detail (cat. 14)

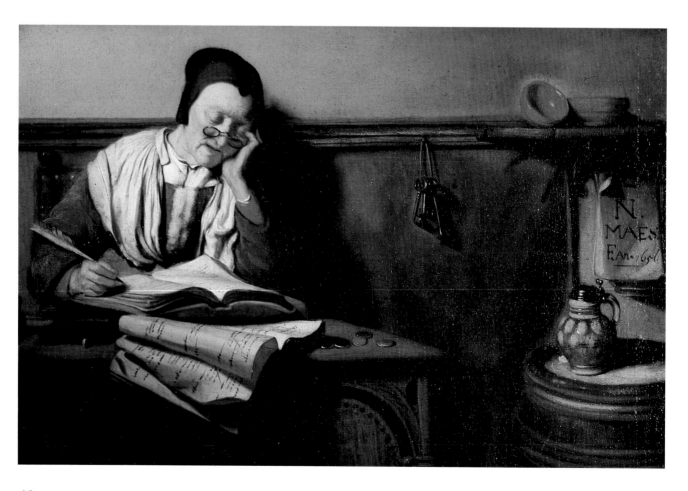

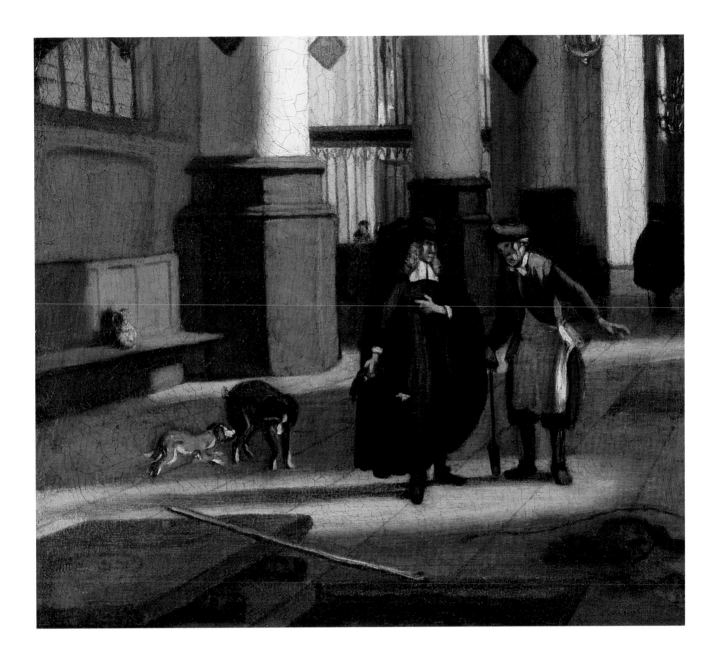

in Antwerp by 1600, if not in the variety later produced in the Republic. Several paintings in the exhibition call into question any clear-cut divide between southern and northern Netherlandish painting. The *Study of Butterflies and Insects* (cat. 13) by Jan van Kessel I, a painter of Antwerp, rivals the Dutch flower-and-insect still life in its meticulous observation of nature's artifice. Jan Davidsz. de Heem's *Still Life with a Glass and Oysters* (cat. 11) is a masterpiece of Flemish Baroque exuberance, but de Heem started his career in the Dutch city of Leyden. His still lifes were bought eagerly by Dutch collectors and provided a model of elegance for Dutch painters. For all the trade, travel, and patronage that preserved artistic ties between North and South, however, most Dutch art of the seventeenth century testifies to the novelty of the unique religious and economic climate in which it flourished.

Emanuel de Witte,
*Interior of the Oude
Kerk, Amsterdam,*
detail (cat. 26)

NOTES

1. Eugène Fromentin, *The Masters of Past Time: Dutch and Flemish Painting from Van Eyck to Rembrandt*, ed. H. Gerson (Oxford, 1948), p. 108. All quotations from Fromentin in this essay have been taken from this translation.

2. For this painting, see Gary Schwartz and Marten Jan Bok, *Pieter Saenredam: De schilder in zijn tijd* (The Hague, 1989), p. 236, cat. no. 6, and Jeroen Giltaij et al., *Perspectiven: Saenredam en de architectuurschilders van de 17e eeuw* (exhib. cat., Rotterdam: Museum Boijmans van Beuningen, 1991), no. 27.

3. On the symbolic charge of the grave digger in paintings of church interiors, see E. de Jongh et al., *Die Sprache der Bilder: Realität und Bedeutung in der niederländischen Malerei des 17. Jahrhunderts* (exhib. cat., Braunschweig: Herzog Anton Ulrich-Museum, 1978), no. 40, and B. Heisner, "Mortality and Faith: The Figural Motifs within Emanuel de Witte's Dutch Church Interiors," *Studies in Iconography* 6 (1980): 107-21.

4. Christopher White and Karel G. Boon, *Rembrandt's Etchings: An Illustrated Catalogue* (Amsterdam, 1969), no. B101, dated 1632.

5. For further analysis of Dou's special efforts to emphasize the Bible, see the discussion of X-ray photographs of the painting by Arthur K. Wheelock Jr., *Dutch Paintings of the Seventeenth Century: The Collections of the National Gallery of Art Systematic Catalogue* (Washington, 1995), p. 58.

6. On the varied seventeenth-century responses to still-life painting, see Lawrence O. Goedde, "A Little World Made Cunningly: Dutch Still Life and *Ekphrasis*," in Arthur K. Wheelock Jr. et al., *Still Lifes of the Golden Age: Northern European Paintings from the Heinz Family Collection* (exhib. cat., Washington: National Gallery of Art, 1989), pp. 35-44.

7. For these paintings, which are in different collections but have been convincingly argued to be pendents, see Seymour Slive, *Frans Hals* (3 vols., London, 1970-74), vol. 3, nos. 126, 127.

8. On the wide range of possible readings suggested by ter Borch's paintings, see Alison McNeil Kettering, "Ter Borch's Ladies in Satin," *Art History* 16 (1993): 95-124.

9. On the practice of and value attached to cleaning in the Republic, see Simon Schama, *The Embarrassment of Riches: An Interpretation of Dutch Culture in the Golden Age* (New York, 1987), pp. 375-97.

10. Despite its sweeping generalizations, Max Weber's notorious analysis of the relationship between Reformed doctrine and the conditions that allowed capitalism to flourish still offers provocative insight; Max Weber, *The Protestant Ethic and the Spirit of Capitalism* (London, 1930; first published in German in 1904-5). For Calvinist censure of financial irresponsibility see Herman Roodenburg, *Onder censuur: De kerkelijke tucht in de gereformeerde gemeente van Amsterdam, 1578–1700* (Hilversum, 1990), pp. 377-81.

Catalogue Entries

HENRY M. LUTTIKHUIZEN

1 Hendrick Averkamp

Amsterdam 1585-1634 Kampen

*Winter Landscape with Figures
Skating on a Frozen River*

Signed with monogram
Oil on panel, ca. 1615-20
12¼ × 18½ inches (31 × 47 cm.)
Private Collection

Hendrick Averkamp, one of the best-known seventeenth-century painters of winter scenes, came from a well-educated family. His father, Barent Hendricksz. Averkamp, initially from Friesland, was an accomplished schoolmaster at the Latin school on the Nieuwezijds Burgwal in Amsterdam. In 1583 Barent married Beatrix Vekemans, the daughter of the school's headmaster. Hendrick was the first of their five children and was baptized in Amsterdam's Oude Kerk in 1585. About a year after Hendrick's birth, the Averkamp family moved to Kampen, where Barent began a very successful apothecary business. In 1602 Barent fell victim to the plague. Beatrix received permission from the civic magistrates to manage the apothecary until her son was of sufficient age to take control. The son in question, however, was not Hendrick but his younger brother Lambert. Beatrix's will, written in 1633, may shed light on the reason why the eldest son was overlooked. In her will, Beatrix stipulated that her "mute and miserable son" Hendrick should receive a hundred guilders annually for the rest of his life in case he could not care for himself.

In spite of his impairment, Hendrick de Stomme (the Mute), as he was often called, received proper instruction in the art of painting. Seventeenth-century sources suggest that he probably studied in Amsterdam under the guidance of Pieter Isaacsz., a Danish portraitist and history painter. Unlike his master, however, Averkamp chose to concentrate on painting winter landscapes, a subject commonly represented by contemporary artists in Amsterdam. Early in 1614 Averkamp returned to Kampen, where he continued to paint winter scenes, almost exclusively. There he trained lesser-known artists such as his nephew, Barent Averkamp, Arent Arentz., also known as Cabel, and Dirck Hardenstein II. Averkamp remained in Kampen until his death in May of 1634.[1]

Although Averkamp made frozen landscapes popular, he did not invent the subject. Winter scenes first appear in late medieval illuminated manuscripts, where artists such as the Limbourg Brothers depicted the labors of the month. In the sixteenth century Pieter Bruegel the Elder continued this tradition by producing a series of panel paintings representing the seasons. His use of a high vantage point offers viewers opportunities to focus on naturalistic details across a panoramic scene as they imagine climatic conditions. Hals Bol, Gillis van Coninxloo, and David Vinckboons, three Flemish landscape painters deeply influenced by Bruegel's artistry, brought this stylistic tradition north when they immigrated to Amsterdam from Antwerp and Mechelen. Their work likely served as an inspiration to Averkamp.[2]

In this painting, as in most of his winter scenes, the spectator encounters a variety of everyday activities associated with the coldest of seasons. Figures skate, ride on sleighs, ice fish, spear for eels, play *kolf,* a Dutch predecessor to golf and ice hockey, and even watch others at play. A wealthy woman in the foreground wears a facial mask to protect her skin from the cold, reinforcing one's sense of the extreme temperature. Averkamp's description of winter life, although quite naturalistic, need not be interpreted so narrowly. In other words, his painting need not be understood simply as a representation of a specific season of the year. It may also be viewed as a metaphor on the human condition, revealing the slipperiness of life.[3] Throughout the picture, one can readily find vignettes suggesting human folly. Some of his figures have lost their balance and fallen onto the ice. Furthermore, in the background some individuals foolishly have fallen through the ice. The man hanging from distant gallows, a frequent motif in Averkamp's work, may allude to the wages of sin, which is death.

At the same time, however, the landscape seems idyllic. The overall effect of the scene is not one of violent horror or severe cold. On the contrary, it seems heartwarming in spite of the wintery chill depicted. Recreation and play are enjoyed throughout the picture. Participants appear to delight in the frozen canal and take pleasure in the follies of others. The meaning of the work is admittedly somewhat ambiguous and may depend heavily upon the expectations of viewers. The game of *kolf,* for instance, was criticized by some seventeenth-century observers as a frivolous waste of time, whereas for others it taught skills of close perception, strength, and fine judgment as one focused on reaching clearly marked goals.[4] Averkamp's painting is open-ended enough to accommodate both interpretations.

Throughout the scene old and young, rich and poor, appear to celebrate winter in harmony. The pale overcast sky and the large darkened tree in near *repoussoir* on the far left also unify the scene, bringing a variety of people and activities together in one outdoor place. This is not to say, however, that Averkamp's picture is democratic. He preserves the distinctions of social class, and no one of high status falls victim to the slipperiness of the ice. Nonetheless, communal solidarity seems to permeate Averkamp's painting. His figures stand on a "new land" of frozen ice, temporary though it may be, as they celebrate life ideally, without civic conflict or social discord.[5] Those who have foolishly fallen through the ice are heroically saved by the fast actions of others. Perhaps Averkamp hoped to show the importance of quick thinking and teamwork in daily life. The overall tenor of his presentation appears to evoke empathy, asking viewers to reconsider the human condition, its pleasures and potential slipperiness, as they discover ways to improve the quality of life.

44

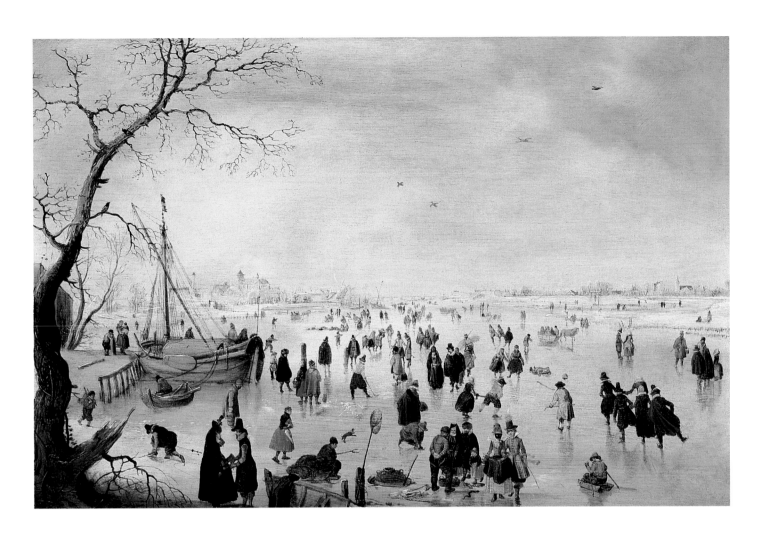

2 Gerrit Berckheyde

Haarlem 1638-1698 Haarlem

The Town Hall on the Dam, Amsterdam

Signed and dated on lower left
Oil on canvas, 1672
13¼ × 16⅜ inches (33.5 × 41.5 cm.)
Rijksmuseum, Amsterdam
28.34

Gerrit Berckheyde, the son of a butcher, grew up in the city of Haarlem. He probably studied painting under the tutelage of his elder brother, Job Berckheyde. Sometime prior to 1660, the year Gerrit entered the Guild of St. Luke in Haarlem, the two brothers traveled to Germany together. Gerrit and Job worked in Cologne, Mannheim, Bonn, and for the Elector Palatine in Heidelberg. Upon their return to Haarlem, the two brothers lived with their unmarried sister, Aeckje. Throughout his career, Gerrit painted small pictures of major sites in Amsterdam and Haarlem.[6]

Though the scale of his work is typically intimate, Berckheyde's cityscapes are quite monumental in character. In this painting Berckheyde depicts one of the most famous places in Amsterdam, the Town Hall on the Dam. Located on the medieval dam across the Amstel River, Dam Square is the political, religious, and commercial center of Amsterdam. Berckheyde shows the hustle and bustle of the square, which served as a marketplace for perishable goods such as fish, butter, and cheese. Customers and sellers, citizens and foreigners from the East, gracefully move across the Dam without social conflict. Business transactions and conversations are conducted with dignity and honor. A horse pulling a heavy load of goods to the Weigh House, which is barely visible on the picture's extreme right, suggests the high volume of trade.

At a time of political crisis, the French invasion of the Netherlands in 1672, Berckheyde produced a painting reinforcing Dutch pride. His representation of the Dam promotes the Amsterdam square as the center of the world. In the background on the right, he portrayed the Nieuwe Kerk, a recently restored Gothic church from the early fifteenth century. The dominant architectural site in his work, however, is the monumental Town Hall, filling about half of his painting. Together the two buildings convey the site of secular and religious authority.[7] The clarity of his presentation and the symmetry of his composition suggest the sense of order and balance that is apparent on the Dam. The pristine light that shines throughout the work affirms the apparent goodness of the church, the seat of government, and the marketplace, as it conveys the moral virtue of those located there.

The heroic Town Hall, which since the nineteenth century has functioned as a royal palace, was considered the "eighth wonder of the world" during the seventeenth century. Jacob van Campen, an architect and painter from Haarlem, was commissioned by the burgomasters of Amsterdam to design the building. Like other buildings by van Campen, such as the Mauritshuis in The Hague, the Town Hall is an excellent example of Dutch Classicism. The monumental grandeur of the facade and harmonious balance of architectural elements cannot be overlooked. The Town Hall was the largest European public building constructed in the seventeenth century. Over thirteen thousand wooden piles had to be driven into the boggy soil to support the structure. Its massive scale and classical style made the Town Hall an ideal site of civic pride.[8] In addition, work on the structure began in 1648, the year that Spain formally recognized the independence of the United Provinces of the Netherlands, giving the building even more patriotic significance.

Berckheyde painted the Dam on numerous occasions, coming back to the subject at least once every decade of his career. In 1669 the Haarlem poet Pieter Rixtel praised one of Berckheyde's representations of the Town Hall. In one poem he compares Berckheyde to Apelles and Zeuxis, legendary painters from classical antiquity, who were often praised for their illusionistic images. A second poem gives the artist even greater significance. In the words of Rixtel, "The eighth wonder of the world, built of stone, stands on the banks of the River Ij, but the ninth is this painting of the eighth."[9] Berckheyde's sensitivity to naturalistic light and his attention to meticulous detail not only provide viewers with a faithful rendering of the famous place, but also it offers them an opportunity to take pride in this site as they appreciate his illusionistic skill.

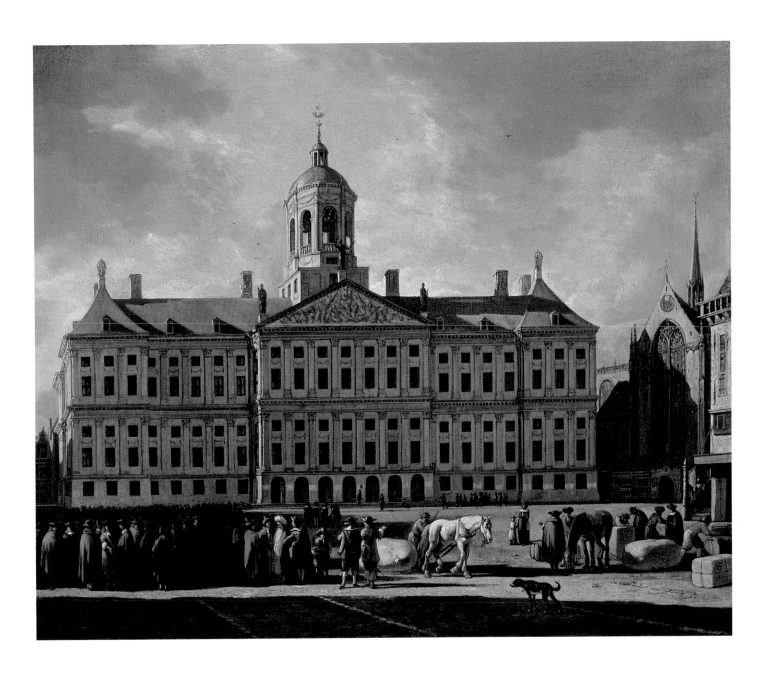

3 Gerard ter Borch

Zwolle 1617-1681 Deventer

Lady at Her Toilet

Signed with monogram on the fireplace
Oil on canvas, ca. 1660
30 × 23½ inches (76.2 × 59.7 cm.)
Detroit Institute of Arts
Founders Society Purchase, Eleanor Clay
Ford Fund, General Membership Fund,
Endowment Income Fund, and Special
Activities Fund
65.10

Gerard ter Borch was born in Zwolle in 1617. He came from a well-to-do family noted for its artistic talent. His father, Gerard the Elder, was an accomplished poet, songwriter, and topographical draughtsman. Ter Borch probably started his artistic training under his father shortly after the death of his mother in 1621. Judging from a figure study completed at the age of eight, ter Borch must have been a gifted pupil.[10]

In 1634 he moved to Haarlem, where he studied with the landscape painter Pieter Molijn. Ter Borch entered the painters' guild there one year later. For the next fifteen years, ter Borch traveled extensively throughout Europe, including visits to England, Italy, Germany, France, and Spain. Through his travels, Gerard ter Borch came into contact with other prominent artists. For instance, court documents from Delft reveal that ter Borch co-witnessed the signing of an affidavit with the famous painter Johannes Vermeer. In 1654 ter Borch moved to Deventer. He would reside there until his death in 1681.[11]

Early in his career, ter Borch primarily painted guardroom scenes, similar to those by Willem Duyster, Pieter Codde, and Jacob Duck. Around 1645, however, he changed his style and developed a new type of genre painting focusing upon the refined activities of a few elegantly dressed figures. These works are generally small in scale and upright in format. Often called the "satin painter" for his sensitivity to surface textures, ter Borch was also quite gifted at presenting the inner psychology of his figures.

As in many of his paintings, the meaning of *Lady at the Toilet* is highly ambiguous in terms of its setting and the responses of figures to their situation. A beautiful woman, dressed in fine blue-and-white satin, turns toward the beholder from within a refined boudoir filled with exquisite and expensive furnishings. In the background of the room stands a marble mantle and a canopied bed. The table on the left is covered by an imported Turkish carpet and set with items made of silver — a mirror, a box, a basin, and a candlestick. The woman is attended by a page, who extends a sumptuously decorated container probably filled with perfumed water. She is also accompanied by a maidservant, who adjusts the lady's garment. The central narrative of the work, however, remains tantalizingly just out of reach, enticing viewers to use their imaginations.

Since Pilate cleansed himself of responsibility for the death of Christ, washing the hands has become a traditional symbol of absolution. Yet, as Peter Sutton has suggested, in ter Borch's painting it is unclear whether the woman's preparation to wash marks her innocence or her need for purification. Furthermore, the lady pensively plays with her ring, but it is difficult to determine why this is the case. She may be performing this gesture to signify thoughts about marriage or infidelity. Perhaps this act is not symbolic at all. The lady might simply be removing her jewelry before she washes. The mirror on the table, deliberately inconsistent with the principles of perspective, reflects the image of the woman. Again, the meaning of this is highly ambiguous, for the mirror can suggest a multitude of possibilities, including vanity, prudence, self-knowledge, transience, deception, and the power of vision. The extinguished candle could allude to the brevity of life, the fleeting character of romance, the annunciation of love, or the arrival of daybreak. Finally, the lapdog about to jump into the chair seems highly animated.[12] According to Jacob Cats, the author of many famous Dutch emblems, "A lady is as her dog."[13] Like her dog, the woman seems to act in anticipation.[14] The source of her interest, however, continues to elude us. Ter Borch seems to withhold information, keeping the viewer from knowing whether the central figure in his painting is a woman of virtue or of vice, a refined lady or a high-class prostitute.

As Alison McNeil Kettering suggests, the painting may also be interpreted in association with the poetic theme of Petrarchan love, whereby a man, smitten by the beauty and charm of a woman, endlessly pursues her even though she will remain forever an unattainable lady. His eternal quest is motivated by the heart rather than mere sexual desire. Petrarchan love is a common motif in seventeenth-century Dutch literature. In fact, ter Borch's younger half-sister Gesina, who may have served as the model for his painting, collected and illustrated such love poetry. The central figure in ter Borch's work is absorbed in her own thoughts and does not seem to recognize the presence of the viewer. Her beauty and elegance are alluring, but she remains aloof and self-absorbed.

Ter Borch's painting can be interpreted in a variety of ways. Some viewers may find themselves preoccupied with his technical virtuosity, especially in regard to his treatment of surface textures. The rich sensuality that permeates his work is quite astonishing. Seventeenth-century observers, like those today, may have appreciated the painting primarily for its technical merit. The labor-intensive rendering of an elegant woman, surrounded by attendants, with precious materials in a lavish interior likely affirmed the value of the work both literally and figuratively.[15]

Whether this painted woman will be romantically adored as the unattainable ideal or voyeuristically desired for her physical appearance will depend on the predisposition of viewers. Observers may respond to her presence in a variety of ways. Some may be attracted to her as an ideal or, at least, empathize with her condition, whereas others may feel repelled by her charm. Nonetheless, like ter Borch's painting, the woman entices us to look further and to enjoy the act of viewing, but she never fully discloses her implicit intentions, leaving this for beholders to decide.

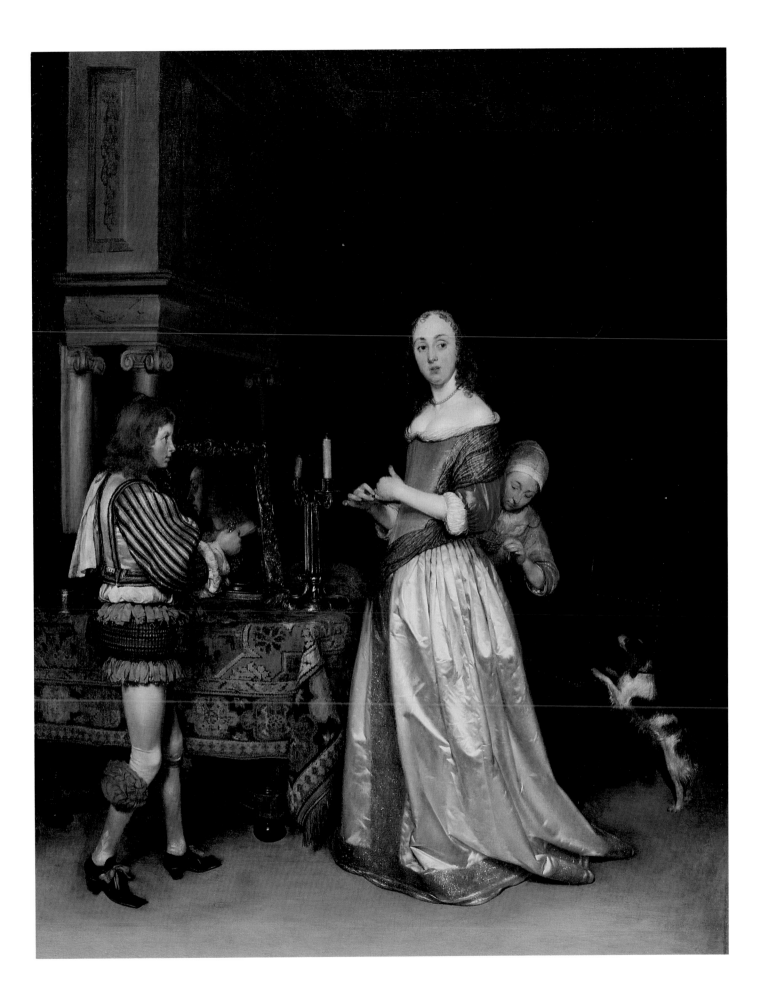

4 Aelbert Cuyp
Dordrecht 1620-1691 Dordrecht

Shepherds in a Rocky Landscape

Signed and dated on lower right
Oil on canvas, 1640
40½ × 51 inches (103 × 129.5 cm.)
Private Collection

Aelbert Cuyp came from an artistic family. His paternal grandfather, Gerrit Gerritsz., was a successful glass painter from Venlo. Benjamin Cuyp, his uncle, belonged to a circle of artists surrounding Rembrandt, and Cuyp's father, Jacob, was a gifted portrait painter who had studied in Utrecht. While in Utrecht, Jacob met his future wife, Aertken van Cooten. Upon their marriage, the couple moved to Dordrecht, one of the oldest cities in the Netherlands. There Jacob worked alongside his brother Benjamin and gained civic prominence as an artist.

In his youth, Aelbert probably trained under his father. The two would later collaborate on a series of pastoral portraits in the early 1640s. Aelbert's earliest-known paintings are monochromatic in style and resemble works by Jan van Goyen and Salomon van Ruysdael. Around 1640, however, Cuyp seems to have changed artistic direction. His work appears more closely aligned with that of Jan Both, Cornelis van Poelenburch, and Herman Saftleven, painters from Utrecht producing Italianate landscapes. Like their pictures, Cuyp's later landscapes are idyllic scenes illuminated in warm golden light.[16]

After the death of his father and uncle in the early 1650s, Aelbert Cuyp inherited the patronage of patrician families in Dordrecht. In 1658 he married Cornelia Bosman, a wealthy widow. Her deceased husband, Johan van den Corput, was a regent who served as a representative to the admiralty at Middelburg. Cornelia also came from one of the city's most prominent families. Her maternal grandfather, Franciscus Gomarus, led the Counter-Remonstrants at the Synod of Dordrecht.[17] Cuyp's marriage significantly elevated his social and economic status. No longer dependent upon making his income from art, Cuyp began to paint less frequently and spent more of his time in church activities. He became an elder and deacon in the city's Reformed Church and served as a regent for a local charity. Upon his death in 1691, Aelbert Cuyp was one of the wealthiest citizens of Dordrecht.[18]

Dated 1640, this is an early work by Aelbert Cuyp, completed around the time he began experimenting with an Italianate style of landscape.[19] In this pastoral scene, shepherds play music and converse with one another as they attend cows, sheep, and a goat. The sky is filled with golden light and windswept clouds. On the far right, a large cliff dramatically frames the scene as a gentle waterway slowly meanders toward a distant town. In this arcadian landscape, humanity and nature are harmoniously joined, without conflict or labor. The simplicity and purity of the setting evoke nostalgia for a time or place of innocence and peace.

As in many of his paintings, Cuyp places large figures in the foreground of a panoramic landscape, giving them a quality of heroic presence. In this work, four cows are depicted as creatures of dignity, grandeur, and grace. Although for some readers this may seem a bit odd, Cuyp's presentation of cows fits the artistic conventions of his day. Cows were often described as noble creatures and were closely associated with regional pride. Throughout the seventeenth century painters and poets praised the cow as a metaphor for natural abundance and economic prosperity.[20] In his book of emblems, Jacob Cats compared Dutch cows to the fruit trees praised by the ancient Latin poet Virgil. Whereas Virgil's trees could bear fruit twice annually, cows can be milked twice a day, offering ample supplies for cream, butter, and cheese. By placing heroic cows in an idyllic landscape, Cuyp seems to elicit images of a New Canaan, a land rich with milk and cheese.[21] The arcadian shepherds could also be associated with the Old Testament psalmist, King David, or with Jesus Christ, the caretaker of souls. Whether this interpretation can be extended to include the sheep and the goat as references to the elect and reprobate, however, is debatable.

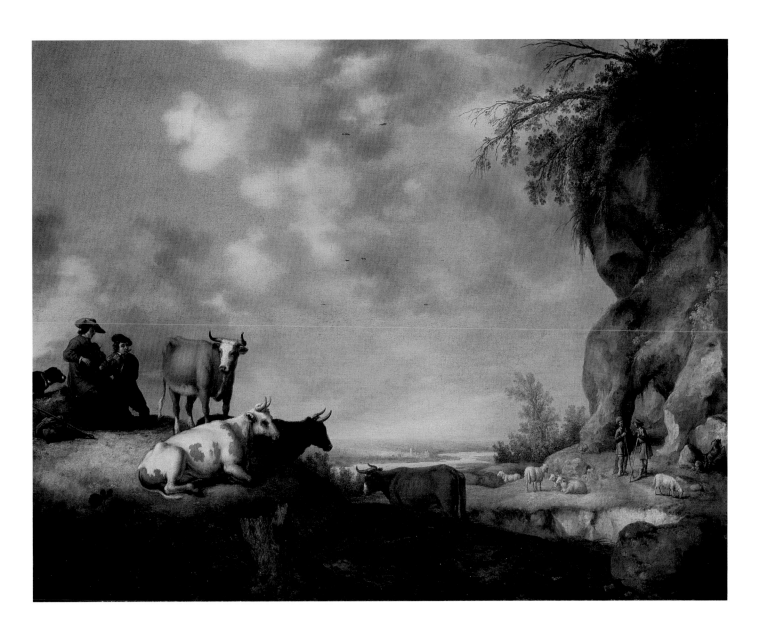

5 Gerard Dou
Leiden 1613-1675 Leiden

The Hermit

Signed and dated on book strap
Oil on panel, 1670
18⅛ × 13⅝ inches (46 × 34.5 cm.)
National Gallery of Art, Washington
Timken Collection
1960.6.8

Gerard Dou was born in 1613. His parents, Douwe Jansz. and Marijtje Jansdr. van Rosenburg, raised Gerard in Leiden, a city he would seldom leave throughout his entire life. As a child Gerard studied glass engraving under the direction of his father. At the age of nine, he may have trained for a year and a half with a copper engraver named Bartholomeus Dolendo. After that he entered the workshop of Pieter Couwenhorn, a local glass painter. Dou must have been a gifted pupil, for he entered the city's glaziers' guild in 1625. This early education with copper and glass may also have encouraged him to pursue a highly polished style of painting.

In February of 1628 Dou became an apprentice of Rembrandt van Rijn. Dou was only fifteen years old at the time, and Rembrandt was himself only twenty-one. Dou continued to participate in Rembrandt's workshop until 1631/32, when Rembrandt moved to Amsterdam. After his master's departure, Dou began to develop a style of his own.

He started producing works of incredible technical control. Dou's paintings barely reveal the process of their making. Concealing his brush strokes with smooth precision, Dou founded a new style of art called *fijnschilderij,* or fine-painting. In 1665 a local collector, Johan de Bije, exhibited twenty-seven of his paintings, making this one of the first recorded one-person shows in Europe.[22]

Even though Dou rarely left his hometown, his work was collected throughout the royal courts of Europe and his paintings continued to fetch high prices throughout his life. Peter Spiering, the Swedish ambassador to The Hague, paid Dou a thousand guilders annually to secure the privilege of first refusal, giving him first choice to purchase whatever Dou produced. After the British monarch Charles II was given one of Dou's paintings, he invited the artist to work in his court. Dou, however, did not accept, preferring to remain in Leiden, where he died in 1675.[23]

Dou's painting *The Hermit* reveals the artist's astonishing virtuosity and painstaking attention to detail.[24] His skillful use of subtle chiaroscuro and his meticulous attention to detail were often praised by his contemporaries. Due to the highly illusionistic character of his work, seventeenth-century Dutch poets often compared Dou to the ancient Greek artist Parrhasios. According to legend, Parrhasios defeated Zeuxis in an artistic competition to trick the eye. He did so by painting a curtain that Zeuxis quickly asked to be removed. The "Dutch Parrhasios," as Dou was sometimes called, also gained fame for his naturalistic style.[25]

In this work, an old monk dressed in a Franciscan habit kneels in prayer, resting his folded hands on a well-used Bible. The edifice behind the pious hermit seems tattered and in ruins, while the marshy soil beneath him appears to invite decay. Objects throughout the painting refer to the brevity of life. On the ground, the horse's jaw, water pouch, and overturned jug suggest mortality, as do the human skull and hour glass on the ledge. In addition, the extinguished lantern hanging from a dead tree stump and the beads with pendent cross and skull suspended from the hermit's cloak are also reminders of death. Other aspects of the work, however, point to vitality and life after death. For example, as Susan Kuretsky has argued, the juxtaposition of the crucifix with the dead tree affirms the Christian belief that through Christ's sacrifice on the cross comes eternal life. The dead tree may allude to the Tree of Knowledge from which Adam and Eve took the forbidden fruit. According to medieval legend, the cross was carved from the same tree, reinforcing the notion that redemption through Christ overcomes sin and death.[26] Not only does the conjunction of cross and tree in Dou's painting seem to affirm this interpretation, so does the presence of new branches sprouting from the stump. The wicker basket that supports the crucifix also implies salvation. The basket has complex iconographical associations. It may allude to the basket that held the infant Moses, protecting him from the dangers of the Nile and from slavery at the hands of the Egyptians. The basket is also found in numerous representations of Rest on the Flight to Egypt, a journey that saved the Christ child from Herod's Massacre of the Innocents. In addition, the basket typically holds bread and thus could refer to the altar or the Virgin Mary, who contained "the bread of life" in her womb. In Dou's painting the basket appears empty. Perhaps this is an allusion to the Resurrection, to the Empty Tomb.

All of this pictorial symbolism reinforces the notion that the hermit is contemplating human mortality and everlasting life in Christ. The intense gaze of the sitter and the illumination on his forehead imply the depth of his meditation. The large thistle in the foreground on the right is a traditional Dutch symbol for constant devotion, affirming the hermit's Christian piety. By presenting the hermit in meticulous detail and placing him close to the picture plane, Dou encourages the viewer to become intimate with the contemplative man. The small scale of the picture also reinforces this rhetorical effect.

Even though the presence of prayer beads, the crucified Christ, and a monastic habit have Catholic connotations, Dou's painting is ecumenical enough to accommodate the expectations of Catholics and Protestants alike. The hermit may appear saintly, but he does not have sufficient attributes to identify him as a particular saint. In other words, Dou seems to concentrate upon the virtues of the contemplative and saintly life rather than upon the veneration of a particular saint, making the painting far more acceptable to Protestant viewers. Furthermore, the hermit rests his prayerful hands on the Word, a gesture implying the primacy of the Scriptures as the foundation of his beliefs. The intense naturalism of Dou's painting, though stunning in itself, would not have necessarily detracted Catholics and Protestants from discovering sacred truths.[27] On the contrary, it could foster greater religious devotion by revealing the importance of Christian piety in the here and now. In other words, the illusionistic quality of Dou's work could help viewers imagine true spirituality and encourage them to empathize with the contemplative hermit.

6 Jacob Duck

Utrecht? ca. 1600-1667 Utrecht

Musical Ensemble with Cockatoo

Signed on the envelope located on the floor
Oil on panel, ca. 1660
19½ × 25⅜ inches (49.5 × 64.5 cm.)
Private Collection

J acob Duck, born in Utrecht around 1600, was the second son of Jan Jansz. Duck and Maria Kool. The absence of his name, as well as those of his siblings, from the baptismal records of the Reformed Church suggests that his family was Catholic. Jacob Duck's two brothers, Johan and Cornelis, and his uncle, Jacob Kool, all entered the priesthood, giving greater support to the argument that Duck was Catholic. Little is known about Jacob Duck's father, but his mother was known as a linen merchant. When Jacob married in 1620, he wed Rijckgen Crook, whose family was also involved in the linen trade.

In his youth, Duck was trained as a goldsmith, beginning his apprenticeship in 1611. By 1619 he became a master of the craft, and his name is listed in the guild register throughout his life span. Two years later, for reasons unknown, Duck entered the workshop of the Utrecht painter Joost Cornelisz. Droochsloot as a pupil. Droochsloot, like the Amsterdam painters Willem Duyster and Pieter Codde, was best known for his guardroom scenes, a subject Duck would also frequently paint. Legal documents imply that Jacob Duck knew other prominent Catholic painters in Utrecht quite well. Abraham Bloemaert witnessed his father's will, and Willem Moreelse married his sister-in-law. One of Bloemaert's relatives also owned one of the houses Jacob Duck and his wife rented.

Although Duck frequently painted scenes of the affluent middle class imitating aristocracy, he never achieved such wealth. After Rijckgen's death in 1648, Duck for a long time lived with six of his unmarried daughters. At his death in 1667, his surviving children declined their inheritance, suggesting that the artist died in debt.[28]

J acob Duck's painting *Musical Ensemble with Cockatoo* reveals a dramatic tale of true love and false romance. A painted curtain unveils the theatrical scene. On the left side of the table a solitary woman stares back at the viewer. She lifts up her left index finger of admonition as her right hand points to a pocket watch, implying the brevity of life and the need to separate true love from lust. Directly behind her, a man vainly combs his hair before a mirror, apparently so preoccupied with himself that he is unable to love another.

At the table, a couple play a game of dice, an allusion to their gamble at love. The woman's low-cut bodice may imply that the romance was initiated by sexual desire. If so, however, their passion may already have subsided, for they appear more interested in the game than with each other. The landscape paintings behind them picture tempests, suggesting perhaps the tumultuous quality of their relationship.

By contrast, the couple in the foreground gaze lovingly into each other's eyes. The woman plays an alto viol and her mate plays bass as the two make beautiful music together. The harmony of their music suggests the perfect unity of their bonds. There is also a foot warmer under her elegant skirt. A foot warmer is illustrated in Roemer Visscher's *Sinnepoppen* as an emblem for a "woman's favorite." The subtext reads: "He who aspires to win second place in esteem must embark upon serving them with sweet, witty and amusing talk, avoiding all boorishness and vulgarity, without reprimanding their cackling and chattering and never mocking their fussy and showy clothes; but praising them for everything they do and propose, then he will be praised in their company as a perfect courtier."[29] The woman's costume may be overly extravagant, but the gentleman's eyes remain fixed upon hers. The cool color of her garment may also imply that though her passion is heated, her morals and manners as a fine lady will prevail. This painting, like other merry companies by Duck's hand, seems to advocate middle-class virtue in the construction of noble manners.[30] The ivy revealed through the windows on the far left may allude to ideal love, for it is a plant that is traditionally associated with marital love and fidelity.

The importance of true love is accentuated by the young boy who plays his flute in the background, for he will learn his lessons of love from the couples he sees. As the Dutch proverb puts it, "As the old sing, so pipe the young." Children imitate the actions of adults. Above the table, a cockatoo is perched upon a swing. The cockatoo was brought back to the Netherlands by sailors and traders from Indonesia and sold as an expensive family pet. The exotic bird in Duck's painting may be interpreted as a bird of love, as an eloquent singer, or as a creature that simply imitates what it hears. Outside a gilded cage, the bird seems free to mimic what it chooses.[31] The meaning of the dogs is also quite ambiguous. The spaniel seems to be curious about the happenings around the table, whereas the posture of the small lapdog appears to be rather defensive. Perhaps the dogs are engaged in some sort of playful tease, an activity that would reinforce the erotic qualities of the scene. They may also function as an unequal couple, as potential lovers who should not mate with one another. It remains impossible, however, to determine the precise source of their excitement or the nature of their sentiments.

The meaning of the rumpled cloak and abandoned sword placed on a nearby chair is also somewhat elusive, though it can suggest the absence of vigilance, the loss of one's Christian armor, or the disarming qualities of romance. Although at first glance it seems easy to distinguish true love from false, a closer look at Duck's painting imaginatively reveals the complexities of making such an important decision, for matters of the heart are difficult to interpret.

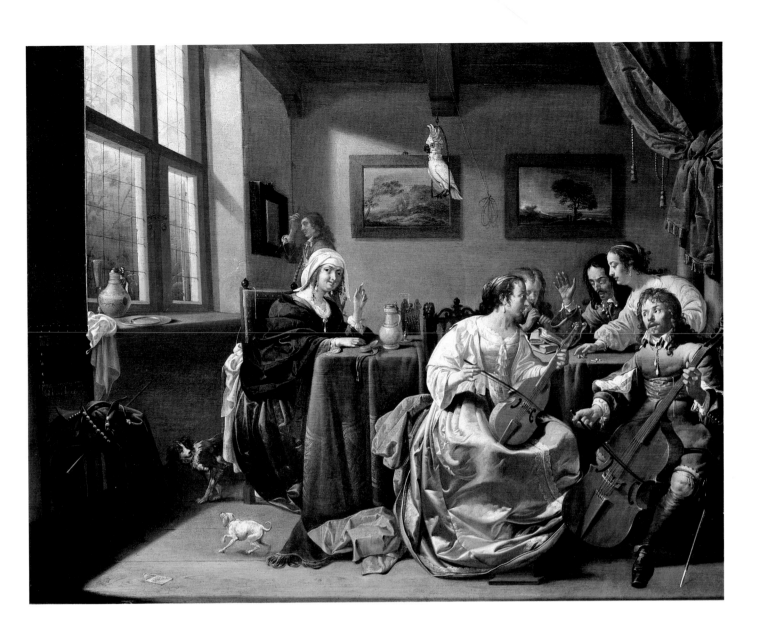

7 Jan van Goyen
Leiden 1596-1656 The Hague

A River Landscape with Fisherman Mooring a Rowing Boat

Signed with monogram and dated on boat
Oil on panel, 1653
10⅜ × 16 inches (26.4 × 40.6 cm.)
Private Collection

Jan Josephsz. van Goyen, the son of a shoemaker, grew up in the city of Leiden. At the age of ten he began his apprenticeship in the visual arts. From 1606 to 1615 he studied successively under the Leiden painters Coenraet van Schilperoot, Isaac Claesz. van Swanenburgh, Jan Arentsz. de Man, the glass painter Hendrick Clock, and then for two years under painter Willem Gerritsz. in the city of Hoorn. After his training, Jan van Goyen went back to his native city and painted on his own. The following year, 1617, however, would prove to be decisive in his artistic career. During this time he moved to Haarlem and became the pupil of Esaias van de Velde, one of the first Dutch landscape painters to abandon Flemish mannerism for a more naturalistic style concentrating on tonal qualities.

Upon returning to Leiden in 1618, Jan van Goyen married Annetje Willemsdr. van Raelst. In the summer of 1632 the van Goyens moved to The Hague, where he would gain citizenship two years later. In The Hague, van Goyen was named *hoofdman* of the painters' guild in 1640 and 1651. Throughout his life Jan van Goyen traveled extensively throughout the Netherlands, drawing the countryside. Around 1634 he visited Haarlem, staying in the house of Isaack van Ruysdael, the brother of Salomon and the uncle of Jacob van Ruisdael. His stay was cut short, however, when he was caught selling his paintings without proper authorization from the city's guild.

In the year 1649, his two daughters married artists: Maria the still-life painter Jacques de Clauw and Margarethe the famous genre painter Jan Steen. Jan van Goyen was incredible prolific as a painter and draughtsmen. Nonetheless, van Goyen struggled financially. He tried his hand at art appraisal and dealing with no success, and he also speculated in tulip bulbs and real estate, poor investments in which he suffered significant losses. At his death in 1656, the artist remained financially insolvent.[32]

Although this painting is late in Jan van Goyen's oeuvre, it resembles those of his earlier career, revealing his continual interest in the naturalistic style of Esaias van de Velde. Like his mentor, van Goyen provides a monochromatic description of a locality, limiting his use of color to a tonal palette. His fluid brush strokes and reduction of color produce splendid atmospheric effects. The dark shadows in the foreground intensify the drama of the scene, while the low horizon emphasizes the rich panorama of the flat topography. Like many of his paintings, this landscape is probably based on preparatory studies, drawings sketched after life but completed in his studio.[33]

In this particular painting, van Goyen depicts the ordinary activities of fishermen at the close of a workday. The meandering estuary appears calm and tranquil, while the dark clouds in the sky suggest the possibility of approaching rain. Distant buildings seem rustic and weathered by time. The composition seems natural, without the calculated structure or superimposed order associated with classical styles. Seemingly artless, the painting apparently records the artist's optical experience of a particular time and place. This informal appearance, however, is used for rhetorical effect, to persuade viewers that they are seeing something real or true to life.[34]

Van Goyen's poetic description of the simple life invites quiet contemplation. The heightened naturalism of the work evokes a variety of imaginative responses. Observers can simply take pleasure in the rustic scene, or they can ponder the harvesting of nature. They can feel nostalgic for the countryside or consider the experience of process and change as they confront the effects of time and weather.

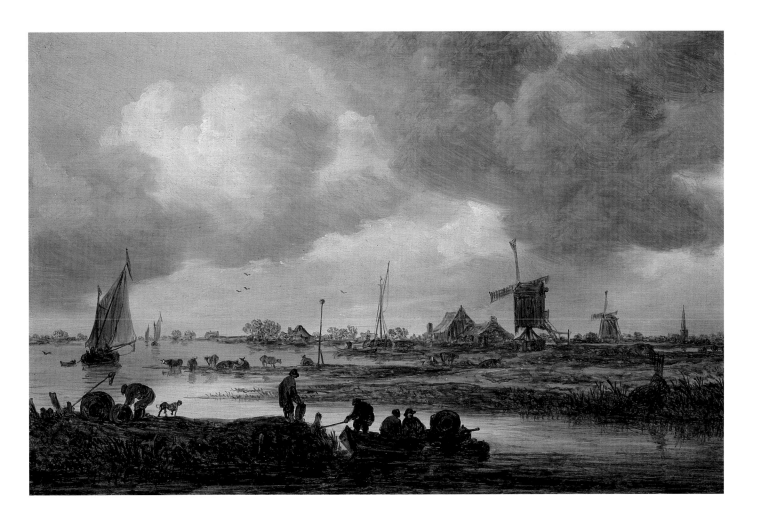

8 Dirck Hals

Haarlem 1591-1656 Haarlem

Cavaliers Playing Tric-Trac in a Tavern

Signed and dated
Oil on panel, 1631
18 × 26½ inches (45.7 × 67.3 cm.)
Private Collection

Little is known about Dirck Hals, the younger brother and pupil of Frans Hals. He was born and baptized in Haarlem. His parents, Franchoys Hals and Adriaentgen van Geertgenrijck, immigrated to Holland from Antwerp sometime between 1595 and Dirck's birth. Although trained by his brother, Dirck closely imitated the work of the Rotterdam artist Willem Buytewech, who lived in Haarlem from 1612 to 1617. Like Buytewech, Dirck Hals primarily painted merry companies. He is best known for his depiction of elegantly dressed figures in shallow interiors. Samuel Ampzing, the author of *Beschrijvinge ende lof der stad Haarlem* [1628], noted "the neat little figures" in his work.

From 1618 to 1626 Dirck Hals was an active member of a rhetorical society, *De Wijngaertranken*, which was well known for its amateur theatrical performances. Dirck and his wife, Agnietje Jans, had seven children. The family may have lived in Leiden during the 1640s. He is recorded there in 1641-42 and again in 1648-49. Nonetheless, Haarlem appears to have remained their hometown. Upon his death in 1656, Dirck Hals was buried in the city of his birth.[35]

Pictures such as Dirck Hals's *Cavaliers Playing Tric-Trac in a Tavern* are usually described as genre paintings, scenes of everyday life. The term "genre," however, is French and eighteenth century in origin. Seventeenth-century Dutch viewers, however, referred to such works as merry companies and understood them as typically represented theatrical narratives rather than unmediated experiences of common life. In Hals's dramatic painting, figures gamble in the fortunes of love and wealth on the stage of a shallow interior.

The figures in Hals's painting are clothed in the high fashion of the day but seem to lack the social graces associated with aristocracy. On the left stands a well-dressed hostess holding a pewter pitcher at her side. This vessel was also known as a "pipe," a word resonant with sexual connotations. Even though this woman does not have a globe on her head, an attribute often given to the allegory of *Vrouw Wereld,* she may personify worldly desire.[36] The map of the Netherlands directly behind her may simply be decorative. Many Dutch homes displayed wall maps. But it could also serve to reinforce the allusion to Dame World. The standing cavalier addressing the hostess seems to accept her invitation.

On the back side of the table, a young woman offers a glass of wine to a cavalier, as she seductively sits upon his lap, in an overtly erotic gesture. At the table, soldiers play tric-trac, a game of chance resembling backgammon. During the seventeenth century, it was considered socially acceptable to play tric-trac for fun, as a form of recreation at dinner parties. The game, however, was criticized heavily by Christian humanists and Calvinist preachers, who believed that tric-trac could easily lead to vice. It could encourage players to waste time and money. Like cardplaying, tric-trac had a bad reputation in the Netherlands as a game of chance, and it was often associated with idleness and sloth. Excessive drinking, fighting, and sexual promiscuity were also frequently linked to the game. The eighteenth-century author Arnold Houbraken even labelled tric-trac a home-wrecker. The game was also called *verkeerspel.* Borrowed from the verb *verkeer,* to change or turn over at a disadvantage, *verkeerspel* could imply the negative results of rolling dice. In a play of words, *verkeerspel* could easily suggest *verkeert,* doing wrong, literally to be turned around. Dirck Hals's painting, like the biblical tale of the Prodigal Son, may have warned viewers of the dangers of gambling, excessive drinking, and sexual promiscuity. On the far right, a male figure seems to stare back at observers in apparent admonition. Nevertheless, it is also possible that seventeenth-century viewers may have interpreted the meaning of tric-trac on another level. Comparisons between games of chance and the uncertainty of life and love are commonplace in Dutch literature. As the Dutch playwright Gerbrand Adriaensz. Bredero, in his famous motto, puts it, "'t kan verkeren," life (like *kans* or chance) can change. In Hals's painting, the playing of dice may simply allude to the cavalier's willingness to gamble with his life or with his heart in matters of love. No one in the painting is quarreling or stealing money. If any kind of deception is occurring, it is in the cheating of time or, perhaps, the cheating of one's absent lover.[37]

Seventeenth-century viewers could see Hals's painting in a variety of ways. Many of them would have expected to encounter more than a visual sermon. The painting may have served to instruct, but it also intended to delight. They would have enjoyed seeing visual puns. The quality of Hals's imaginative presentation would not have been overlooked. His use of naturalism and his painterly technique were also likely appreciated for their fine quality and rhetorical effect.

9 Frans Hals

Antwerp ca. 1582-1666 Haarlem

Hendrik Swalmius

Signed with monogram and dated on right
near center
Oil on panel, 1639
10⅝ × 7⅞ inches (27 × 20 cm.)
The Detroit Institute of Arts
City of Detroit and Founders Society Joint
Purchase
49.347

10 Frans Hals

Antwerp ca. 1582-1666 Haarlem

Mrs. Hendrik Swalmius

Signed with monogram and dated on left
near center
Oil on panel, 1639
11⅝ × 8¼ (29.5 × 21 cm.)
Museum Boijmans van Beuningen,
Rotterdam
62.2498

The portrait painter Frans Hals was born around 1595. His parents, Franchoys Hals, a cloth worker from Mechelen, and Andriaentgen van Geertenrijck, resided in Antwerp, her hometown. Frans was the eldest of their children. After the Spanish Siege of Antwerp in 1595, the Hals family fled north to Haarlem. The date of their immigration from Flanders is undocumented. Their first mention in Haarlem is found in the baptismal records of their second son, Dirck. Frans Hals would spend the rest of his life in Haarlem, except for a visit back to the city of his birth in the autumn of 1616.

Hals entered the Haarlem Guild of St. Luke in 1610, but the origin of his artistic training remains somewhat enigmatic. According to the posthumous second edition of Karel van Mander's *Het Schilderboeck,* published in 1618, Hals was the author's pupil. There is no stylistic evidence, however, to support van Mander's claim. If the alleged apprenticeship occurred, it seems to have had little impact on Hals's artistic development.

Sometime prior to September of 1611, Hals married Annetje Harmansdr. The couple had two children; she died in 1615. Two years later Hals remarried. He and his second wife, Lysbeth Reynier, had at least eight children together.

Early in his career Hals received the praise of Samuel Ampzing, who lauded the artist's ability to capture the vitality of his sitters. Although he had only two documented pupils, Pieter Gerritsz. van Roestraeten and Vincent Laurensz. van der Vinne, the eighteenth-century art biographer Arnold Houbraken suggested that artists Adriaen Brouwer, Dirck van Delen, Adriaen van Ostade, and Philips Wouwerman may also have studied with Hals. In addition, it is very likely that he taught his younger brother Dirck to paint. Other Haarlem painters, such as Judith Leyster and Jan Miense Molenaar, closely imitated his work. Nonetheless, Frans Hals struggled financially throughout his life. Even during the 1630s and 1640s, the period of greatest demand for his paintings, Hals did not accumulate wealth. In spite of his popularity as a portraitist, stiff competition for portrait commissions among Haarlem artists kept Hals's profits low. From 1662 to his death in 1666, he was destitute and depended upon economic relief to survive, given in the form of an annual subsidy from the civic magistrates of Haarlem.

After his death, Hals's portraits received little recognition. After two centuries of relative obscurity, he regained fame when Manet and the French impressionists, fascinated by Hals's rough brush strokes and painterly technique, rejuvenated interest in his work. Today he continues to be celebrated as one of the greatest portrait painters of the seventeenth century.[38]

60

The identity of the sitter in the Detroit panel has been identified by comparing the painting to a reversed engraving by Jonas Suyderhoef, which names the sitter in an inscription. In both pictures, Hendrik Swalmius, a Calvinist preacher from Haarlem, is portrayed. The compositions are almost identical. In the engraving there is more space above Swalmius's head and the side margins seem to extend beyond those of the painting.[39] Seven years after Hals's painting was completed, Hendrik Swalmius, along with Salomon Echinus of Haarlem and Mellius Aegidius of Molkwerum, witnessed the marriage banns of Sara Hals, Frans and Lysbeth's eldest child, to a Frisian seaman named Sjoerd Eles.[40]

In 1921 Wilhelm Valentiner suggested that a portrait of an unknown elderly woman in the Museum Boijmans van Beuningen might be a companion panel, representing Swalmius's wife.[41] Throughout the seventeenth century, Dutch artists commonly painted portraits of husbands and wives in separate panels, a practice that easily accommodated revision upon remarriage should one of the spouses die. The harmonious relationship between the marital couple was, nonetheless, reinforced by the composition. In this case, the bond between Swalmius and his wife is implied by the nearly symmetrical arrangement of the two panels. In both pictures, Hals's brush strokes are highly visible, revealing the process of their making. Through use of *impasto,* the heavy application of pigment, and of liberated brushwork, Hals not only reveals how his portraits were produced, but he also conveys a sense of spontaneity and immediacy. His rough manner of painting encourages viewers to recognize the vitality of his sitters.

The piety of the couple is conveyed by their attributes. Both carry prayer books or small Bibles and wear sober attire. Their costumes are old-fashioned, suggesting their age and the conservative nature of their sentiments. Hendrik, aged sixty, wears the skullcap of a minister and a dark cloak buttoned to a *molensteenkraag,* or millstone collar, fashionable at the beginning of the seventeenth century. His fifty-seven-year-old wife also wears a millstone collar attached to her *vliegerkostuum,* a kite-shaped dress with white lace cuffs at the sleeves. On her head is placed a *brede vleugelmuts,* or broad-winged cap, with narrow and bent-down sides. Although their attire is admittedly old-fashioned by the late 1630s, nonetheless it offers them the respectability associated with old age.[42]

When these two images were temporarily reunited at the Frans Halsmuseum in 1962, some scholars questioned the validity of Valentiner's argument that the Detroit and Rotterdam panels were companion portraits. Their doubts were grounded in the difference of scale between the two pictures. As Slive suggests, judging from Suyderhoef's engraving, the Detroit panel may have been trimmed. The portraits may originally have been more comparable in scale. Even if the Detroit panel has not been trimmed, this does not discount the possibility that the portraits functioned as a pair, for the two paintings share many stylistic characteristics and the differences in dimension are not excessive.[43]

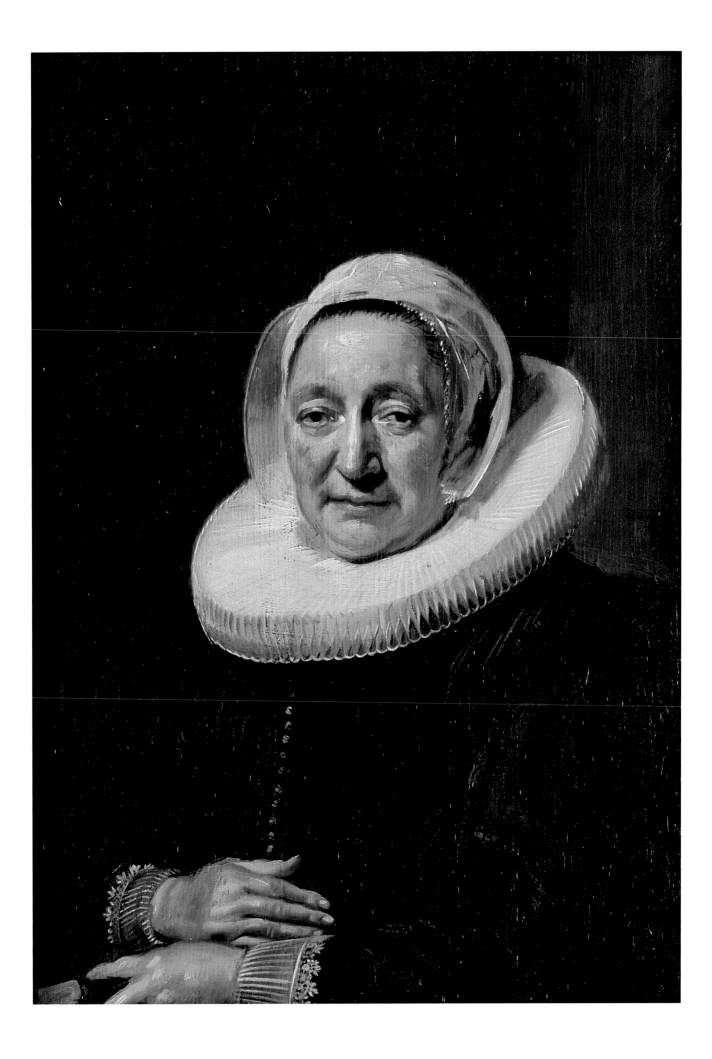

11 Jan Davidsz. de Heem
Utrecht 1606-1683/84 Antwerp

Still Life with a Glass and Oysters

Signed on upper left
Oil on panel, ca. 1640
9⅞ × 7½ inches (25.1 × 19.1 cm.)
The Metropolitan Museum of Art
71.78

Jan Davidsz. de Heem was born in Utrecht to Catholic parents. In his youth he probably studied under the direction of his father, David de Heem, a still-life painter. He may also have worked with Balthasar van der Ast, who moved to Utrecht in 1619. De Heem left Utrecht in 1625 and took up residence in Leiden, where he lived for at least five years. A year after his move, de Heem married Aletta van Weede of Utrecht. During his stay in Leiden, he produced still lifes depicting tattered books scattered on tables against monochromatic backgrounds. His preoccupation with the vanity of books was well suited for the academic communities of Leiden and was likely stimulated by the still lifes of Harmen Steenwijck and David Bailly.

Sometime in the early 1630s, de Heem probably transferred to Haarlem. Many of his paintings from this era closely resemble the works of Pieter Claesz. and Willem Claesz. Heda, especially their tonal *onbijtjes*, or breakfast pieces. In 1636 de Heem moved to Antwerp, where he would reside for the next twenty-two years. While residing in Antwerp, de Heem began to imitate the flower and fruit still-life paintings of Daniel Seghers. Like Seghers, he depicts sumptuous fruit and beautiful flowers in naturalistic detail. During this time de Heem also developed still lifes of incredibly showy objects, or *pronken*. In these paintings de Heem revealed ostentatious luxury in his depictions of lavish banquets served on exquisite tableware.

A year after the death of his wife Aletta in 1643, de Heem married Anna Ruckers, a native of Antwerp. In 1658 the couple moved to Utrecht. Following the French invasion of Utrecht in 1672, de Heem and his wife returned to Antwerp, where the artist would spend the last years of his life. Throughout his career de Heem experimented with still-life painting. Like a chameleon, he changed his style with his location. De Heem enjoyed great popularity and attracted numerous pupils and followers throughout the Northern and Southern Netherlands, including Abraham Mignon, Abraham van Beyeren, and Joris van Son.[44]

Still Life with a Glass and Oysters was likely painted shortly after de Heem's arrival in Antwerp. In this work, a few select objects are arranged on a table or ledge partially covered by a green cloth, against a monochromatic blond background, illuminated from the left. The muted colors and loose arrangement of the objects on the table provide a strong sense of atmosphere. Throughout the painting, de Heem skillfully presents a variety of textures in a harmonious composition, balanced by complementary curvilinear elements. The intense naturalism of the work encourages beholders to see the painted scene as an extension of their own space.

De Heem's painting invites the beholder to consume the attractive items it displays. It offers a variety of worldly pleasures. According to seventeenth-century medicine, oysters could heighten one's sexual performance. The wine and grapes in this painting do not allude to the Eucharist. There is no bread in this still life, and the flavor of eucharistic wine is never enhanced by the addition of lemons, which are also used to season oysters. Instead, the wine likely suggests lust. Like oysters, wine was considered to be an effective aphrodisiac. The vertical format of the painting, the central placement of the roemer, the spiraling grapevine, and the brilliant curved, peeled lemon rinds dangling from the glass all call greater attention to the wine. The pale green grapes in de Heem's painting not only balance the composition, but they also allude to sensual pleasures. Their physical appearance, succulent and ripe, whets the appetite.

Unlike many other still lifes of this type, the painting does not include a pocket watch, smoking implements, or tipped-over items to suggest the transience of life. Nor is the roemer broken to evoke notions of the frailty of life. The grapes in his painting do not appear to rot. De Heem's still life does not include traditional motifs associated with mortality and vanity. Instead, he reduces the painting to the presentation of sumptuous objects, known for their sensual pleasures. This is not to say, however, that de Heem's work advocates some kind of hedonism. Rather, it shows the seductive power of these objects by revealing their deceptive beauty. By producing a tension between appetite and restraint, the painting invites observers to choose between temporal pleasures and eternal gratification.[45]

At the same time, de Heem's painting can encourage viewers to consider the value of art, for like oysters and wine, it can also trick the eye. The beauty of de Heem's still life surely must have delighted seventeenth-century beholders. Like the items it represents, the painting raises a moral dilemma. Beholders can simply enjoy the pleasures it offers to sight or they can view the painting as an evocation for spiritual insight.[46]

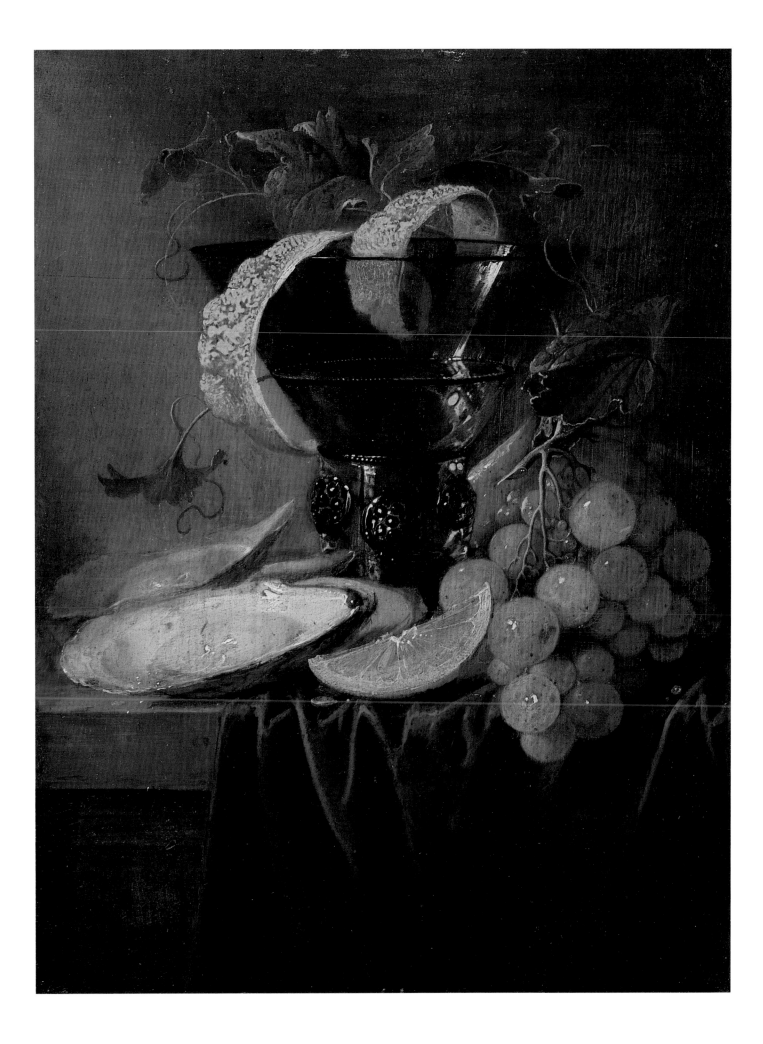

12 Pieter de Hooch
Rotterdam 1629-1684 Amsterdam

Courtyard, Delft

Signed on lower left on step
Oil on panel, ca. 1657
26¾ × 22⅝ inches (68 × 57.5 cm.)
The Toledo Museum of Art
Purchased with funds from the Libbey
Endowment; gift of Edward Drummond
Libbey
49.27

Pieter de Hooch, the son of a master bricklayer, Hendrick Hendricksz. de Hooch, and a midwife, Annetje Pieters, was born in Rotterdam and baptized in the city's Reformed Church. According to the eighteenth-century biographer Arnold Houbraken, de Hooch studied the art of painting, presumably in Haarlem, under the supervision of Nicolaes Berchem. The genre painter Jacob Ochtervelt is said to have been Berchem's pupil at the same time. De Hooch's earliest paintings, however, are guardroom scenes in the style of the Rotterdam artist Ludolf de Jongh, raising the possibility that de Hooch studied in his hometown rather than in Haarlem.

In 1653 de Hooch is recorded to be in Delft, working as a servant to and painter for the linen merchant Justus de la Grange. By 1655 de la Grange had accumulated eleven works by de Hooch. Their commercial relationship was, however, cut short. Apparently, de la Grange also collected debts. While in Delft, de Hooch came into contact with the artist Hendrick van der Burgh. In 1654 he married van der Burgh's sister Jannetje, with whom he would have seven children. A year later de Hooch joined the Delft Guild of St. Luke. During this time he likely encountered Johannes Vermeer, who also experimented with perspectival space and naturalistic light, but the nature of their relationship remains unknown.

By 1661 Pieter de Hooch and his family moved to Amsterdam. This change of address was probably made in hopes of finding financial security. If so, it did not work. As in Delft, de Hooch continued to struggle against impoverishment. In 1670 he testified in a lawsuit raised by Adriana van Heusden, the widow of Joris van Wijs, an Amsterdam notary, against the painter Emanuel de Witte for failure to fulfill his contractual obligations with the deceased. Little is known about de Hooch's final years in Amsterdam. For reasons unknown, he spent his last days in the Dolhuijs, an insane asylum.[47]

This painting is one of de Hooch's earliest representations of a *hofje,* or little courtyard, a frequent subject in his work. Although the image is based on the quaint architecture of the oldest parts of Delft, the view is constructed from his imagination as a plausible fiction. Scholars often compare de Hooch and Vermeer, but it is important to recognize the differences between these two artists. Unlike Vermeer, de Hooch usually shows women engaged in daily labors and represents children. In addition, de Hooch does not seem to have studied the effects of the camera obscura. Nonetheless, de Hooch and Vermeer may have influenced one another's development.

Like many of his pictures, *Courtyard, Delft* seems to elicit domestic virtue. The enclosed courtyard is a clean and tidy, intimate place. In the foreground are a broom and a pail, reminding observers of the purification of this space. Within the courtyard, one woman draws water from a well while another washes laundry. A young girl watches the woman on the right with attentive concentration, learning how to perform daily chores. The women in de Hooch's picture, like the courtyard that surrounds them, seem simple and pure. The comparison between women and courtyards or gardens goes back to the Song of Solomon (4:12), and the courtyard was frequently used throughout the Middle Ages and Renaissance as a metaphor for the Virgin Mary. In de Hooch's painting, as in contemporary Dutch literature, this association is broadened to include the domestic virtue and grace of ordinary, hard-working women. Even though these women do not appear to be contemplating the theological implications of their activities, the religious dimension of their efforts is intimated by the presence of the Oude Kerk's tower in the background and the purity of their space. Like the church beyond it, the courtyard also appears to be a sanctified place, where dirt and filth are eliminated by human labor and the grace of God. Although the labor of these humble women is rather mundane, it reveals the importance of protecting cleanliness and order. By implication, observers, like the women depicted in de Hooch's painting, are encouraged to be chaste and pure as they modestly follow their own religious vocation to cleanse the world of sin.[48]

Even though this work may provide a visual example of morality to imitate, this does not foreclose other possible interpretations. For some seventeenth-century viewers, de Hooch's painting could also evoke local pride in a community that advocates true purity and piety. Other observers may have found delight in the simple beauty of the work, without concern for either personal or communal purification. In addition, such responses are not necessarily mutually exclusive; interpretations of the painting could be as plural and mixed as they are today.

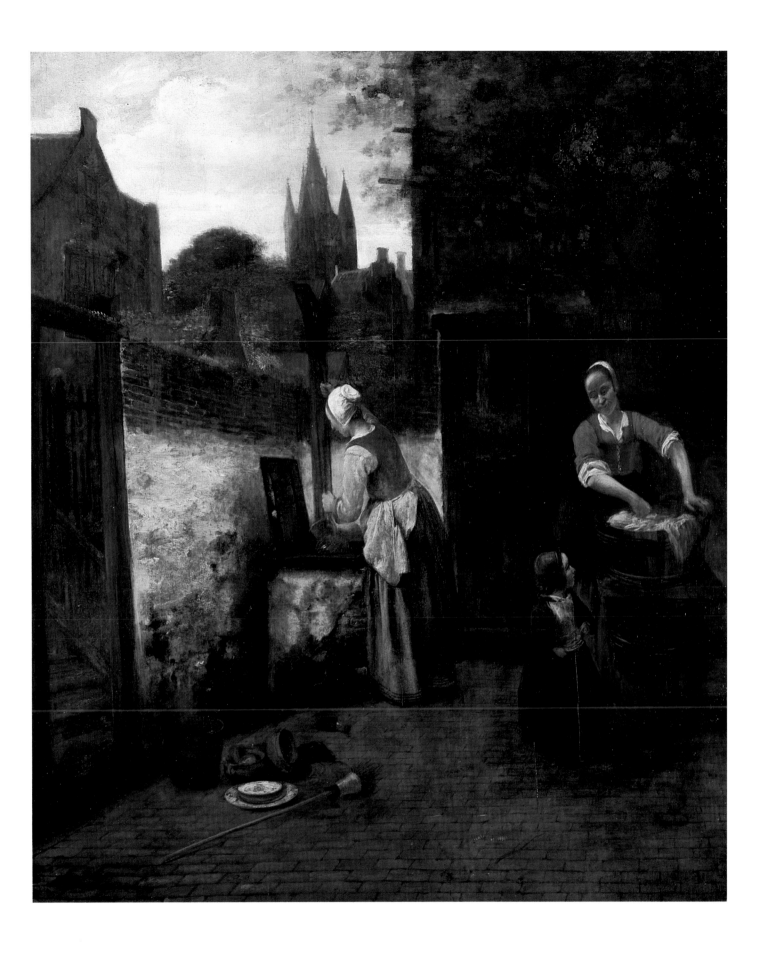

13 Jan van Kessel I
Antwerp 1626-1679 Antwerp

Study of Butterflies and Insects

Oil on copper, ca. 1655
4⁵⁄₁₆ × 5¹³⁄₁₆ inches (11 × 14.8 cm.)
National Gallery of Art, Washington
Gift of John Dimick
1983.19.3

At Jan van Kessel's birth in 1626, his extended family was already well known for its artistic achievements. His father Hieronymus was an accomplished painter. In addition, his maternal grandfather was the famed Jan Brueghel the Elder, also known as the Velvet Brueghel, who on occasion collaborated with Pieter Paul Rubens. Pieter Bruegel the Elder was his great-grandfather. One of Jan van Kessel's uncles was the artist David Teniers the Younger, who is often recognized for his depiction of tavern scenes. Another of his uncles, Jan Brueghel the Younger, was his godfather and probably taught Jan van Kessel to paint. Brueghel the Younger also commissioned his nephew to make copies of his paintings. As a child, van Kessel was a pupil of Simon de Vos, a friend of the family. By the age of eighteen he is listed in the 1644/45 registry of the Antwerp Guild of St. Luke as a master with the title of *blomschilder,* or flower painter. About a year later, van Kessel married Maria van Apshoven in Onze Lieve Vrouwe Kerk, the cathedral church of Antwerp. The couple had thirteen children, two of whom would become painters, Ferdinand-Leonard and Jan the Younger.[49]

Van Kessel was quite prolific and painted numerous bouquets and garlands of flowers. The style of these flower paintings seems to resemble those of fellow Flemish artists Daniel Seghers, who had studied with the Velvet Brueghel, and Jan Davidsz. de Heem. Like Seghers and de Heem, Jan van Kessel applied his brush strokes with precision, without the painterly fluidity of the two Brueghels.

Many of his pictures were acquired by Spanish collectors, even though there is no evidence that van Kessel ever traveled to Spain. The popularity of his work may be explained by its similarity to that of Seghers, whose work was already highly valued in Spain. Although Jan van Kessel painted numerous pictures that were frequently sought after by Spanish and Flemish collectors, he died in relative poverty.

Van Kessel, though known primarily for his flower paintings, also produced representations of bugs. In *Study of Butterflies and Insects,* van Kessel paints them with scientific precision, analogous to that of Joris Hoefnagel, the famed late-sixteenth-century watercolorist in the court of Rudolf II of Prague. Like Hoefnagel, van Kessel depicts rare and unusual tiny creatures, such as the tiger beetle on the upper left margin and the scorpion fly on the lower left. He paints these insects against a neutral light-grey background.

The light in van Kessel's small picture is not entirely consistent. On the image's periphery, the beetles and flies cast shadows in a manner that implies that the insects are poised on a vertical surface. By contrast, the creatures surrounding the gooseberry branch seem to rest on a surface that recedes in space, an effect heightened by the absence of shadows. Nonetheless, van Kessel's use of light is not immediately apparent, nor does it interfere with the work's compositional unity. Van Kessel arranges the insects for optimal identification of their respective species. His lighting complements this aim by clarifying the definition of each specimen.[50]

Most likely, this small, painted panel was once part of a larger group of pictures decorating the front of a cabinet of curiosities. The insects represented by van Kessel may have been preserved inside. Like a reliquary box, the painting seems to reveal the contents it conceals. Van Kessel's careful analysis of the world in miniature invites viewers to marvel at the wonders of nature as they consider the richness of God's creation. His fascination with insects, in particular, may have been enhanced by recent scientific advances in taxonomy.[51]

Even though this intimate painting of insects can encourage scientific exploration and inspire a deeper understanding of God's general revelation, it is also an incredible artistic illusion, able to trick the eye. Van Kessel's picture not only describes miniature things in precise detail, but it keeps them from changing by isolating these objects from time and space. In a sense, his brush has stopped the natural process. In the words of antiquity, *ars longa, vita brevis* — "The art is long, the life is short." His painted insects will outlast those found in nature, extending our enjoyment of their delicate beauty.[52] The illusionistic quality of van Kessel's presentation and its apparent power to halt the effects of time may have seemed almost as wondrous as the marvels of nature he represented.

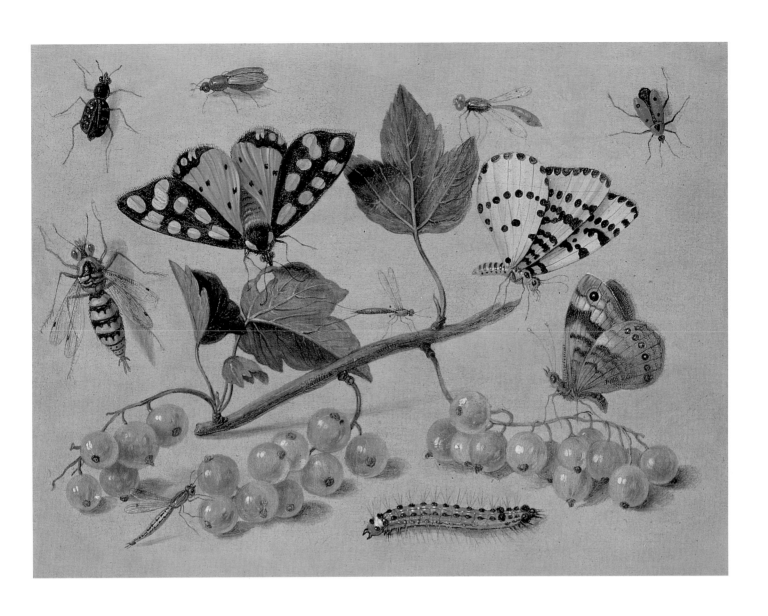

14 Nicolaes Maes
Dordrecht 1634-1693 Amsterdam

The Account Keeper
(The Housekeeper)

Signed and dated on a note to the right
Oil on canvas, 1656
26 × 21⅛ inches (66 × 53.7 cm.)
The Saint Louis Art Museum, Purchase

The son of a Dordrecht merchant, Nicolaes Maes was born in January of 1634. According to the eighteenth-century biographer Arnold Houbraken, Maes studied drawing under the supervision of an unknown local master. In the late 1640s he moved to Amsterdam. Around 1650 he appears to have entered the workshop of Rembrandt van Rijn. Three years later Maes returned to his hometown of Dordrecht, where he would remain for over twenty years. In 1654 he married Adriana Brouwers, the widow of a Calvinist preacher. The couple had three children. Throughout the 1640s and 1650s Maes painted domestic interiors, most of which show the influence of Rembrandt.

Sometime in the early or mid 1660s, Maes apparently traveled to the Southern Netherlands to study the works of Pieter Paul Rubens and other Flemish painters. While there he visited the artist Jacob Jordaens in Antwerp. Upon his return to Dordrecht, Maes's style of painting changed dramatically. He began to concentrate on portraiture of wealthy merchants, and he used brighter colors. His later paintings resemble those of Anthony van Dyck more than those of Rembrandt. Apparently Maes became quite successful as a portraitist. Sometime prior to 1673 he settled back in Amsterdam. He would remain there until his death in 1693.[53]

Nicolaes Maes painted the *Account Keeper* a couple of years after leaving Rembrandt's studio and shortly after his return to Dordrecht. The subject of his painting is somewhat ambiguous. In 1973 Eddy de Jongh argued that Maes's picture is an admonition against greed, for the woman is surrounded with coins and hefty ledgers.[54] Behind her is a map of the world, alluding to her worldliness and the great lengths of her avarice. Left of the map, a medallion bust of Juno, the omnivoyant goddess of commerce, witnesses her international aspirations with disapproval.

More recently, William Robinson challenged this interpretation of the picture, pointing out that the woman is asleep. Traditionally, in depictions of greedy money changers, the misers are shown counting their possessions or staring at their apparent wealth. In Maes's painting, however, the account keeper sleeps instead of performing her duties. Consequently, the issue at hand, says Robinson, is sloth rather than avarice. The strong chiaroscuro and pale palette, in conjunction with the clarity and balance of the composition, evoke a serenity conducive to sleep.[55] Throughout the 1650s, Maes explored the theme of a sleeping woman.[56]

In addition, the unattended keys hanging from the wall behind her may allude to the neglecting of duties, for keys are traditionally associated with responsibility. Living in Dordrecht, the site of the famous Synods of 1618-19, and married to the widow of a Reformed minister, Nicolaes Maes would have been quite familiar with the Calvinist belief that faith without works is dead. Local patrons would also be quick to warn against the evils of laziness. The bust of Juno and the map could also suggest commercial ventures irresponsibly lost.

Even though this work can evoke notions of sloth, this does not eliminate the possibility that the painting also alludes to the dangers of avarice. Her slumber may have been caused by her greed. As Simon Schama has noted, to receive wealth was considered a blessing from God in the seventeenth century, but it was also a potential curse, for it is easier for a camel to go through the eye of a needle than for a rich person to enter heaven.[57] The woman in Maes's picture may have been working so hard in her pursuit of wealth that she has fallen asleep to the world around her. Maes's painting is open-ended enough to accommodate both interpretations. Regardless of whether she is preoccupied with the accumulation of earthly treasures or wrapped up in her lethargic sleep, the account keeper has apparently abandoned the keys of heaven and is lost in her dreams.

Maes's painting of the slumbering old woman is also somewhat unconventional. The sleeping women in seventeenth-century paintings are usually young women in their teens or twenties. But Maes's account keeper is quite elderly. Furthermore, although in allegories the vices are represented traditionally as women in emblematic prints, it is exceedingly rare to see women employed as money changers or accountants in Dutch paintings. Typically, misers are depicted as men, and most of these figures are old men. In cases where women are present, they are usually accompanying their money-changing husbands. Most of them sit or stand in close proximity to devotional books instead of account ledgers. The old woman in Maes's painting lacks a husband and prayer books. In her sleep, she is both negligent and imprudent.

Although the message of Maes's painting is admittedly quite moralizing, viewers, nonetheless, probably also found humor in the account keeper's predicament. Not only does his painting offer opportunities to take pleasure in the defects of someone else, but it provides observers a chance to laugh quietly at themselves. The peaceful quality of the composition encourages viewers to empathize with her condition, while the details of his painting remind them of the importance of staying awake and vigilant.

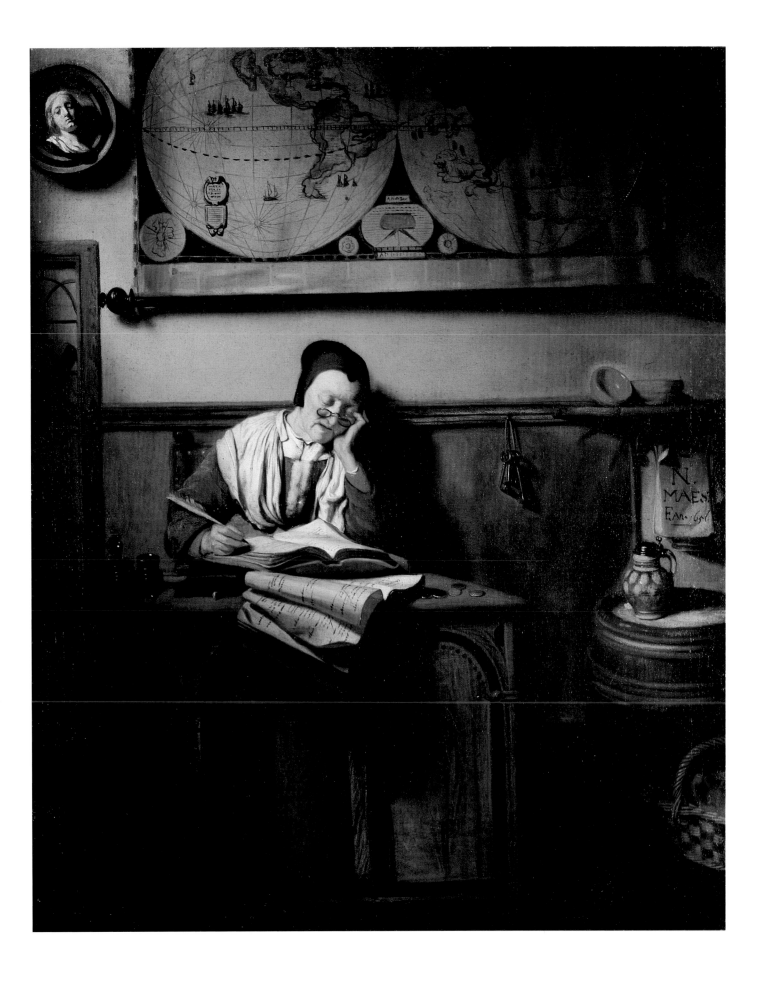

15 Gabriel Metsu

Leiden 1629-1667 Amsterdam

A Musical Party

Signed and dated on the lower left on the
piece of sheet music
Oil on canvas, 1659
24¼ × 21⅜ inches (61.6 × 54.3 cm.)
The Metropolitan Museum of Art
Gift of Henry G. Marquand, 1890
91.26.11

Gabriel Metsu was the son of a Flemish
painter, Jacques Metsue, and his third
wife, Jacquemijnte Garniers. Two months af-
ter Gabriel's birth, his father died. According to
biographer Arnold Houbraken, Metsu studied
the art of painting with Gerard Dou. Although
this may be the case, for reasons unknown,
Metsu does not seem to appropriate Dou's
fijnschilderij immediately. Throughout his res-
idence in Leiden, Metsu employed a rather
fluid technique with little concern for intimate
details. Nonetheless, like Dou, he was a found-
ing member of the Leiden Guild of St. Luke in
1648.

In 1657 Metsu moved to Amsterdam,
where a year later he married Isabella de
Wolff of Enkhuizen, the daughter of artist
Maria de Wolff-de Grebber and a relative of
Pieter de Grebber, a painter of classical
themes from Haarlem. While in Amsterdam,
Metsu imitated the highly polished work of
Dou. But he seems to have had multiple in-
terests, for his Amsterdam paintings can be
quite eclectic, at times resembling the work
of Gerard ter Borch and Pieter de Hooch. He
may also have been influenced by two
Utrecht painters, Jan Weenix and Nicolaus
Knüpfer. Perhaps it is best to view Metsu as
an artist who experimented with numerous
styles. Unfortunately, his efforts were cut
short. Metsu died in Amsterdam at the
young age of thirty-nine.[58]

In the *Musical Party* Metsu depicts an informal gathering of extravagantly
dressed musicians preparing to play. Near the center of the picture, a woman in
satin holds an upturned lute as she rests her arm on a table covered with a Turkish
carpet and carelessly tossed songbooks. With her right hand she extends a song-
book toward a man leaning on a windowsill. On the far right, another man tunes
his violoncello. Meanwhile, in an adjacent room a maid can seen through a door-
way, carrying a tray and a ceramic jug.[59]

Suggestions of excessive passion can be found throughout the warm-colored
picture. The open chest on the lower left reveals even more sheets of music, imply-
ing that the romantic play is overdone. The sword and bandolier located on a cush-
ion in the lower right are abandoned, suggesting the disarming quality of any ap-
parent love. A foot warmer under the lady's skirt may allude to the intensity of her
passion, which neither potential suitor is likely to satisfy. Finally, the bound cary-
atid decorating a fireplace in the background may be interpreted as an allegory
warning viewers of the dangers of extreme passion, unrestrained by reason.[60] Per-
haps the presence of two suitors is itself an allusion to erotic excess.

Traditionally, music has often been associated with love and romance. In this
painting the actions of the musicians preparing to play seem to elicit amorous pro-
posals. The lute held in the center of the picture may have erotic connotations. In
Dutch culture, the word *luit*, or lute, can also be used as a vulgar reference to a
woman's sexuality. Lutes are typically depicted in painted brothel scenes, but the
instrument was also commonly associated with courtship rituals. Consequently, its
meaning can be quite ambiguous. The carefree manner in which Metsu's woman
holds her instrument may imply flirtation, but it is difficult to determine whether
she will offer to play her lute or coyly withhold it. Other questions arise while view-
ing Metsu's painting. Will the man near the window accept the woman's invitation
to make music? Is the other man tuning his instrument in anticipation of a lover?
Is she the woman in the center of the picture or a woman unseen? Will he be able to
play, or is he doomed to fail? Will any of these proposals lead to harmonious love,
or are they simply fleeting moments of infatuation? Will the entrance of the maid
interrupt any possibility of romance? Should she? Or will her service only intensify
amorous feelings? Metsu refuses to answer questions such as these, leaving it for
the observer to decide.

Like ter Borch, Metsu seems to withhold his intentions, leaving his picture
open-ended enough to promote imaginative engagement. The viewer is encour-
aged to complete the central narrative. Although the painting may caution observ-
ers about extreme passion and encourage moderation in matters of the heart, it is
more than a visual sermon. The rich ambiguity of the picture entices viewers to
keep looking as they imagine possible narratives in conjunction with Metsu's work.
His painting does not invite a precise interpretation or a single meaning, but delib-
erately keeps the narrative structure of his composition loose enough to elicit a va-
riety of responses. This is not to say, however, that Metsu's picture is amoral. On
the contrary, the artist arranged his work in such a way that viewers are given
greater responsibility. Metsu makes numerous allusions to the excesses of love and
romance throughout his image, but ultimately he asks observers to choose for
themselves which path love should or should not take.

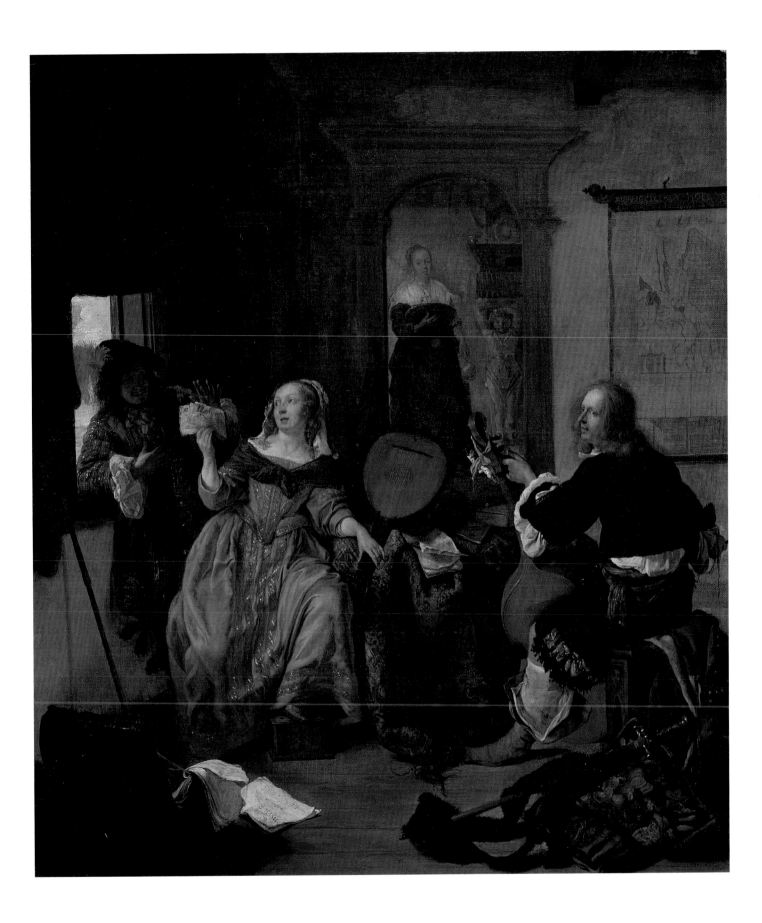

16 Willem van Mieris
Leiden 1662-1747 Leiden

*Portrait of a Gentleman in
Classical Dress*

Signed middle right and dated
Oil on panel, 1706
10 × 8¼ inches (25.4 × 21 cm.)
Private Collection

Born in Leiden, site of the oldest university in Holland, Willem was the second son of Frans van Mieris the Elder. His father studied under Gerard Dou, the founder of the *fijnschilderij* (fine-painting) style. Like Dou, Frans van Mieris painted highly detailed works that concealed their own making. Both Willem and his older brother Jan were trained by their father, who taught them the art of *fijnschilderij*. Throughout their lives, Willem and Jan continued to paint in the style of their father.

In 1685, four years after his father's death, Willem was admitted to Leiden's Guild of St. Luke. In 1699 he became dean of the guild. Willem van Mieris painted shopkeeper scenes and portraits as well as works based on religious and mythological themes.[61] He also worked in a variety of media. Not only did Willem van Mieris produce drawings, paintings, and engravings, but he also made images in wax and clay. Between 1702 and 1704 van Mieris produced ornamental vases decorated with scenes of the four seasons in bas-relief for Allard de la Court van der Voort, for whom van Mieris also made numerous paintings copied after those of his father.[62]

Early in his career, Willem van Mieris produced works that closely resembled those by his father and Gerard Dou. In time, however, his style underwent alteration. Though van Mieris still worked in a *fijnschilderij* fashion, his colors and modeling became cool and stiff. In his later work he seems to combine a preoccupation with individual nuance and intimate detail, grounded in the tradition of Dou and his father, with a fondness for classical notions of universal beauty and heroic allegory.

Willem van Mieris probably lived his entire life in Leiden. There is no evidence that he ever left. Around 1736, van Mieris went blind, leaving his son and former pupil Frans to complete his unfinished works. Even though van Mieris died in 1747, the legacy of *fijnschilderij* would continue to affect painting in Leiden well into the nineteenth century.[63]

In this painting, the sitter remains unknown. In 1928 Cornelis Hofstede de Groot suggested that the picture portrayed a Scottish architect from the Paterson family. Although the Paterson family owned van Mieris's painting, it is unlikely that the work represents an architect.[64] The unknown sitter in this portrait is dressed in classical attire and surrounded by drawings and sculptures. Architecture seems to play only a minor role in this painting. One of the sculptures represented in this work resembles the Belvedere torso, a famous marble fragment from classical antiquity. The presence of drawings and sculptures suggests that the sitter was either an artist or a connoisseur of the arts. A piece of chalk on the left edge of the tabletop implies that the drawings, though in classical style, are more recent than the sculptures behind them.

Throughout the seventeenth and eighteenth centuries, many sitters had themselves portrayed in the guise of biblical or mythological figures. In this case, the sitter wears a classical garment, but it is impossible to determine which particular figure from Graeco-Roman history or legend he hoped to imitate. Perhaps the sitter simply wished to look cultured and did not desire to mimic any specific person from the past. Even though the reference of the allegorical portrait remains elusive, van Mieris's painting unveils a renewed fascination with classicism, which would have appealed to Leiden's academic community. The gestures of the sitter also reveal a scholarly interest.

Since the early sixteenth century, Italian artists and writers debated the ideals of *paragone*, or the relative value of painting and sculpture. Not surprisingly, painters claimed that painting was superior to sculpture, while sculptors argued the greater merits of sculpture. Those more sympathetic to sculpture sometimes contended that sculpture was more real than painting. Through touch, even a blind man could recognize the truth of this insight, for whereas he could understand what sculpture represented, his experience of a painting would be nonsensical. As Peter Hecht has shown, by the seventeenth century, painters poked fun of this argument. Using irony as an effective weapon, they depicted blind men comparing painting and sculpture, exposing the practical folly of accepting such a theory. The aim of their jest was not, however, to reestablish the triumph of painting in a hierarchy of the arts. Rather, it was intended to convey their relative equality while it humorously exposes the pointlessness of such debates. Merit, they claimed, was not determined by media but by artistic excellence.[65]

Van Mieris, an artist who appears to have been a gifted painter and sculptor, seems to criticize the tradition of *paragone* as he appreciates the beauty and verisimilitude of classical works of art. Although the sitter in van Mieris's painting is not blind, he looks away from the objects he fondles. His left fingers grasp the top of the Belvedere torso as those on his right hand touch classical drawings resting on a tabletop. The sitter appears to appreciate the two equally, for although he touches the drawing with his right hand, the sculpture holds an elevated position. The sculptural relief to the right of the sitter represents the drunken Bacchus supported by a young satyr. Although the style of this work reveals an interest in classical form, especially in regard to optical naturalism, its meaning is somewhat ambiguous. The scene can elicit notions of inspiration and the power of transformation, positive attributes typically associated with the Roman god of wine, but it can also convey negative ones such as lust, foolishness, and the loss of reason. In van Mieris's painting, the sitter looks away from the relief, hinting at the disapproval of Bacchus and the qualities he represents.

17 Pieter Molijn
London 1595-1661 Haarlem

Landscape with an Open Gate

Oil on panel, ca. 1630
13¼ × 18⅞ inches
National Gallery of Art, Washington
Ailsa Mellon Bruce Fund and Gift of
Arthur K. and Susan H. Wheelock
1986.10.1

The landscape painter Pieter Molijn was born to Flemish immigrants in London. Unfortunately, little else is known about his youth. The dates of his departure from England and immigration to the Netherlands are undocumented. Information surrounding his artistic training is also missing. The first recorded evidence of Molijn's presence in Holland is the appearance of his name in the 1616 registry of the Haarlem Guild of St. Luke. Between 1630 and 1649 Molijn regularly served as the administrator of the painter's guild. In 1624 he married a local woman, Mayken Gerards, and joined one of Haarlem's civic militias. Molijn may occasionally have collaborated with Frans Hals, painting background landscapes to accompany Hals's portraits. Gerard ter Borch and, likely, Allart van Everdingen served as his apprentices.[66]

Throughout his career, Molijn employed a limited palette and abbreviated brush strokes. The style of his work resembles that found in the tonal landscapes of Esaias van de Velde, Jan van Goyen, and Salomon van Ruysdael, who also worked in Haarlem. Many of Molijn's paintings depict rural roads and rustic dunes seen from a low vantage point.[67]

In *Landscape with an Open Gate,* Pieter Molijn represents a dilapidated barn and a dead oak tree covered by vines, behind an old, rickety fence. On the hillcrest of a countryside road crossing a dune, Molijn paints a distant shepherd approaching with his flock. Behind the fence on the far right, he depicts a somewhat more mysterious figure, who seems to acknowledge the viewer's presence. Molijn's vigorous brushwork provides a sense of immediacy as it reveals the dynamic qualities of an animated wind. The strong diagonal accent raking across his composition gives the work pictorial unity and heightens the dramatic effect of the scene. His use of sunlight also intensifies the viewer's experience.

An open gate encourages observers to take a meditative journey, to let their eyes travel across the landscape. The rustic scene can stimulate beholders, both then and now, to use their imaginations or reminisce nostalgically about a simpler life. Molijn's painting could also be viewed in moralizing terms. The nearby dead tree with distant healthy ones in the background may have been interpreted in light of Roemer Visscher's popular emblem *Keur baert angst,* "Choice causes anxiety." The emblem's inscription is accompanied with an illustration of a dead tree juxtaposed with a hearty one in front of an old fence. Like Visscher's illustrated emblem, Molijn's painting may have suggested the difficulties posed by moral dilemmas, asking viewers whether they should pass the gate or welcome the oncoming stranger. The dead tree in his painting could also evoke images of the Fall and the transience of life.[68]

Instead of representing polderlands recently reclaimed from the sea, Molijn produces a plausible fiction of an older Dutch terrain with well-seasoned, decaying structures. Contemporary paintings and literary works like Molijn's *Landscape with an Open Gate* were often described as *schilderachtig,* or picturesque. The term could be applied both to Molijn's rough painterly technique and the rustic subject matter of his painting. In comparison to classical imagery, Molijn's picturesque painting is seemingly artless in its informality. The sense of immediacy conveyed by his animated brushwork appears relatively unplanned and without much design. Rather than represent extraordinary locations or heroic moments of grandeur, Molijn depicts a rather commonplace scene with simple folk. He explores the contingent qualities of the landscape. Molijn focuses on the effects of weather and the passage of time, dimensions of life outside human control.

His picturesque style possesses a greater sense of freedom than does classicism, for it is without a strong set of prescriptive rules. This need not imply that Molijn's work is either crude or unsophisticated. On the contrary, it is a product of cultivated taste. His application of paint is not lazy or poor. Molijn carefully selects the proper pigments to make his tonal landscapes and sensitively works his brush to convey the immediacy of the scene. His art is designed to look unmannered, to have the spontaneity of nature. The apparent directness of his technique reinforces the rhetorical aim of his painting, persuading viewers to delight and learn from the simplest of places.[69]

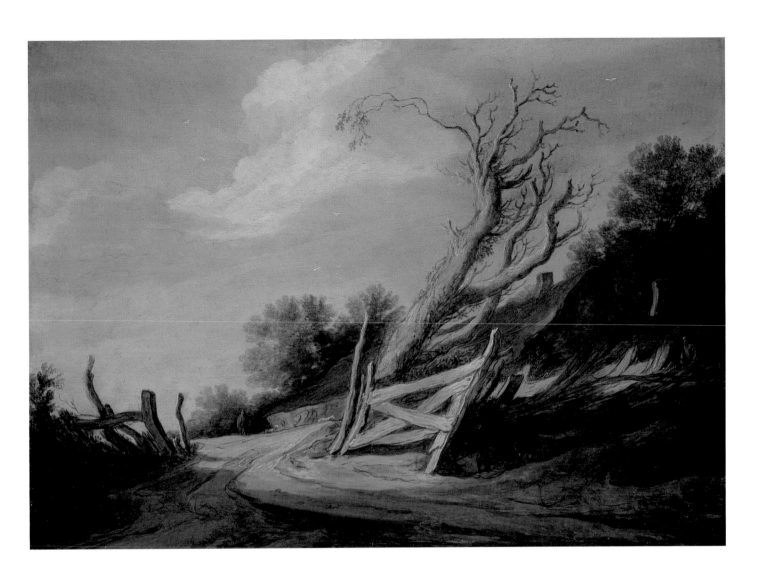

18 Isaak Ouwater

Amsterdam 1750-1793 Amsterdam

View of the Spui at Delft Bridge, The Hague

Signed and dated
Oil on canvas, 1786
16½ × 21 inches (41.9 × 53.3 cm.)
Private Collection

Very little is known about the eighteenth-century streetscape painter Isaak Ouwater. Although much about his artistic training remains clouded in mystery, his work repeatedly shows interest in the seventeenth-century townscape paintings of the Berckheyde brothers and Jan van der Heyden. In fact, many of Ouwater's civic views seem to have been inspired by van der Heyden. He painted scenes from numerous Dutch cities, including Amsterdam, Delft, Edam, Haarlem, The Hague, Hoorn, and Utrecht, suggesting that Ouwater traveled throughout the Netherlands.[70]

Many of his paintings provide rather accurate descriptions of buildings and canals seen from eye level. Ouwater's attention to details not only conveys his preoccupation with optical naturalism, but it also reveals his antiquarian interests in the historical value of seventeenth-century cityscapes and the places they represent.[71] The clean and pristine quality of his scenes invites local pride at a time of political instability, economic crises, and social unrest. After the defeat of the Dutch commercial fleet in 1780, Dutch colonies and trade interests were placed at the mercy of the English.[72] At home, tensions between burger-regents and the House of Orange increased dramatically. None of these problems, however, is shown in Ouwater's paintings, which appear innocent of all strife.

In this work, Ouwater depicts the Delft Bridge, a drawbridge, over the Spui, an important waterway leading out of The Hague toward Delft. His vantage point for the painting is easily identified and is taken from the Groene Wegje, opposite the Bierkade. The large building on the right is the Armhuis, or poorhouse, an edifice that no longer exists.[73] Within this charming panorama, fashionable pedestrians enjoy a morning stroll. A gentleman in uniform greets an attractive governess, who is watching two children. The elder child is playing *hoepel*, chasing a wheel with a stick. Another child, presumably his sister, uses a device intended to teach toddlers how to walk. She wears a protective headpiece to keep her from serious injury.

These affluent pedestrians stroll near the city's poorhouse, but there are no signs of poverty anywhere in Ouwater's painting. The streets and canals are shown to be safe and clean. In addition, the exteriors of the poorhouse and adjacent buildings appear freshly bricked, without any indication of pollution. The purity found throughout the picture encourages viewers to see The Hague, the seat of the Dutch Republic's government, as an ideal community of wealth and virtue, where people politely greet one another and well-dressed children can learn and play with little risk of harm. The architectural facades, tidy and well kept, evoke a sense of the eternal, implying that life there has always been clean and will remain so. Ouwater's representation, though produced during tough times, continues in the tradition of seventeenth-century Dutch cityscapes by promoting this local scene as an exemplary place, both affluent and pure.

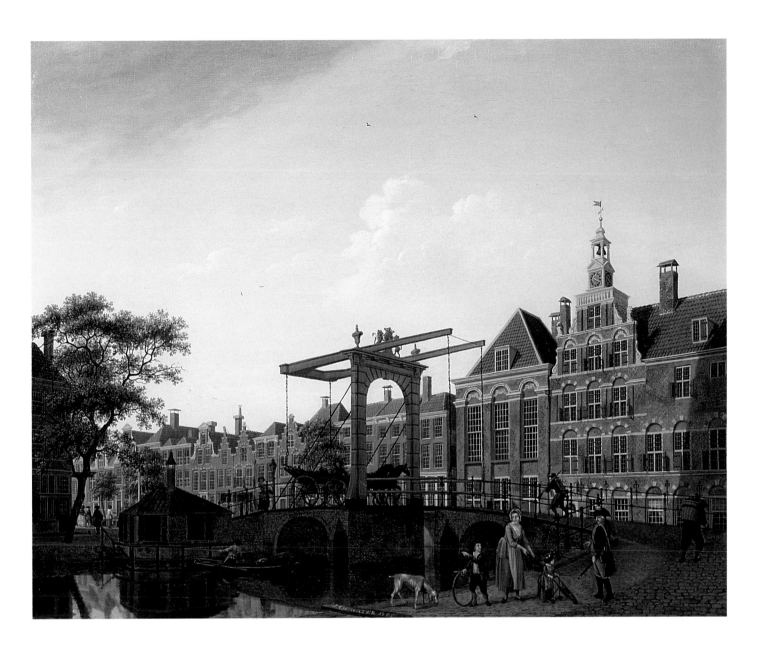

19 Jacob van Ruisdael

Haarlem ca. 1628-1682 Haarlem

Farm and Hayricks on a River

Signed with monogram on lower right
Oil on canvas, ca. 1650
15¼ × 20⅛ inches (38.9 × 51.3 cm.)
The Detroit Institute of Arts
Gift of Mr. N. Katz
37.21

The precise date of Jacob van Ruisdael's birth is unknown, though a later document states that he was thirty-two in June of 1661. His father, Isaack Ruysdael, was an ebony frame maker, art dealer, and tapestry designer, who came to Haarlem from Naarden. At the time of Isaack's birth the family surname was de Goyer. Sometime early in the seventeenth century, Isaack's eldest brother Jacob called himself van Ruysdael, after the castle of Ruysdael near Blaricum, where his father had previously resided. In time Isaack and his younger brother, the landscape painter Salomon, also adopted the name. Although Isaack and his brothers went by the name van Ruysdael, his son Jacob consistently spelled it van Ruisdael.

Jacob van Ruisdael probably studied painting under his father and uncle. During this time Jacob also came to know Jan van Goyen, who stayed in Isaack van Ruysdael's house while working in Haarlem. He also appears to have become quite familiar with the work of Cornelis Vroom, a Haarlem painter of wooded landscapes.

Around 1651 he traveled to Westphalia near the Dutch-German border with his close friend, the Italianate landscape painter Nicolaes Berchem. Although the journey provided new sites for van Ruisdael and Berchem to paint, the trip did not bring their styles closer together. A few years after his *Wanderjahre* with Berchem, van Ruisdael moved to Amsterdam.

Although he was brought up in a Mennonite family, van Ruisdael became a baptized member of the Reformed Church in 1657. Two years later he became a citizen of Amsterdam. During this time van Ruisdael came into contact with the work of Allart van Everdingen. In the mid-1660s, he would imitate Everdingen's rushing waterfalls and mountainous landscapes. Van Ruisdael nonetheless remains better known for the towering windmills, enlivened cemeteries, and expansive bleaching fields found in his later work.[74]

This painting was produced early in van Ruisdael's career and likely predates his trip to Westphalia with Berchem. In this work, a boat drifts down a river past farmhouses as it approaches haystacks. Although the landscape seems rather commonplace and unpretentious, it contains great power. In comparison to the tonal landscapes of Jan van Goyen and Pieter Molijn, Jacob van Ruisdael's presentation of nature is far more heroic. The contrast between highlight and shadow is more pronounced in his work. Van Ruisdael also applies thick paint in areas of highlight, giving his illuminated forms a sense of vitality and freshness. From a slightly elevated vantage point, he reveals the small waves and undercurrents of a river, as reflections dance upon the water's surface. Above the estuary, clouds sweep diagonally across the sky in patterns parallel to the farmhouses' rooflines. A group of rugged trees tower over the houses, conveying their vitality and grandeur.

Throughout the composition, van Ruisdael effectively balances dynamic and static elements. The monumental haystacks, rustic houses, and distant church spire provide stability to the scene, keeping the forces of nature in check. In the dense and scraggly foliage around the river's bank, wild and cultivated spaces subtly interplay in equilibrium. Van Ruisdael also unveils the irregularity of nature by showing the individuality of each gnarled tree. His landscape seems to evokes a dialectical tension between tranquility and excitement. It conveys the mutability of nature by suggesting the changing of seasons and weather patterns. His painting also alludes to the transience of nature by alluding to the effects of cultivation and the organic cycle of life.[75]

In van Ruisdael's work, concerns for content and form are intertwined. The landscape is designed both to please the eyes and to awaken the imagination. Although the work is based on his observations of nature, it is arranged to produce dramatic effects. His painting invites viewers to meditate on the "Book of Nature" and to discover the extraordinary power found in the simplest of places. The dynamic force of the river, clouds, and trees implies the presence of the divine as it encourages beholders to contemplate the mutability of nature and the transience of human life, as they delight in the rustic grandeur of van Ruisdael's painted scene.[76]

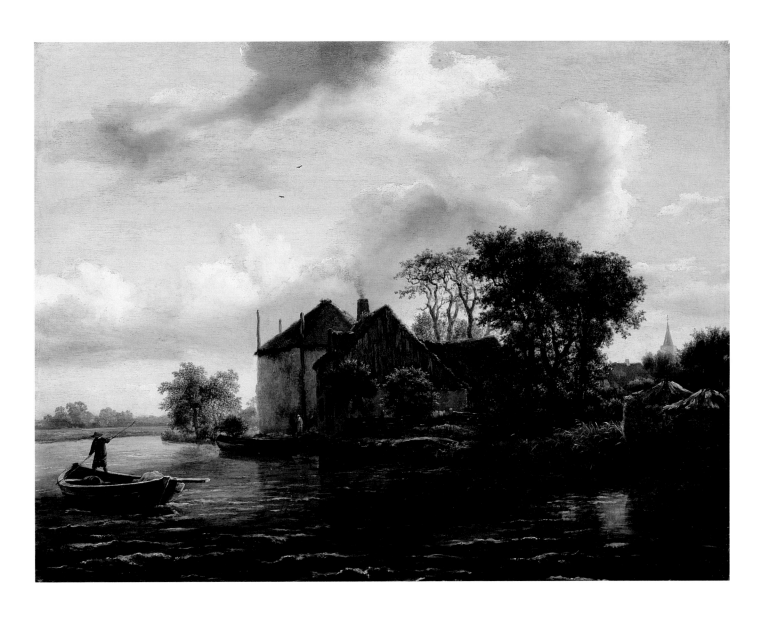

20 Salomon van Ruysdael
Naarden 1600/3-1670 Haarlem

Landscape with Travelers

Signed with monogram
Oil on panel, ca. 1640
24 × 22 inches (61 × 56 cm.)
Grand Rapids Art Museum
Gift of Booth Newspapers, Inc., in memory
of George G. Booth, Ralph H. Booth, and
Edmund W. Booth,
1950.1.3

Salomon van Ruysdael was named Salo-
mon de Goyer at his birth, after the Gooi-
land near Naarden. As an adult, however,
Salomon, along with two of his elder broth-
ers, Jacob and Isaack, changed his surname to
van Ruysdael, after a castle near his father's
home.[77] Van Ruysdael moved to Haarlem
sometime prior to 1623, the year he entered
the city's painters' guild. Even though there
are no written records regarding his artistic
training, stylistic evidence supports the view
that van Ruysdael may have studied with
Esaias van de Velde, who worked in Haarlem
from 1609 to 1618. In addition, van Ruysdael
seems to have maintained close ties with Jan
van Goyen and Pieter Molijn, two Haarlem
painters often associated with van de Velde.
Like van Goyen and Molijn, van Ruysdael is
best known for his tonal landscapes, repre-
senting the local countryside in simple diago-
nal compositions in monochromatic color.

Van Ruysdael was a Mennonite and be-
longed to the church's United Flemish,
High-German, and Frisian community in
Haarlem. During his career, he probably
taught his famous nephew Jacob van Ruis-
dael the art of painting. Salomon's son Jacob
Salomonsz. van Ruysdael also became a
painter and quite likely studied under his
father's tutelage. Although Salomon van
Ruysdael traveled extensively throughout
the Netherlands, his landscapes consistently
suggest the topography surrounding Haar-
lem. The city of Haarlem appears to have re-
mained his hometown until his death in
1670.[78]

During the early 1640s Salomon van Ruysdael painted numerous canal scenes
and landscapes with travelers resting before an inn. Many of these works are
arranged in a horizontal format. In this painting, however, there is no canal or inn
to be seen and the picture is vertical rather than horizontal. Nonetheless, *Landscape
with Travelers* shares many stylistic features with these other tonal paintings. It pro-
vides a vivid description of the local terrain in local color. A country road sweeps
across a rural landscape. As evening approaches, a group of well-dressed travelers,
accompanied by dogs, horses, and a covered wagon, advance toward a herdsman
with two cows. In the distance, a lone traveler can be seen walking with his dog.

Salomon van Ruysdael limits his palette to the use of greenish browns and
places the horizon line of his landscape quite low. Like the rhetorical style of "plain
speech," van Ruysdael's style appears to be direct and spontaneous. Its naturalistic
presentation suggests notions of simplicity, for it seems to lack the supplements of
ornament. Despite its apparent artlessness, however, the painting is highly artifi-
cial. The artist has subtly employed conventional techniques to encourage such a
rhetorical effect.[79] The vibrancy of his brush strokes reinforces the suggestion of
immediacy. Van Ruysdael heightens the sense of drama by extending a darkened
strip of *repoissoir* across the painting's foreground and by stretching the monu-
mental trees across the left margin of the scene. The juxtaposition of highlight and
shadow, added to the heroic quality of van Ruysdael's trees, invites the viewer to
further contemplation.

The painting asks observers to make interpretive decisions. Within the work,
figures remain anonymous and the narrative remains implicit, leaving it open for
the viewer to use her or his imagination. Van Ruysdael's landscape appears to invite
beholders to participate in a contemplative journey with their eyes.[80] It encourages
observers to consider the quiet grandeur of the commonplace, that space between
the wild and the tame which is often overlooked. The vertical format of the picture
directs attention to the scene, keeping viewers from wandering elsewhere. Such
meditational travel can evoke notions of the simple life, invite nostalgic memories
of the past, and promote local pride. It can also elicit metaphorical associations
concerning the journey of life and the juxtaposition of freedom and nature.

21 Pieter Jansz. Saenredam
Assendelft 1597-1665 Haarlem

View from the Aisle of Sint Laurenskerk, Alkmaar

Signed and dated in the inscription on the organ case
Oil on panel, 1661
21⅜ × 17⅛ inches (54.4 × 43.5 cm.)
Museum Boijmans van Beuningen, Rotterdam
36.1849

Pieter Jansz. Saenredam was born in the small village of Assendelft and baptized in the Reformed Church there. His father, Jan Pietersz. Saenredam, a famous engraver and draughtsman working in the mannerist style of Hendrick Golzius, served the local church as a deacon and later as an elder. Jan Pietersz. probably introduced his son to the art of drawing. Unfortunately, he died shortly after Pieter reached the age of nine.

After Jan Pietersz.'s death, the Saenredam family moved to Haarlem, a city about seven miles away from Assendelft. In Haarlem, Pieter studied with a portrait painter, Frans Pietersz. de Grebber. His apprenticeship lasted ten years, from 1612 to 1622. During this time Saenredam also came into regular contact with architects residing in Haarlem, including Salomon de Bray, Pieter Post, and Jacob van Campen, designer of the Mauritshuis and the Town Hall of Amsterdam. His relationships with these prominent architects likely encouraged Saenredam to produce paintings of architectural scenes. Nonetheless, it was probably a local mathematician and surveyor, Pieter Wils, who taught Saenredam the principles of linear perspective. In 1623 Saenredam joined the Haarlem Guild of St. Luke. From that point on, he concentrated on painting illusionistic representations of church interiors and exteriors.[81]

During the seventeenth century, architectural paintings were often called "perspectives," a term that connotes a strong interest in optical naturalism. They must have been quite prized as paintings, for perspectives fetched high prices and were collected by wealthy and prestigious patrons.[82] Most of the individuals purchasing this type of painting belonged to the patrician class of the Dutch Republic or foreign nobility. One of these collectors, Constantijn Huygens, secretary to the House of Orange, even wrote poetry about Saenredam's work.[83] Needless to say, Saenredam appears to have been extremely popular as a painter and does not seem to have ever suffered financial difficulties.

Throughout his career, Saenredam painted churches in Alkmaar, Amsterdam, Assendelft, Haarlem, 's-Hertogenbosch, Rhenen, and Utrecht. Although these ecclesiastical structures were initially constructed as Catholic churches, by the seventeenth century they were functioning primarily as places for Calvinist worship. Confiscated by Calvinists, these churches were whitewashed and cleansed of "false idols." Saenredam was an artist with strong antiquarian interests.[84] On some occasions he reconstitutes his church interiors to reveal the historical past. His paintings usually do not unveil the search for a "Protestant" church interior. Nor do they typically show the antithesis between Calvinist and Catholic liturgies. His interest seems for the most part ecumenical in spirit.[85]

View from the Aisle of Sint Laurenskerk, Alkmaar is one of his last paintings. Saenredam had visited the church before in the 1630s to measure the church organ as a favor to its designer, Jacob van Campen. Two of his drawings of the St. Laurenskerk still exist, one displaying van Campen's grand organ case and the other showing the tomb of Count Floris V of Holland.[86] Unfortunately, no drawing from the aisle survives.[87]

His presentation of this marginalized space is quite astonishing, as viewers see through two doorways leading toward an intimate cloister.[88] The small figures on the extreme right accentuate the immense scale of the building and draw attention to the massive column. Not only does Saenredam employ linear perspective with great skill, but he is also a gifted colorist. His delicate application of pink, yellow, and white pigments with a dry brush produces a strong tactile appeal, whereby observers seem to touch the structure with their eyes.

Above the doorway Saenredam painted the shutters of a small organ. At the time of Saenredam's painting, the organ pipes had been removed. Only the organ's protective panels remained. On these shutters he depicted musicians, in accordance with proper decorum for a organ. Left of the column he painted two elongated pipes leading to an ornamental bearded head. This hanging object likely served as a musical instrument. When struck, it sounded like a drum. The open-mouthed wooden head, called a *gaper,* seems to bellow out the instrument's sound.[89]

Schwartz and Bok have recently suggested that the figures on the organ shutters are playing psalms composed by David and that the head of Goliath adorns the nearby pipes.[90] However, this need not be the case. The iconography can be explained by the functionality of the instruments without making explicit reference to the Old Testament musician and monarch. Nonetheless, this imagery may have invited such a response, encouraging observers to pay homage to King David and praise God in song. This would be especially true for Calvinists, who sang primarily psalms in worship.[91] The presence of the organ case in the center of his painting may have induced greater debate among Calvinists on the place of organ music in worship, for although strict theologians denounced it as a distraction from the Word, many churches continued to use it.[92] For viewers who knew that the case was empty, Saenredam's painting may have presented a challenge to consider the place of visual imagery in the church. It may also have invited them to reconsider whether visual images kept worshipers from hearing the Word. None of this discussion, however, denies that Catholic viewers would also have been affected by Saenredam's painting. His presentation of St. Laurenskerk, with its intimate cloister and beautiful small organ, may have moved them to lament or celebrate the church's past.

Saenredam's painting of the Alkmaar church entices viewers, regardless of denominational affiliation, to ponder the nooks and crannies of the building where Christ edifies souls. His subtle use of muted color, his attention to detail, and the crisp clarity of his forms evoke quiet contemplation of a place where grace is perpetually revealed. Although he does not advocate Catholicism or Calvinism per se, Saenredam's painting of St. Laurenskerk can elicit reverence and devotion among both types of Christians as it fosters local pride and promotes greater appreciation for artistic skill.

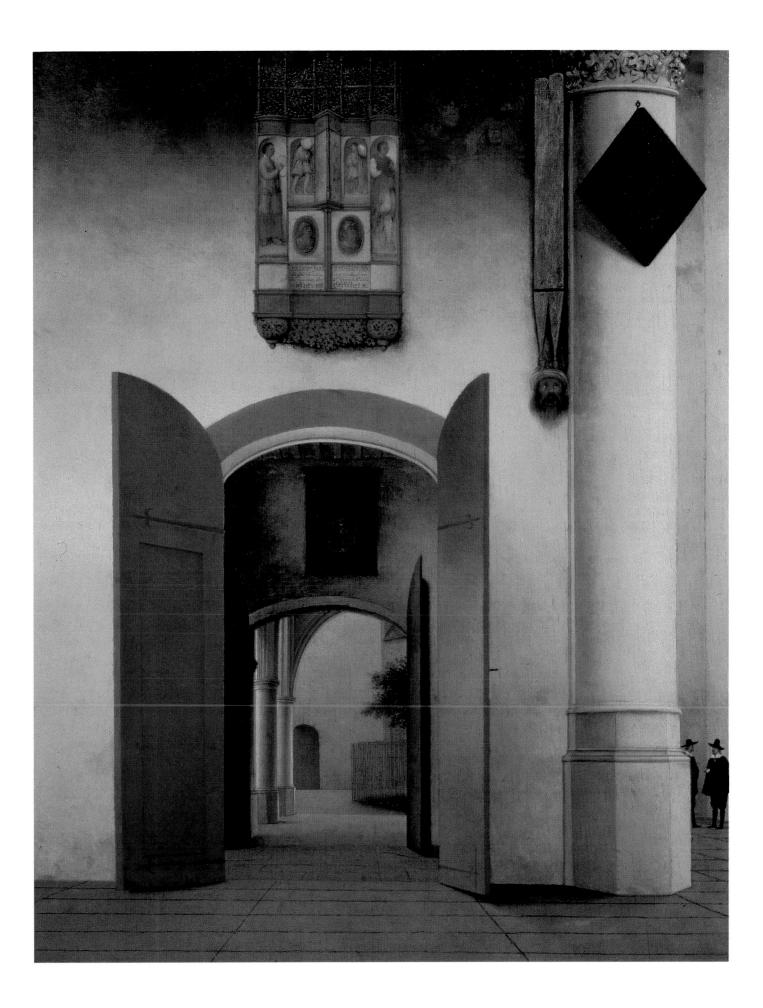

22 Joris van Son

Antwerp 1623-1667 Antwerp

Still Life with Fruit

Signed and dated on dark shield on upper right

Oil on canvas, 1659

15¼ × 21 inches (38.5 × 53 cm.)

Private Collection

Little is known about the Flemish still-life painter Joris van Son. He was baptized in Onze Lieve Vrouwe Kerk, the cathedral of Antwerp, in 1667. Although no records surrounding his training have been found, van Son's style of painting closely resembles that of Jan Davidsz. de Heem. Like de Heem, van Son produced works of rich coloration and vivid naturalism. The arrangement of fruit and flowers in their paintings is also very similar. Nonetheless, there is no evidence that van Son ever studied with de Heem, who had numerous Flemish imitators.

In 1643 van Son registered in the Antwerp Guild of St. Luke as a master painter. He likely worked with the still-life artist Jan Pauwel Gillemans the Elder. Without the presence of signatures, their paintings are difficult to distinguish from one another. Probably van Son also taught Jan Pauwel Gillemans the Younger to paint. In addition to his apparent friendship with Gillemans the Elder, van Son on occasion collaborated with the Antwerp artist Erasmus Quellinus the Younger, who, like Gillemans the Elder and van Son, closely imitated the work of de Heem. Unlike other Flemish still-life painters, however, van Son rarely depicted insects in his work.[93]

Contemporaries praised van Son for his skillfully painted flower and fruit paintings. They especially appreciated his polished technique and his meticulous attention to details. The poet Cornelis de Bie, in a simple play of words, compared him to the sun (Sonne). At the age of forty-three, Joris van Son died in the city of his birth.

Still Life with Fruit reveals van Son's ability to present a wide variety of surface textures while maintaining a harmonious composition. His painting is not designed to depict a meal; rather, it is arranged as a conventional type of display. Many of the objects in his painting can be interpreted symbolically. The meaning of these symbols, however, was not hidden. On the contrary, such inferences were easily recognizable to literate seventeenth-century Netherlandish viewers.

At a general level, fruit is often associated with fertility and abundance, with being fruitful. However, it can also allude to vanity, for its ripeness does not last. In addition, Christ is often called the fruit of Mary's womb, and wisdom is sometimes referred to as the fruit of the past. The illusionistic representation of fruit not only invites the sense of sight but also those of smell, touch, and taste. Even though van Son does not depict anyone in his painting, human presence is made known through the arrangement of the fruit on a table and plate. This is also conveyed by the broken piece of bread, partially empty glasses of wine, and the absence of one of the oysters from its half shell.

In many ways, van Son's painting evokes images of human experience. The Seville oranges on the left are exotic fruits, unable to grow naturally in the Netherlands. As items of luxury, their value is quickly spoiled. Furthermore, Seville oranges, like the apples of today, have traditionally been linked to the Fall as fruit from the Tree of Knowledge. Nonetheless, the orange could also have more positive connotations. It grew from a evergreen tree, suggesting immortality, and its taste is sweet and refreshing. The bitter lemon is also imported and can interpreted in terms of vanity. What appears beautiful on the outside may be sour on the inside. Yet, used in proper measure, lemon could improve the taste of wine and oysters. Cherries have erotic connotations, but their redness could also suggest the sacred passion of Jesus Christ. Sometimes cherries are considered "heavenly fruit." Joris van Son typically represents cherries in bunches of three, a gesture with trinitarian associations.[94] The absence of insects and decay heightens the picture's ambiguity, making it more difficult to distinguish good fruit from bad.

The nuts, comprised of husk, shell, and meat, may also allude to the Trinity. More specifically, walnuts, with two separate halves protected by a shell, can suggest Jesus Christ, who is both human and divine, though they can also connote the ideal marriage, the conjoining of equals. In addition, walnuts seem to encourage belief in transubstantiation, the real presence of Christ in the sacrament of the Mass. Walnuts were compared to the consecrated host, for in both cases the flesh is concealed by external appearances.[95] The presence of bread, grapes, and wine can also elicit the presence of the body and blood of Christ. However, the juxtaposition of white and red grapes, as well as that of a roemer of white wine and a flute of red, can also invite other associations, including drunkenness, overindulgence, and lust.[96]

The tears in van Son's painting may simply indicate the sweating of fruit, but they may also suggest a variety of human emotions ranging from intense joy to deep sorrow. They may allude to Christian charity, the compassion of Mary, the mystical longing to be with God, the cleansing waters of baptism, and proper preparation for the Eucharist.[97] The presence of tears in his painting could be intended to elicit the shedding of tears from empathetic observers, to reveal van Son's ability to deceive the eye, or, more likely, to promote both at once.

The oysters on the pewter plate, however, are less ambiguous. They are typically interpreted as aphrodisiacs. In conjunction with eucharistic symbols, the oysters, consequently, allude to unholy food. By extending the plate over the edge of the table, van Son gives the oysters a greater sense of immediacy, enhancing the desire to taste its sensual pleasures. The fact that one of the oysters has already been consumed reveals the initiation of sinful lust. Van Son's painting savors the imagination. It offers viewers numerous opportunities to choose between the false and fleeting sensual pleasures of earthly fruits and the eternal joys of the fruits of heaven. Yet he has deliberately left it open for the viewer to decide which of the items are sacred and which are profane.[98]

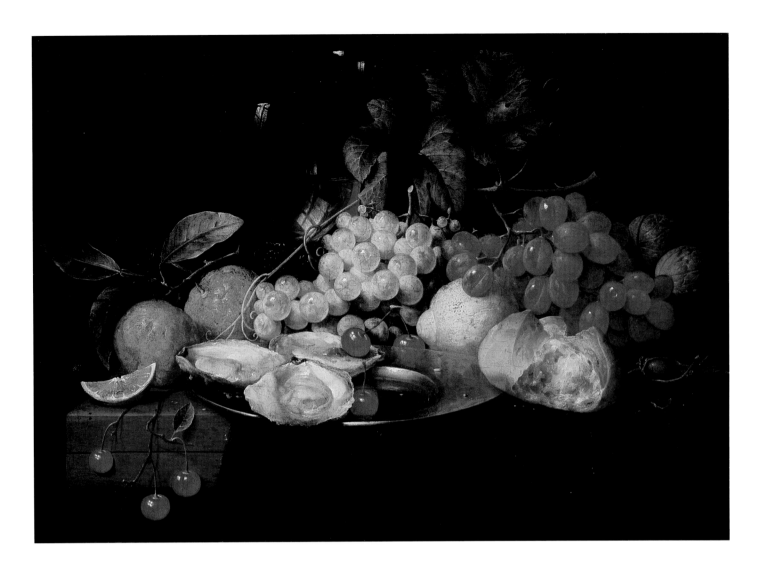

23 Jan Philips van Thielen
Mechelen 1618-1667 Boisschot

Bouquet in a Glass Vase

Signed on lower right
Oil on panel, ca. 1652
20½ × 14¾ inches (52 × 37.5 cm.)
Private Collection

Jan Philips van Thielen, the son of noble-man Librecht van Thielen, Lord of Couwenburgh, and his wife Anna Rigoults, was born in the Flemish city of Mechelen. At the age of thirteen, he studied under his brother-in-law, the Flemish still-life painter Theodoor Rombouts. Shortly after his apprenticeship with Rombouts, van Thielen became the pupil of Daniel Seghers in Antwerp. During this time he also married Francisca de Hemelaer, the sister-in-law of the Flemish painter and printmaker Erasmus Quellinus the Younger, with whom he would often collaborate. The van Thielens had nine children, and three of their daughters, Maria-Theresa, Anna-Maria, and Francisca-Catharina, became flower painters.

Around 1641 van Thielen became a master painter in the Antwerp Guild of St. Luke. Throughout his career, van Thielen's paintings continued to resemble those of his mentor. Like Seghers, van Thielen painted garlands and bouquets in vivid color. His pictures typically represent a cluster of flowers, limited in variety, against a dark background. Although their work is quite similar, van Thielen's compositions are more symmetrical, his brush strokes are more vigorous, and his bouquets include more tulips.

In 1660 van Thielen's name appears in two registries. He is listed as a *buitenpoorter* member of the Antwerp guild, and recorded in the Mechelen Guild of St. Luke. This suggests that van Thielen and his family moved to Mechelen in that year. The painter likely spent the rest of his life in Mechelen. At his death in 1667, van Thielen was buried in Boisschot, a small village just east of Mechelen.[99]

In this picture, van Thielen paints a bouquet of cut flowers in a glass vase placed on a ledge. The flowers include carnations, cyclamen, variegated irises, lilies of the valley, bitter orange blossoms, dwarf nasturtiums, roses, and tulips. On the lower sections of the bouquet, small insects, moths, and butterflies devour blossoms and leaves. Meanwhile, a blue butterfly, a banded brush beetle, and a caterpillar appear to inch their way across the surface of the ledge.

This work does not represent a scene from everyday life. The flowers depicted in van Thielen's painting do not blossom at the same time. Van Thielen is not alone in producing such artificial bouquets. In fact, his efforts are quite conventional. For van Thielen and his contemporaries, such flowerpieces demanded greater artistic skill, for they depended on the use of memory and the imagination as well as of sight. The artificiality of these images implies that the painted work is of greater value than an actual bouquet of flowers, for they last longer.

Flower paintings such as this one are highly ambiguous in meaning and can elicit a variety of imaginative responses.[100] On the negative side, flowers can suggest vanity and the transience of life, for their beauty quickly passes. The bouquet in van Thielen's painting is beyond its peak. A house fly, yellow ants, and tiger moths consume its flowers. Such a presentation may have reminded viewers of their own mortality since it prompted them to recall Isaiah 40:8, which states that although the grass withers and the flower fades, the Word of God will last forever. Yet, at the same time, van Thielen's painting extends the brief life of the flowers, giving them the sense of eternal presence.

Van Thielen's bouquet includes numerous long-stemmed, red-and-white-striped tulips. Although today people typically associate tulips with the Netherlands, this was not always the case. In fact, the flower originated in Turkey. Like Turkish carpets and Ming porcelain, tulips were once exotic luxuries and their bulbs demanded high prices. In the late sixteenth century, individuals began to cultivate tulips in the Netherlands and develop new hybrids. They also began to speculate heavily on the tulip trade. For instance, Joris Rye, a botanist and merchant from Mechelen, introduced new varieties and sold them.[101] Van Thielen's preoccupation with tulips may in part have been inspired by Rye's discoveries, but it went well beyond an interest in botany. Throughout the Netherlands, critics of the costly flower warned against immodest speculation. In 1614 Roemer Visscher illustrated his emblem entitled "A Fool and His Money Are Soon Parted" with two tulips with bulbs. Tulipomania came to a head in the late 1630s when the market dropped significantly, leaving many speculators bankrupt.[102] The brilliant flaming tulips in van Thielen's bouquet could imply the foolish pursuit of earthly treasures. This same logic could also be playfully applied to the painting itself, for in its beauty the work deceives the eye.

On the positive side, flowers, including tulips, can reveal the rich variety and beauty of God's creation. Furthermore, the Virgin Mary and Christ are often compared to flowers. Roses, irises, and carnations can allude to the joys and sorrows of Mary. They can also point to the love and compassion of Christ. In addition, van Thielen's flowers can connote the attributes of the Christian soul, which is called to imitate the characteristics of Christ. For instance, the lily of the valley may elicit notions of purity and humility, qualities shared by Mary, Christ, and the ideal soul. Carnations, also called "nail flowers" in the Netherlands, can be associated metaphorically with Christ's redemptive sacrifice as well as with Christian charity. Roses, besides making inferences to the rosary, can allude both to the love between Mary and Christ and that between Christ and the soul.[103]

The butterflies and moths in the painting may extend such associations by suggesting the possibility of resurrection and renewal, through their metamorphosis from caterpillars. The flowers and creatures in van Thielen's painting are ambiguous in meaning, for they can be interpreted as precious gifts leading observers toward God or as vain objects of fleeting beauty leading beholders astray. Charged with multiple metaphorical associations, van Thielen's flowers, insects, and butterflies invite viewers to consider the human condition and imaginatively discover a personal path of truth and beauty.

88

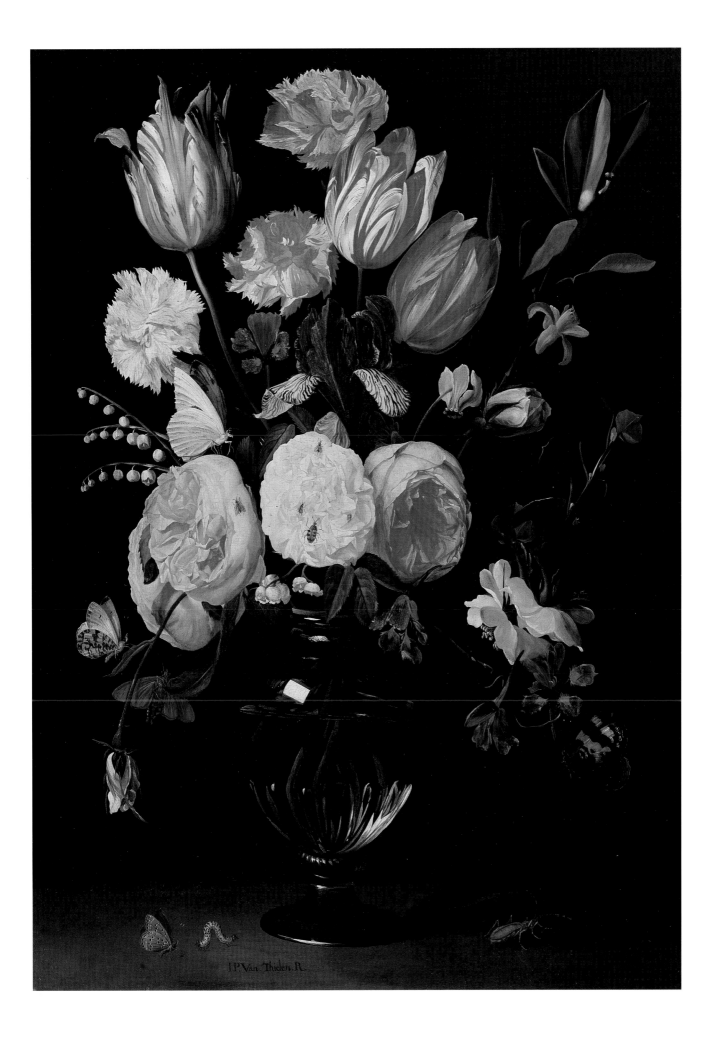

J P Van Thielen R

24-25 Willem van de Velde II

Leiden 1633-1707 Westminster

Ships in a Harbor (Marine Painting Pair)

Oil on panel, ca. 1655-58
7¾ × 7⅛ inches (19.7 × 18 cm.) each
Private Collection

Willem van de Velde the Younger was born in the city of Leiden. His father, Willem the Elder, was an artist, famous for his pen drawings of naval battles between the Dutch and English fleets. Sometime prior to 1636 the family moved to Amsterdam. Willem the Younger likely learned how to draw from his talented father. Around 1650 Willem the Younger continued his education, serving as an apprentice to Simon de Vlieger. When de Vlieger relocated his studio from Amsterdam to Weesp, Willem the Younger accompanied him.

In 1652 van de Velde married a local woman, Petronella Le Maitre, and moved back to Amsterdam, where he served as his father's assistant. Unfortunately, a year later the couple appeared before a notary to end their marriage. According to court testimony, Petronella denounced her husband as a villain who falsely claimed to have witnessed her having sexual relations with an-other man. Not surprisingly, the proceedings ended in divorce.[104]

In 1656 Willem van de Velde the Younger remarried. He and his second wife Magdaleentje Walravens of Amsterdam, had six children.[105] Apparently four of these children followed in their father's footsteps and became marine painters. Few of their works, however, have been identified.[106]

Around 1672, the year the Dutch navy led by Admiral Michiel de Ruyter defeated the English fleet, all of the van der Veldes left Amsterdam and moved to London, where Willem the Elder and his son worked as court artists for Charles II. Their transfer to England was probably prompted by the French invasion of the Netherlands during that same year. Although they occasionally traveled to the Netherlands, both artists continued to reside in England, where they served Charles II and his successor, James II.[107]

In this pair of marine paintings, completed in Amsterdam between the First and Second Anglo-Dutch Wars, Willem van de Velde the Younger depicts a variety of Dutch ships floating in a harbor on a cloudy day. The right panel represents a *fluit,* a Dutch trade ship, undergoing minor repairs as it is being cleaned of barnacles before it sets sail for the Baltic or the Mediterranean. In the middle ground is a Dutch warship, with a decorated stern. A distant port can be seen in the background. Although the city cannot be identified, its appearance fits the expectations of a Dutch town. The left panel depicts a different *fluit,* one with gunports. It setting, however, is somewhat ambiguous, for it is difficult to determine whether the ship is coming to anchor or preparing to set sail.

Not surprisingly, marine paintings were quite popular in seventeenth-century Holland. The Dutch gained and maintained their political independence and their economic prosperity through the sea. Much of the Dutch landscape is also closely associated with the sea, for polderland is acquired and protected by a series of dikes and dams. Admittedly, van de Velde's two paintings lack highly dramatic narratives. They do not represent either naval battles or tempests. Instead, they show ships secure in a harbor. The weather seems fair, and the wind appears to be blowing gently. Although the sky is partially overcast, there is no threat of forthcoming bad weather. The reflective quality of light pervades the picture, making the ships shimmer as they are illuminated by the sun. Van de Velde seems to have placed a high value on producing a faithful record. The scenes appear to have veracity, and the types of boats are clearly defined, even down to the details of the rigging. Nonetheless, these paintings are not simply a means of visual documentation or historical record. On the contrary, like other types of seventeenth-century Netherlandish paintings, these marine paintings elicit metaphorical associations. The naturalistic presentation of the seascapes only enhances the images' affective power.

Both of these paintings encourage communal identity among viewers. Everything in the pictures appears to be Dutch. The broad coastal waters and the ships in the harbor are characteristically Dutch. Furthermore, even though the sails of the trade ships in both works are down, the Dutch flag heroically waves openly. Together these pictures elicit even greater pride in Dutch maritime culture.[108]

Van de Velde's pictures also invite observers to identify empathetically with the seamen. Like the calm seas, these men perform their humble duties in an orderly and balanced fashion. They work together in unpretentious unity, without competition or dissension. Their labors appear harmonious with one another, with the weather, and with the sea. The modesty of their actions is reinforced by the intimate scale of the pictures. At once seeming to advocate hard work, humility, and pride, van de Velde's little seascapes are charged with allusions, encouraging viewers to acquire moral virtues commonly associated with Dutch patriotism.

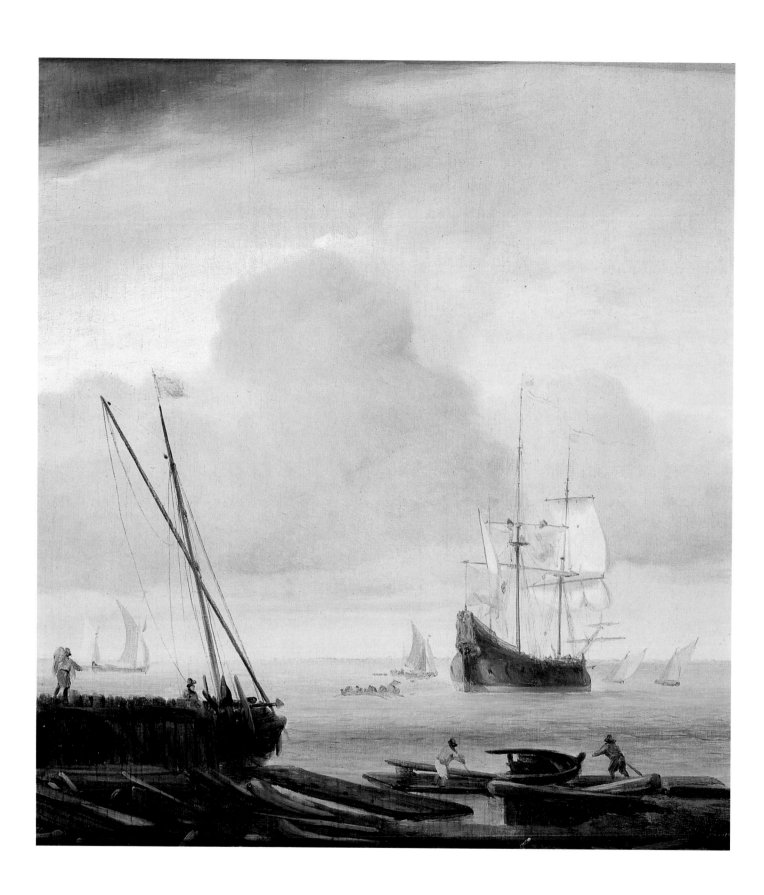

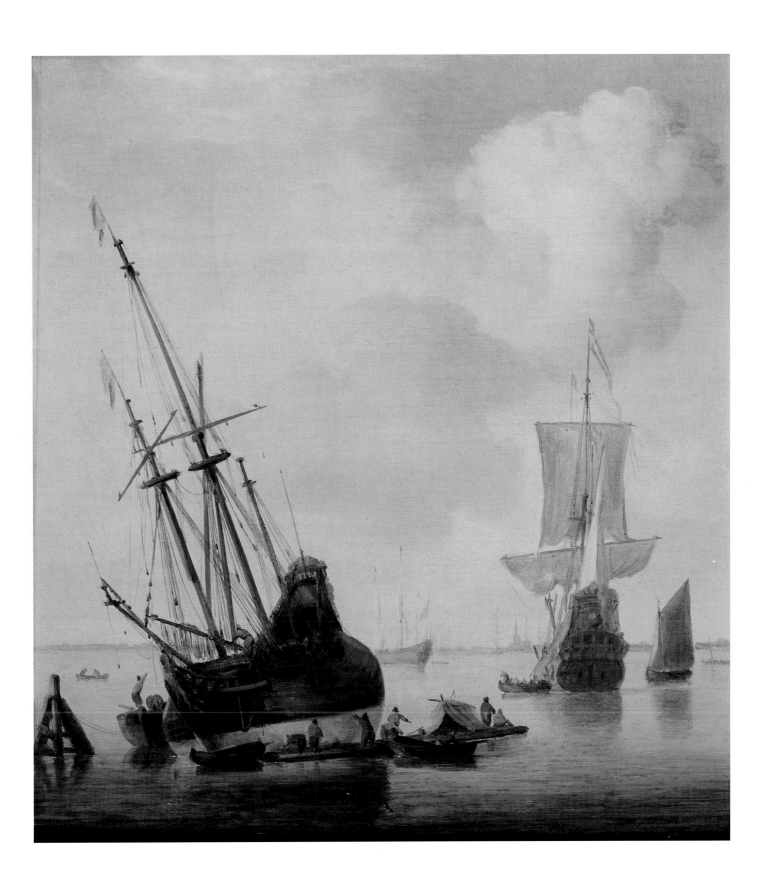

26 Emanuel de Witte

Alkmaar ca. 1617-1692 Amsterdam

Interior of the Oude Kerk, Amsterdam

Signed and dated
Oil on canvas, 1679
31¾ × 27½ inches (80.8 × 69.8 cm.)
Private Collection

Born in Alkmaar, Emanuel de Witte was the son of Pieter de Wit, a local schoolmaster, and his wife, Jacomijntge van der Beck. According to biographer Arnold Houbraken, de Witte trained under Evert van Aelst, a still-life painter from Delft. After completing his apprenticeship, de Witte joined the Alkmaar Guild of St. Luke in 1636. He began his career as a painter of biblical and mythological themes, though on occasion he depicted portraits and genre scenes. Three years after enrolling in Alkmaar's painters' guild, de Witte was reportedly active in the city of Rotterdam. By 1641 he transferred to Delft. While in Delft, de Witte came into contact with architectural painters such as Gerrit Houckgeest and Hendrik Cornelisz. van Vliet. He began to paint church interiors in the manner of Gerrit Houckgeest.[109]

Around 1651 de Witte moved to Amsterdam. Once there, de Witte seems to have concentrated exclusively on painting architectural scenes. During this time de Witte started to imitate the work of Pieter Saenredam, using linear perspective to produce deep recessions into space. Perhaps his interest in Saenredam was sparked by Saenredam's financial success. If so, it did not help.

Financial difficulties overcame de Witte.[110] In poverty, he indentured himself to a Amsterdam notary in 1660. De Witte was given room and board as well as an annual stipend of eight hundred guilders in exchange for all of his paintings. Failing to fulfill his end of the bargain, de Witte was sued by the notary's estate. The artist Pieter de Hooch offered testimony at the proceedings. De Witte's miseries persisted. Records indicate that he was forced to indenture himself on numerous occasions. According to Houbraken, de Witte suffered horrendous bouts of depression and in 1692 committed suicide. His body was discovered beneath the frozen ice of an Amsterdam canal eleven weeks after his disappearance.[111]

This picture, *Interior of the Oude Kerk, Amsterdam,* was produced while de Witte lived in Amsterdam. At first glance, de Witte's painting seems to share qualities found in the work of Saenredam. It represents an actual building and, through the use of linear perspective, conveys the church's spatial depth. De Witte's treatment, however, differs significantly from that of Saenredam. His naturalistic interior lacks the same degree of veracity. The work does not reveal a keen preoccupation with representing architectural details with accuracy. His use of linear perspective typically is also mathematically inconsistent. Unlike Saenredam, de Witte does not produce an optical record of a particular place. In this painting, he incorporates architectural elements from Amsterdam's Nieuwe Kerk into his depiction of the Oude Kerk. De Witte freely arranges church furnishing to fit the needs of his composition. His alterations partially cloud the identity of this particular church interior. Although such changes may limit the image's capacity to evoke civic pride, it can call greater attention to his personal interpretation of that architectural structure and space.

Not only does de Witte's manner of presentation evoke a greater sense of his subjectivity; it also encourages beholders to reciprocate by engaging imaginatively with his painted spaces. Figures in his painting not only convey the great scale of the building, but they also appear to participate in an implicit narrative. His depiction of small figures located near side chapels invites a devout response. The fluidity of his brush strokes and the interplay of highlight and shadow in his work add to the vibrancy of the scene, making the interior space quite dramatic. In addition, the tonality of de Witte's interior heightens the observer's experience by producing a somber and melodramatic mood.[112]

The Oude Kerk was initially a place designed for Catholic worship, but later it was converted to meet the needs of Calvinist congregations. Although it once housed sculptures of the Madonna and Child, in de Witte's painting the interior gives shelter to an anonymous mother breast-feeding her infant. The motif of mother and child appears quite frequently in his work.

Some scholars have suggested that de Witte's church interiors symbolize the three Pauline virtues. First of all, his churches are described as allusions to *fides,* for it is in the church that those faithful to Christ gather to worship. Secondly, graves and grave diggers, motifs often found throughout de Witte's oeuvre, reveal *spes,* hope in the afterlife. And, finally, his numerous depictions of an unknown mother and child suggest *caritas,* charity based on Christian compassion and love.[113]

Such an interpretation, however, is far too limiting and may be misguided. Although metaphorical associations with the Pauline virtues are possible, this does not foreclose the image's capacity to elicit other connotations. As Rob Ruurs has stated, graves can also suggest the brevity of life and function as a reminder of death. The presence of the attending gentleman in this painting may suggest proper devotion to the deceased and provoke greater viewer empathy.[114] Furthermore, the juxtaposition of the nursing child with the open tomb may also allude to the transient process of life. Breast-feeding can have numerous connotations, including human vulnerability, nourishment of the soul, and the lineage of original sin. Additional motifs within this church interior may also elicit imaginative responses, such as the enigmatic wine jug abandoned on the pew. The dogs in the foreground may simply represent a commonplace occurrence. Canine pets frequently entered buildings with their owners. But their presence can also evoke metaphorical associations. For instance, the solitary dog sitting near the pulpit may allude to fidelity, though other possibilities also exist.

Although de Witte's painting can be appreciated for its technical merits, especially in regard to his treatment of color and light, it can also be valued for its metaphorical ambiguity. Although churches are usually considered to be primarily places of worship, de Witte concentrates upon another of their traditional functions, their service as consecrated burial grounds for the deceased. His picture appears to be charged with imaginative allusions to Christian devotion and the transience of life, ecumenical enough to accommodate the spiritual needs of Catholic and Protestant observers alike.

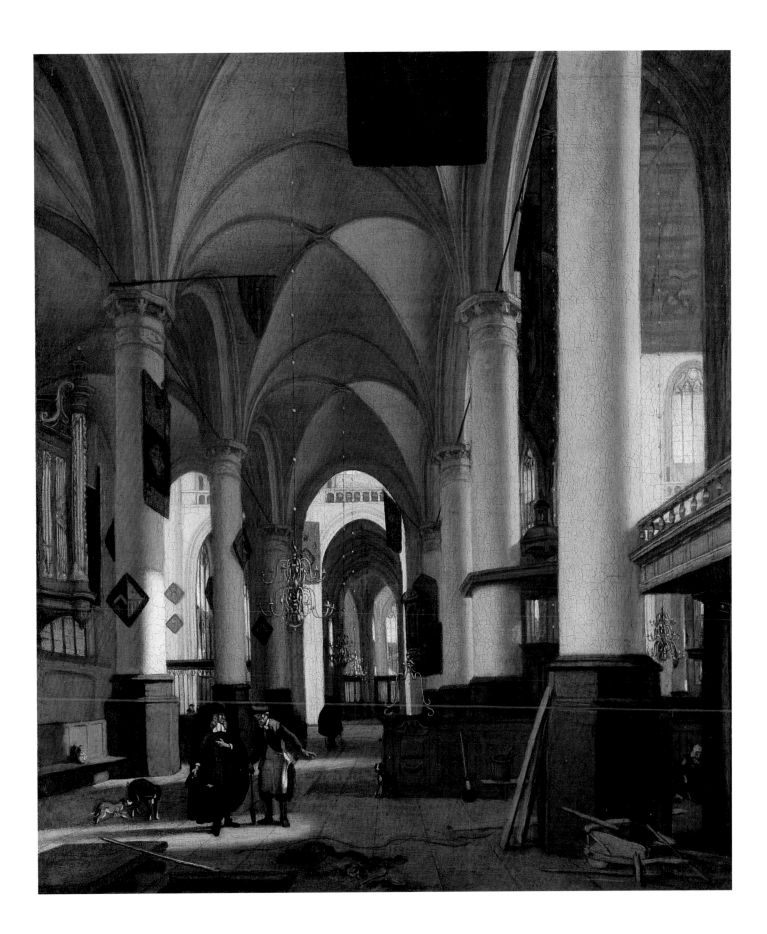

Notes to the Catalogue Entries

1. Amsterdam 1982a, pp. 15-19; Amsterdam 1987, p. 254; Welcker 1979, pp. 33-77; and Wheelock 1995, p. 9.

2. George Keyes, "Hendrick Averkamp and the Winter Landscape," in Amsterdam 1982a, pp. 37-55.

3. Amsterdam 1982a, p. 30. For more on ice scenes in emblematic literature, see van Straaten 1977, pp. 43-58.

4. Franits 1993, pp. 106-7.

5. Schama in Amsterdam 1987, pp. 75-76; and Westermann 1996, p. 106.

6. Rotterdam 1991, p. 283.

7. Perth 1997, p. 72; Lawrence 1991, pp. 54-56; and Vancouver 1986, p. 43.

8. Haak 1984, pp. 352-54; and Rosenberg and Slive 1966, pp. 396-99.

9. Pieter Rixel, *Mengel-rymen* (Haarlem, 1669). Cited and translated in Rotterdam 1991, p. 287.

10. This drawing is housed in the Rijksprentenkabinet of the Rijksmuseum.

11. Philadelphia 1984, pp. 142-43; and Wheelock 1995, p. 26.

12. Philadelphia 1984, pp. 150-51.

13. Jacob Cats, *Spiegel van den ouden en nieuwen tijdt* (Amsterdam, 1658), pt. 3, no. 12.

14. The same dog appears in another work by ter Borch, *Curiosity* (Metropolitan Museum, New York), which S. J. Gudlaugsson has suggested may have been a pendent to the Detroit painting. See Gudlaugsson 1959-60, vol. 2, p. 169.

15. Alison McNeil Kettering, "Ter Borch's Ladies in Satin," *Art History* 16 (1993): 95-124. Reprinted in Franits 1997, pp. 98-115.

16. Although Cuyp never lived in Utrecht, he seems to have visited the city quite regularly, which is not surprising, for it remained the hometown of the maternal side of his extended family.

17. Cuyp's hometown of Dordrecht was built on the banks of the Maas River and is located where numerous inland waterways converge, making it an important commercial city. But the city gained even more cultural significance as a center of strict Calvinism. In 1618-19 it was the site of a national synod on Reformed theology, which settled the dispute between the Remonstrants, otherwise known as Arminians, who believed in the free will to discover grace, and the Counter-Remonstrants or Gomarians, who preached predestination. The latter group was victorious in Dordrecht, and their triumph continues to guide Dutch Calvinism to the present. A year after the Synod of Dordrecht was adjourned, Aelbert Cuyp was baptized in the city's Reformed Church.

18. Amsterdam 1987, p. 290; and Wheelock 1995, pp. 32-33.

19. Chong 1991, pp. 606-12.

20. Spicer 1983, pp. 251-56.

21. Ibid., p. 256.

22. Because of his great popularity, Dou also attracted numerous students, including Godfried Schalcken and Frans van Mieris the Elder.

23. Philadelphia 1984, p. 181; and Wheelock 1995, pp. 56-57.

24. For more on the cultural significance of verisimilitude in *fijnschilderij*, see Hecht in Franits 1997, pp. 88-97.

25. For more on this comparison, see Eric Jan Sluijter in Franits 1997, p. 87.

26. Kuretsky 1974, pp. 571-80.

27. Wheelock 1995, pp. 59-60.

28. Philadelphia 1984, p. 189; and Salomon 1998, pp. 16-18.

29. Visscher 1614, p. 178. Cited and translated in Franits 1993, p. 50.

30. Salomon 1998, pp. 107-25.

31. Ibid., pp. 122-23.

32. Amsterdam 1987, pp. 317-18; and Wheelock 1995, p. 61.

33. Rosenberg and Slive 1966, pp. 251-62.

34. Goedde 1997, pp. 136ff.

35. Philadelphia 1984, pp. 204-6; and Rosenberg and Slive 1966, p. 173.

36. de Jongh 1973, pp. 198-206. For more on the erotic connotations of seventeenth-century Dutch painting, see de Jongh 1971.

37. Amsterdam 1976, pp. 109-11.

38. Philadelphia 1984, p. 208; Washington 1989b, pp. 1-22; and Wheelock 1995, p. 65.

39. Slive 1970-74, vol. 3, pp. 67-68.

40. Washington 1989b, p. 398.

41. Valentiner 1921, pp. 217, 230.

42. The Hague 1990, p. 258.

43. In a recent conversation Alfred Ackerman, Chief Conservator at the Detroit Institute of Arts, confirmed Slive's hypothesis that the Detroit portrait of Hendrik Swalmius was trimmed on the upper and left margins of the panel.

44. Bergström 1947, pp. 162-64, 191-216; Boston 1993, p. 426; Delft 1988, pp. 141-56; Washington 1989a, pp. 110-11; and Wheelock 1995, pp. 102-3.

45. Delft 1988, pp. 29-38; and Schama 1979, pp. 103-23.

46. Goedde in Washington 1989a, pp. 35-44; Lowenthal 1986, pp. 188-90; and Lowenthal 1996, pp. 29-40.

47. Philadelphia 1984, p. 214; Sutton 1980, pp. 9-10; and Wheelock 1995, pp. 132-33.

48. Douglas 1966, p. 7; Franits 1993, pp. 95-100; Schama 1987, pp. 375-97; and Sutton 1980, pp. 24-27.

49. Boston 1993, p. 512; Griendl 1983, pp. 156-62, 365-68; Hairs 1985, pp. 287-300, 483-85; and Washington 1989a, pp. 112-14.

50. Arthur Wheelock shared this information in a copy of his forthcoming catalogue entry for a book on the National Gallery of Art's permanent collection of Flemish paintings.

51. Washington 1998, pp. 56-58.

52. Goedde in Washington 1989a, pp. 41-43.

53. Philadelphia 1984, p. 239; and Wheelock 1995, pp. 159-60.

54. de Jongh 1973, pp. 202-3.

55. Philadelphia 1984, p. 241.

56. *The Idle Servant* (National Gallery of Art, London), *An Old Woman Dozing over a Book* (National Gallery of Art, Washington), and *An Old Woman Asleep before a Bible* (Musées Royaux des Beaux-Arts, Brussels) were all produced by Nicholas Maes around 1655, shortly after his departure from Rembrandt's studio.

57. Schama 1987, pp. 124-25, 323-43.

58. Philadelphia 1984, pp. 248-52; and Washington 1995, p. 164.

59. Philadelphia 1984, pp. 252-53.

60. Mirimonde 1966, p. 281.

61. Minneapolis 1971, p. 62.

62. Fock 1973, pp. 27-48.

63. London 1991, p. 270.

64. Hofstede de Groot 1907-28, vol. 10, p. 201.

65. Hecht 1984, pp. 125-36.

66. Amsterdam 1987, p. 374; and Wheelock 1995, p. 178.

67. Stechow 1966, pp. 23-28.

68. Amsterdam 1987, p. 15; and Wheelock 1995, pp. 180-81.

69. Goedde in Franits 1997, pp. 136-43.

70. Minneapolis 1971, p. 76.

71. Rosenberg and Slive 1966, pp. 367-68.

72. For more on Dutch maritime culture during the early eighteenth century, see Boxer 1965, pp. 302-31.

73. This information was provided by L. J. van der Klooster, Keeper of the Topographical Department of the Rijksbureau voor Kunsthistorische Documentatie in a letter dated 12 July 1985.

74. Amsterdam 1987, pp. 437-38; Walford 1991, pp. 4-14; and Wheelock 1995, pp. 338-39.

75. Wiegand 1971, pp. 87ff. For an emblematic interpretation associating Dutch landscape and *vanitas*, see Bruyn in Amsterdam 1987, pp. 84-101.

76. Walford 1991, pp. 29-46, 204-6.

77. Only Salomon's brother Pieter continued to use the surname de Goyer throughout his lifetime.

78. Stechow 1966, pp. 26-28; and Amsterdam 1987, p. 466.

79. Goedde 1997, pp. 136ff.

80. For more on imaginative journey and Dutch landscape see Falkenburg 1988; and Levesque 1994.

81. London 1991, p. 406; Rotterdam 1991, p. 99; Schwartz and Bok 1989, pp. 15-34; and Wheelock 1995, pp. 348-49.

82. Montias in Rotterdam 1991, pp. 19-28.

83. Schwartz and Bok 1989, pp. 149-54.

84. Saenredam did not invent the genre of architectural painting. Netherlandish artists as early as Jan van Eyck and Rogier van der Weyden occasionally painted church interiors in their altarpieces. Two fifteenth-century artists from Haarlem, Albert van

Ouwater and Geertgen tot Sint Jans, also put their figures in architectural settings; and during the sixteenth century Haarlem artists such as Jan van Scorel and Maarten van Heemskerck represented buildings from Italy's classical past. Saenredam was well aware of the history of architecture and the Haarlem tradition of architectural painting. He owned an extensive library of scholarly books and collected works of art, including an album of van Heemskerck's drawings of Rome. Unlike his predecessors, however, Saenredam painted architectural views almost exclusively, and in most of these works he chose to depict existing structures that he had encountered in the Netherlands.

85. Ruurs in Rotterdam 1991, pp. 44-45.

86. Saendredam's three-step working method shows his antiquarian desire to represent architectural minutiae with perspectival precision. First, he made preliminary sketches of a building on site. Then, based on these sketches, he constructed a more accurate drawing to scale, using straightedges and compasses to aid his measurements. Finally, Saenredam produced a panel painting imitating the constructed drawing. Sometimes years lapsed between these steps, suggesting that Saenredam did not always feel compelled to transform his drawings into paintings. In addition, his pictures not do simply describe a church. Rather, his architectural views are taken from a unique vantage point or cropped in striking ways. Saendredam's personal idiosyncrasies can be easily seen throughout his work.

87. Schwartz and Bok 1989, pp. 232-36.

88. According to Arthur Wheelock, the cloister revealed in Saenredam's painting is fictitious. In actuality, the church doors open to a public square.

89. Rotterdam 1991, p. 57.

90. Schwartz and Bok 1989, p. 237.

91. Dutch Calvinists also sang *gezangen*, songs based on biblical prayers and confessional creeds. All the *gezangen* sung in Reformed churches were approved by the Synod of Dordrecht.

92. Westermann 1996, p. 50.

93. Greindl 1983, pp. 131-33, 381-82; and Washington 1989a, p. 129.

94. Amsterdam 1983, pp. 14-42, 74-75.

95. Ibid., p. 36.

96. Lowenthal 1986, pp. 188-90.

97. For more on the presence of tears in early Netherlandish painting, see Luttikhuizen 1997, pp. 215-17; and Schuler 1992, pp. 5-28.

98. Delft 1988, pp. 29-38; and Lowenthal 1996, pp. 29-40.

99. Boston 1993, p. 521; and Hairs 1955, pp. 107-10, 243-45.

100. Goedde in Washington 1989a, pp. 35-44.

101. Schama 1987, p. 353.

102. Schama 1987, pp. 350-66; and Taylor 1995, pp. 1-28.

103. For more on flower symbolism, see Taylor 1995, pp. 43-76.

104. Minneapolis 1990, pp. 420-22; and Rotterdam 1996, p. 333.

105. Minneapolis 1990, p. 421.

106. Haak 1984, p. 479.

107. London 1991, pp. 447-48.

108. Goedde in Rotterdam 1996, pp. 67-72.

109. Like Houckgeest, de Witte usually painted his interiors from an unusual vantage point, forcing viewers to see architectural elements and spaces at odd angles. Cf. Wheelock 1975-76, pp. 167-85.

110. Emmanuel de Witte's hardships extended beyond financial concerns. Soon after his arrival in Amsterdam, his wife Geertgen Arendts died, leaving him to care for their only child. He remarried in 1655. His second wife, Lysbeth Lodewyck van der Plass, was a twenty-eight-year-old single mother. Three years later de Witte's troubles would worsen. In 1658 his wife and stepdaughter were caught stealing. Lysbeth was banished from Amsterdam, and the girl was sentenced to a year in the city's *Spinhuis*, a house of corrections for petty criminals.

111. London 1991, pp. 486-87; Philadelphia 1984, p. 360; and Rotterdam 1991, p. 183.

112. Rotterdam 1991, pp. 203, 207.

113. Heisner 1980, pp. 107-21.

114. Ruurs in Rotterdam 1991, p. 47.

Gerrit Berckheyde, *The Town Hall on the Dam, Amsterdam,* detail (cat. 2)

Provenance and Exhibitions

1 Hendrick Averkamp
Amsterdam 1585-1634 Kampen

*Winter Landscape with Figures
Skating on a Frozen River*

Signed with monogram
Oil on panel, ca. 1615-20
12¼ × 18½ inches (31 × 47 cm.)
Private Collection

Provenance: Vischer Boelger collection, Basel, ca. 1880; André A. Boucart collection, Montbéliard, by 1929; Boucart heirs collection, until 1985; Richard Green, London, 1985; Cowles family collection, 1988.

Exhibited: *The Great Dutch Paintings in America* (Mauritshuis, The Hague, 1990-91; The Fine Arts Museums of San Francisco, 1991).

Literature: Welcher 1979, p. 209, cat. S 36; The Hague 1990, pp. 145-48, fig. 4.

2 Gerrit Berckheyde
Haarlem 1638-1698 Haarlem

The Town Hall on the Dam, Amsterdam

Signed and dated on lower left
Oil on canvas, 1672
13¼ × 16⅜ inches (33.5 × 41.5 cm.)
Rijksmuseum, Amsterdam
28.34

Provenance: Sale, Amsterdam (de Vries, Brondgeest, Engelberts, and Roos), 4 August 1828, lot 15.

Exhibited: *De Gouden Eeuw* (Paleis-Raadhuis, Tilburg, 1953); *Er was eens . . .* (Prinsenhof, Delft, 1956); *Rembrandt* (The National Museum of Sweden, Stockholm, 1956); *The Royal Palace of Amsterdam in Paintings of the Golden Age* (Koninklijk Paleis, Amsterdam, 1997); *The Golden Age of Dutch Art: Seventeenth-Century Paintings from the Rijksmuseum and Australian Collections* (Art Gallery of Western Australia, Perth, 1997).

Literature: Fremantle 1962, p. 210, fig. 5; van Thiel 1976, p. 111; Lawrence 1991, pp. 49-65; Büttner and Unverfehrt 1993, pp. 72-74; Amsterdam 1997, pp. 12-14, 43-44, no. 6, ill.; Perth 1997, pp. 72-73, no. 24, ill.

3 Gerard ter Borch
Zwolle 1617-1681 Deventer

Lady at Her Toilet

Signed with monogram on the fireplace
Oil on canvas, ca. 1660
30 × 23½ inches (76.2 × 59.7 cm.)
The Detroit Institute of Arts
Founders Society Purchase, Eleanor Clay Ford Fund, General Membership Fund, Endowment Income Fund, and Special Activities Fund
65.10

Provenance: Louvre, Paris, ca. 1810; Château Saint-Cloud; Willems Collection, Frankfort, 1833; Lionel de Rothschild, London, acquired 1836, descended in family; The Hon. Mrs. Clive Behrens, London; Major P. E. C. Harris, London.

Exhibited: *Exhibition* (British Institution, London, 1844); *Exhibition* (Royal Academy of Art, London, 1878); *Exhibition* (Royal Academy of Art, London, 1929); *Exhibition* (Birmingham Museum of Art, 1950); *Dutch Pictures 1450-1750*

(Royal Academy of Art, London, 1952-53); *The Age of Rembrandt* (California Palace of the Legion of Honor, San Francisco; Toledo Museum of Art; and Boston Museum of Fine Arts, 1966); *Gerard ter Borch* (Mauritshuis, The Hague and Landesmuseum, Münster, 1974); *Pictures from Museums in the United States of America* (Hermitage, St. Petersburg; Pushkin Museum, Moscow; State Museum of Ukrainian Art, Minsk; and State Museum of Byelorussian SSR, 1976); *Masters of Seventeenth-Century Dutch Genre Painting* (Philadelphia Museum of Art, 1984; Staatliche Museen, Berlin, 1984; and Royal Academy of Arts, London, 1984); *Masterpieces from the Detroit Institute of Art* (Bunkamura Museum of Art, Tokyo, 1989).

Literature: Smith 1829-42, vol. 4, no. 61; Waagen 1854-57, vol. 2, p. 129; Hofstede de Groot 1907-28, vol. 5, no. 47; Plietzch 1944, p. 21, no. 82, pl. 82; Gudlaugsson 1959-60, vol. 1, pp. 123-24, 134, fig. 165, vol. 2, no. 165; Haverkamp-Begemann 1965, pp. 38-41, ill., 62-63; The Hague 1974, pp. 158-59, cat. 45, rep.; Detroit 1979, p. 70, no. 47, ill.; Philadelphia 1984, pp. 150-51, cat. no. 13, plate 72; Stone-Ferrier 1985, p. 164, fig. 77; Sutton 1986, p. 88, no. 124; Kettering 1993, pp. 95-124; Kettering in Franits 1997, pp. 101-14, fig. 63.

4 Aelbert Cuyp
Dordrecht 1620-1691 Dordrecht

Shepherds in a Rocky Landscape

Signed and dated on lower right
Oil on canvas, 1640
40½ × 51 inches (103 × 129.5 cm.)
Private Collection

Provenance: Count Suboff, Moscow (before 1925); Gebr. Douwes, Amsterdam, from 1926; Leon Sergold, New York, by 1969; private collection, Switzerland, Christie's, 5 April 1979; Martens, Christie's, 1984.

Literature: Stechow 1960, pp. 87-88; Rosenberg and Slive 1966, p. 276; Stechow 1966, p. 159; Blankert 1967-68, p. 106, n. 11; Burnett 1969, p. 372, fig. 3; van Gelder and Jost 1969, p. 101; van Gelder 1972, p. 224, n. 11; Reiss 1975, no. 68, repr. [as a Utrecht follower of Cuyp]; Chong in Amsterdam 1987, p. 292, n. 15; Chong 1991, pp. 606-7.

5 Gerard Dou
Leiden 1613-1675 Leiden

The Hermit

Signed and dated on book strap
Oil on panel, 1670
18⅛ × 13⅝ inches (46 × 34.5 cm.)
National Gallery of Art, Washington
Timken Collection
1960.6.8

Provenance: Probably Kurfürst Karl Albrecht, Munich, by 1742; Kurfürstliche Galerie, Munich; Alte Pinakothek, Munich, inv. no. 399, by 1829; deaccessioned in 1927; Galerie van Diemen, New York and Berlin; William R. Timken, New York; by inheritance to Lillian S. Timken, New York

Exhibited: *A Collector's Cabinet* (National Gallery of Art, Washington, 1998).

Literature: Smith 1829-1842, vol. 1, p. 38, no. 111; Martin 1902, p. 129, no. 132; Hofstede de Groot 1907-28, vol. 1, p. 348, no. 19; Martin 1911, pp. 164-65, no. 11; Martin 1913, p. 6, repr.; Baer 1990, no. 121; London 1980, nos. 2-3; Wheelock 1995, pp. 57-59, ill. color.

6 Jacob Duck
Utrecht? ca. 1600-1667 Utrecht

Musical Ensemble with Cockatoo

Signed on the envelope located on the floor
Oil on panel, ca. 1660
19½ × 25⅜ inches (49.5 × 64.5 cm.)
Private Collection

Provenance: Count Herberstein, Vienna; with Galerie Sanct Lucas, Vienna, 1954; Sir Rupert Hardy et al., sale, London (Christie's), 30 April 1954, lot 51; with A. Staal, Amsterdam; with Noortman, Maastricht/London, 1988.

Literature: Salomon 1998, pp. 122-23, color plate I and fig. 113.

7 Jan van Goyen
Leiden 1596-1656 The Hague

A River Landscape with Fisherman Mooring a Rowing Boat

Signed with monogram and dated on boat
Oil on panel, 1653
10⅜ × 16 inches (26.4 × 40.6 cm.)
Private Collection

Provenance: Dowdeswell and Dowdeswell, London, ca. 1905-10; Th. Bonjean, 10 Rue Lafitte, Paris, no. 6182; Joseph Homberg, sale, Paris, 11 May 1923, lot 25; private collection, Europe

Literature: Beck 1973, vol. 2, p. 260, no. 564, ill.

8 Dirck Hals
Haarlem 1591-1656 Haarlem

Cavaliers Playing Tric-Trac in a Tavern

Signed and dated
Oil on panel, 1631
18 × 26½ inches (45.7 × 67.3 cm.)
Private Collection

Provenance: Private collection; New York, Christie's, 12 October 1989, lot 189.

9 Frans Hals
Antwerp ca. 1582-1666 Haarlem

Hendrik Swalmius

Signed with monogram and dated on right near center
Oil on panel, 1639
10⅝ × 7⅞ inches (27 × 20 cm.)
The Detroit Institute of Arts
City of Detroit and Founders Society Joint Purchase
49.347

Provenance: Mrs. Brown Lindsay, Colstoun, Haddington, East Lothian, Scotland; sale, London (Sotheby), 12 December 1934, lot 65; Asscher and Welker, London; H. E. ten Cate, Almelo; D. Katz, Dieren; Katz Gallerie, Basel.

Exhibited: *Oude Kunst* (Rijksmuseum, Amsterdam, 1936); *Frans Hals* (Frans Halsmuseum, Haarlem 1937); *Masterpieces of Art* (New York's World Fair, New York, 1939); *Five Centuries of Dutch Art* (Montreal Art Association, Montreal 1944); *Frans Hals* (Frans Halsmuseum, Haarlem 1962); *Seventeenth-Century Painters of Haarlem* (Allentown Art Museum, Allentown, PA, 1965).

Literature: Valentiner 1921, pp. 217, 230; Fell 1935, p. 105; Valentiner 1935, pp. 96, 102, no. 17; Slive 1970-74, vol. 1, pp. 129-30, fig. 127, vol. 2, color plate 204, vol. 3, pp. 67-68; Sutton 1986, p. 83; Grimm 1990, pp. 138, 235, 292, fig. 121c and 122 [copy after Hals]; Rotterdam, p. 95, ill.

10 Frans Hals
Antwerp ca. 1582-1666 Haarlem

Mrs. Hendrik Swalmius

Signed with monogram and dated on left near center
Oil on panel, 1639
11⅝ × 8¼ (29.5 × 21 cm.)
Museum Boijmans van Beuningen, Rotterdam
62.2498

Provenance: Sale (anon.), Christie's, London, 20 June 1913, no. 43; August Janssen, Amsterdam; Goudstikker, Amsterdam; D. G. van Beuningen, Vierhouten; acquired by the museum with the van Beuningen collection in 1958.

Exhibited: *Oude Kunst* (Rijksmuseum, Amsterdam, 1929); *Frans Hals* (Frans Halsmuseum, Haarlem, 1937); *Chefs d'Oeuvre de la Collection D. G. van Beuningen* (Petit Palais, Paris, 1952); *Kunstschatten uit Nederlandse verzamelingen* (Museum Boijmans, Rotterdam, 1955); *Frans Hals* (Frans Halsmuseum, Haarlem, 1962); *The Golden Age of the Seventeenth Century: Dutch Painting from the Collection of the Frans Halsmuseum* (The National Museum of Art, Osaka, 1988).

Literature: Valentiner 1921, pp. 218, 231; Hannema 1949, no. 49; Slive 1970-74, vol. 2, color plate 205, vol. 3, p. 68; Middelkoop 1988, p. 59; Grimm 1990, pp. 55, 292, fig. 53 [copy after Hals]; Rotterdam 1995, pp. 94-95, ill.

11 Jan Davidsz. de Heem
Utrecht 1606-1683/84 Antwerp

Still Life with a Glass and Oysters

Signed on upper left
Oil on panel, ca. 1640
9⅞ × 7½ inches (25.1 × 19.1 cm.)
The Metropolitan Museum of Art
71.78

Provenance: Museum Purchase, 1871.

Exhibited: *Thirty Masterpieces: An Exhibition of Paintings from the Metropolitan Museum of Art* (Dallas Museum of Fine Art, 1947).

Literature: Decamps 1872, p. 437; New York 1980, vol. 1, p. 84, vol. 3, p. 409, ill.

12 Pieter de Hooch
Rotterdam 1629-1684 Amsterdam

Courtyard, Delft

Signed on lower left on step
Oil on panel, ca. 1657
26¾ × 22⅝ inches (68 × 57.5 cm.)
The Toledo Museum of Art
Purchased with funds from the Libbey Endowment; gift of Edward Drummond Libbey
49.27

Provenance: J. van der Kellen, Rotterdam; sold to Conttier, London, ca. 1889; Inglis Collection, 1895; W. B. Thomas, Boston, 1907; J. Pierpont Morgan, New York, by 1909; Rosenberg and Stiebel, New York, 1948.

Exhibited: *The Hudson-Fulton Exhibition* (Metropolitan Museum of Art, New York, 1909); *Vermeer: oorsprong en invloed: Fabritius, de Hooch, de Witte* (Museum Boijmans van Beuningen, Rotterdam, 1935); *Pieter de Hooch* (Dulwich and Wadsworth Atheneum, Hartford, 1998).

Literature: von Bode 1895, p. 72; New York 1909, no. 53A, repr., p. 195; Valentiner 1910, p. 9, fig. 10; de Rudder 1913, p. 105; Hofstede de Groot 1907-28, vol. 1, no. 287; Valentiner 1926, p. 61; Brière-Misme 1927, p. 65; Valentiner 1927, p. 77, no. 18; Collins 1930, p. 198; Valentiner 1932, p. 319; Rotterdam 1935, no. 36, fig. 39; Martin 1936, vol. 2, p. 202; MacLaren 1960, p. 185, no. 15; Gerson 1966, p. 308, repr.; Stechow 1966, p. 125, fig. 252; Toledo 1976, pp. 80-81, 267, no. 131; Morse 1979, p. 188; Sutton 1980, pp. 20, 24-26, 79, no. 20, color plate IV; Sutton 1986, pp. 293-94, no. 441; The Hague 1990, p. 106; Lokin 1996, pp. 106-7, fig. 91.

13 Jan van Kessel I
Antwerp 1626-1679 Antwerp

Study of Butterflies and Insects

Oil on copper, ca. 1655
4⁵⁄₁₆ × 5¹³⁄₁₆ inches (11 × 14.8 cm.)
National Gallery of Art, Washington
Gift of John Dimick
1983.19.3

Provenance: Comte de Joigny, France (?); John Dimick, Chevy Chase, Maryland

Exhibited: *Autumn Exhibition of Old Master Paintings* (Brian Koetser Gallery, London, 1966); and *A Collector's Cabinet* (National Gallery of Art, Washington, 1998).

Literature: Washington 1985, p. 214, ill.; Washington 1998, p. 58, fig. 60.

14 Nicolaes Maes
Dordrecht 1634-1693 Amsterdam

The Account Keeper (The Housekeeper)

Signed and dated on a note to the right
Oil on canvas, 1656
26 × 21⅛ inches (66 × 53.7 cm.)
The Saint Louis Art Museum, Purchase

Provenance: Count Christian Sternberg, Czechoslovakia, and thence by descent; Mortimer Brandt Gallery, New York, 1950.

Exhibited: *Man and His Years* (Baltimore Museum of Art, 1954); *Fifty Masterpieces from the City Art Museum of St. Louis* (Wildenstein and Company, New York, 1958); *Paintings of Seventeenth-Century Interiors* (Nelson-Atkins Museum, Kansas City, 1967-68); *Masters of Seventeenth-Century Dutch Genre Painting* (Philadelphia Museum of Art, 1984; Staatliche Museen, Berlin, 1984; and Royal Academy of Arts, London, 1984).

Literature: Baltimore 1954, p. 27, no. 39; New York 1958, p. 11, no. 18, ill. black and white, p. 36; Kansas City 1967, pp. 10, 29, 33, no. 11, ill. black and white; Rathbone 1952, pp. 184-89; de Jongh 1973, pp. 202-3; Burke 1980, p. 24; and Philadelphia 1984, p. 241, cat. no. 66, plate 98; Sutton 1986, pp. 263-64; Yamey 1986, pp. 135, 137-38, no. 70, ill. color.

15 Gabriel Metsu
Leiden 1629-1667 Amsterdam

A Musical Party

Signed and dated on the lower left on the piece of sheet music
Oil on canvas, 1659
24¼ × 21⅜ inches (61.6 × 54.3 cm.)
The Metropolitan Museum of Art
Gift of Henry G. Marquand
91.26.11

Provenance: Possibly Marquis de Voyer, 1756; sale, E. Valkenier-Hooft, Amsterdam, 31 August 1796, no. 25, to Pierre Fouquet, Amsterdam; sale, Fouquet, 13-14 April 1801, to Roos; sale, Robit, Paris, 21 May 1801, no. 69, to La Roche; Michael Bryan, London; Bryan's Gallery, London, 6 November 1801, no. 78; sale, Bryan, Paris, 6 December 1801, no. 8; sale, J. Smith, 1825, to Zachary; sale, Zachary, London, 1828, to Philips; Frederick Perkins, Chipstead, Surrey, by 1832; sale, Perkins, Georges Petit, Paris, 3 June 1889, no. 9; sale, Christie's, London, 14 June 1890; Colnaghi, London; Henry G. Marquand, New York.

Exhibited: *Exhibition* (British Gallery, London, 1832); *The Hudson-Fulton Exhibition* (Metropolitan Museum of Art, New York, 1909); *Treasures of the Metropolitan* (Metropolitan Museum, New York, 1952-53; Leiden, 1966; Kansas City, 1967-68); *Masterpiece Show* (Boston Museum of Fine Arts, 1970); *Masters of Seventeenth-Century Dutch Genre Painting* (Philadelphia Museum of Art, 1984; Staatliche Museen, Berlin, 1984; and Royal Academy of Arts, London, 1984).

Literature: Descamps 1753-64, vol. 2, p. 243, Buchanen 1824, vol. 2, p. 53, no. 69; Smith 1829-42, vol. 4, no. 53; von Bode 1895, p. 18; Hofstede de Groot 1907-28, vol. 1, no. 164; Breck 1910, p. 57; Cox 1910, p. 305, Plietzch 1936, pp. 5, 9; Gowing 1952, p. 155, no. 142; Mirimonde 1966, pp. 281, 283, fig. 5; Gudlaugsson 1968, pp. 13-14, 24-25, 41, fig. 5; Schneede 1968, p. 47; Robinson 1974, pp. 37, 49, 54, 59-60, 64, 138, fig. 68; Wheelock 1976, p. 458; Welu 1977, p. 64, n. 24; New York 1980, vol. 1, p. 125, vol. 3, p. 443, ill.; Naumann 1981, vol. 1, p. 51, n. 15, fig. 44; Philadelphia 1984, pp. 252-53, cat. no. 72, color plate 66; Sutton 1986, 187-88, no. 267.

16 Willem van Mieris
Leiden 1662-1747 Leiden

Portrait of a Gentleman in Classical Dress

Signed middle right and dated
Oil on panel, 1706
10 × 8¼ inches (25.4 × 21 cm.)
Private Collection

Provenance: Possibly Paterson Family, Castle Huntly, Longforgan, Dundee, Scotland; J. Travers Smith, sale, Christie's, London, 22 January 1933, lot 34; probably sale, M. de Waleffe, Paris, 15-16 November 1933, lot 31 (as "Portrait d'un sculpteur").

Literature: Hofstede de Groot 1907-28, vol. 10, p. 201, no. 371 (as dated 1700).

17 Pieter Molijn
London 1595-1661 Haarlem

Landscape with an Open Gate

Oil on panel, ca. 1630
13¼ × 18⅞ inches
National Gallery of Art, Washington
Ailsa Mellon Bruce Fund and Gift of Arthur K. and Susan H. Wheelock
1986.10.1

Provenance: Private collection, France; Arthur K. and Susan H. Wheelock, Washington, 1980.

Exhibited: *Haarlem: The Seventeenth Century* (Jane Voorhees Zimmerli Art Museum, Rutgers University, New Brunswick, NJ, 1983); *A Collector's Cabinet* (National Gallery of Art, Washington, 1998).

Literature: New Brunswick 1983, no. 85; Allen 1987, p. 133, fig. 145; Washington 1995, pp. 178-81, ill. color.

18 Isaak Ouwater
Amsterdam 1750-1793 Amsterdam

View of the Spui at Delft Bridge, The Hague

Signed and dated
Oil on canvas, 1786
16½ × 21 inches (41.9 × 53.3 cm.)
Private Collection

Provenance: Private collection, Sweden; Folke Omell, London (Goteborg Auction, 1968), and thence by descent.

19 Jacob van Ruisdael
Haarlem ca. 1628-1682 Haarlem

Farm and Hayricks on a River

Signed with monogram on lower right
Oil on canvas, ca. 1650
15¼ × 20⅛ inches (38.9 × 51.3 cm.)
The Detroit Institute of Arts
Gift of Mr. N. Katz
37.21

Provenance: Collection, Earl Howe, Gopsall; Schaeffer Galleries, New York, 1936; D. Katz, Dieren, 1936.

Exhibited: *Exhibition* (Arnhem, Gemeente Museum, 1934); *Impressionism and Its Roots* (State University of Iowa Gallery of Art, Iowa City, IA, 1964).

Literature: Richardson 1941, pp. 22-23, repr.; Stechow 1966, p. 59, plate 113 [as "Haystacks"].

20 Salomon van Ruysdael
Naarden 1600/3-1670 Haarlem

Landscape with Travelers

Signed with monogram
Oil on panel, ca. 1640
24 × 22 inches (61 × 56 cm.)
Grand Rapids Art Museum
Gift of Booth Newspapers, Inc., in memory of George G. Booth, Ralph H. Booth, and Edmund W. Booth,
1950.1.3

Provenance: Sale, H. Rottermondt, Amsterdam, 18 July 1786, lot 291; sale, Paris, 21 April 1913, lot 27; Booth Newspapers, Inc., Detroit.

Literature: Stechow 1939, p. 254; Stechow 1975, p. 78, number 65.

21 Pieter Jansz. Saenredam
Assendelft 1597-1665 Haarlem

View from the Aisle of Sint Laurenskerk, Alkmaar

Signed and dated in the inscription on the organ case
Oil on panel, 1661
21⅜ × 17⅛ inches (54.4 × 43.5 cm.)
Museum Boijmans van Beuningen, Rotterdam
36.1849

Provenance: Phillipe van der Land, auction, Amsterdam (de Winter), 22 May 1776, no. 78; J. J. de Bruyn, auction, Amsterdam (van der Schley), 12 September 1798, no. 49; Diderick Baron van Leyden, auction, Amsterdam (van der Schley), 12 May 1811, no. 20; H. Muilman, auction, Amsterdam (van der Schley), 12-13 April 1813, no. 142; Countess Balny d'Avricourt, Paris; donated by W. van der Vorm, 1936.

Exhibition: *Pieter Jansz. Saenredam 1597-1665* (Museum Boijmans van Beuningen, Rotterdam, 1937-38); *Holländer des 17. Jahrhunderts* (Kunsthaus, Zurich, 1953); *Pieter Jansz. Saenredam* (Centraal Museum, Utrecht, 1961); *In het licht van Vermeer* (Mauritshuis, The Hague, 1966); *Saenredam 1597-1665, peinture des églises* (Institut Néerlandais, Paris, 1970); *Perspectives: Saenredam and the Architectural Painters of the Seventeenth Century* (Museum Boijmans van Beuningen, 1991).

Literature: Swillens 1935, no. 215; Liedtke 1971, pp. 133, 140, fig. 10; Jantzen 1979, no. 147a; Alpers 1983, p. 64, fig. 38; Los Angeles 1981, p. 96, fig. 4; Schwartz and Bok, 1989, p. 236, cat. no. 6, fig. 252; Rotterdam 1991, pp. 156-61, no. 27.

22 Joris van Son
Antwerp 1623-1667 Antwerp

Still Life with Fruit

Signed and dated on dark shield on upper right
Oil on canvas, 1659
15¼ × 21 inches (38.5 × 53 cm.)
Private Collection

Provenance: Gallery P. de Boer, Amsterdam; private collection, Austria.

Exhibited: *A Fruitful Past: A Survey of the Fruit Still Lifes of the Northern and Southern Netherlands from Brueghel till van Gogh* (Gallery P. de Boer, Amsterdam, 1983; Herzog Anton Ulrich-Museum, Braunschweig, 1983).

Literature: Amsterdam 1983, no. 41.

23 Jan Philips van Thielen
Mechelen 1618-1667 Boisschot

Bouquet in a Glass Vase

Signed on lower right
Oil on panel, ca. 1652
20½ × 14¾ inches (52 × 37.5 cm.)
Private Collection

Provenance: Private collection, France; Richard Green Gallery, London.

Exhibited: *The Age of Rubens* (Museum of Fine Art, Boston, 1993-94; Toledo Museum of Art, 1994).

Literature: Boston 1993, pp. 521-52, no. 104.

24-25 Willem van de Velde II
Leiden 1633-1707 Westminster

Ships in a Harbor (Marine Painting Pair)

Oil on panel, ca. 1655-58
7¾ × 7⅛ inches (19.7 × 18 cm.) each
Private Collection

Provenance: Lord Howe, Penhouse, Amersham, Buckinghamshire, England and thence by descent.

26 Emanuel de Witte
Alkmaar ca. 1617-1692 Amsterdam

Interior of the Oude Kerk, Amsterdam

Signed and dated
Oil on canvas, 1679
31¾ × 27½ inches (80.8 × 69.8 cm.)
Private Collection

Provenance: Probably Jan Maul, his sale, Leiden, 28 September 1782, lot 110; with D. A. Hoogendijk, Amsterdam; Dr. J. W. Blooker, Amsterdam, 1935, and thence by descent; Anonymous sale, Christie's, Amsterdam, 1981, lot 167; Bob P. Haboldt and Co., New York, 1990, stand 112.

Literature: Trautscholdt in Thieme and Becker 1907-50, vol. 36, p. 125; Manke 1963, p. 103, no. 107.

Bibliography

Adams 1994
Adams, Ann Jensen. "Competing Communities in the 'Great Bog of Europe': Identity and Seventeenth-Century Dutch Landscape Painting," pp. 35-40. In *Landscape and Power*. Edited by W. J. T. Mitchell. Chicago, 1994.

Allen 1987
Allen, Eva Jenney. "The Life and Art of Pieter Molyn." Ph.D. diss., University of Maryland, 1987.

Alpers 1983
Alpers, Svetlana. *The Art of Describing: Dutch Art in the Seventeenth Century*. Chicago, 1983.

Ampzing 1628
Ampzing, Samuel. *Beschrijvinge ende lof der stad Haarlem in Holland*. Haarlem, 1628.

Amsterdam 1976
Jongh, Eddy de, et al. *Tot Lering en Vermaak: betekenissen van Hollandse genrevoorstellingen uit de zeventiende eeuw*. Exhib. cat., Rijksmuseum. Amsterdam, 1976.

Amsterdam 1981
Beck, Hans-Ulrich, M. L. Wurfbain, and W. L. van der Watering. *Jan van Goyen, 1596-1656: Conquest of Space*. Exhib. cat., Waterman Gallery. Amsterdam, 1981.

Amsterdam 1982a
Blankert, Albert, et al. *Hendrick Averkamp, 1584-1634, Barent Averkamp 1612-1679: Frozen Silence*. Exhib. cat., Waterman Gallery, Amsterdam; and Provenciaal Ovewrijssels Museum, Zwolle. Amsterdam, 1982.

Amsterdam 1982b
Segal, Sam. *A Flowery Past: A Survey of Dutch and Flemish Flower Painting from 1600 until the Present*. Exhib. cat., Gallery P. de Boer, Amsterdam; and Noordbrabants Museum, 's-Hertogenbosch. Amsterdam and 's-Hertogenbosch, 1982.

Amsterdam 1983
Segal, Sam. *A Fruitful Past: A Survey of Fruit Still Lifes of the Northern and Southern Netherlands from Brueghel till van Gogh*. Exhib. cat., Gallery P. de Boer, Amsterdam; and Herzog Anton Ulrich-Museum, Braunschweig. Amsterdam, 1983.

Amsterdam 1987
Sutton, Peter, et al. *Masters of Seventeenth-Century Dutch Landscape Painting*. Exhib. cat., Rijksmuseum, Amsterdam; Museum of Fine Art, Boston; and Philadelphia Museum of Art. Boston, 1987.

Amsterdam 1989
Hecht, Peter. *De Hollandse fijn schilders: van Gerard Dou tot Adriaen van der Werff*. Exhib. cat., Rijksmuseum. Amsterdam, 1989.

Amsterdam 1997
Peeters, Jan, et al. *The Royal Palace of Amsterdam in Paintings of the Golden Age*. Exhib. cat., Royal Palace, Amsterdam. Amsterdam, 1997.

Angel 1642
Angel, Philips. *Lof der Schilder-Konst*. Leiden, 1642. Reprinted edition. Utrecht, 1969.

Asaert 1977
Zeventiende eeuw, van 1585 tot ca. 1680. Second volume of *Maritieme geschiedenis der Nederlanden.* Edited by G. Asaert et al. Bussum, 1977.

Baer 1990
Baer, Ronni. "The Paintings of Gerard Dou (1613-1675)." Ph.D. diss., Institute of Fine Arts, New York University, 1990.

Baltimore 1954
Man and His Years. Exhib. cat., Baltimore Museum of Art. Baltimore, 1954.

Barbour 1930
Barbour, Violet. "Dutch Merchant Shipping in the Seventeenth Century." *Economic History Review* 2 (1930): 261-90.

Baur 1948
Geschiedenis van de letterkunde der Nederlanden. Edited by F. Baur. 's-Hertogenbosch and Antwerp, 1948.

Beck 1972-73
Beck, Hans-Ulrich. *Jan van Goyen 1596-1656. Ein Oeuvreverzeichnis.* Two volumes. Amsterdam, 1972-73.

Bedaux 1990
Bedaux, Jan-Baptist. *The Reality of Symbols: Studies in the Iconology of Netherlandish Art.* The Hague, 1990.

Bergström 1947
Bergström, Ingvar. *Holländskt Stillebenmaleri under 1600-talet.* Translated by Christina Hedström and Gerard Taylor as *Dutch Still-Life Painting in the Seventeenth Century.* New York, 1956.

de Bie 1661
Bie, Cornelis de. *Het Gulden Cabinet van de edele vrij Schilderconst.* Antwerp, 1661. Reprinted edition. Soest, 1971.

Blankert 1967-68
Blankert, Albert. "Stechow: Addenda." *Simiolus* 2 (1967-68): 103-8.

von Bode 1895
von Bode, Wilhelm. "Alte Kunstwerks in den Sammlungen der Vereinigten Staten." *Zeitschrift für bildende Kunst* 6 (1895): 13-19, 70-76.

Bol 1973
Bol, Laurens J. *Die holländische Marinemalerei des 17. Jahrhunderts.* Braunschweig, 1973.

Bontekoe 1646
Bontekoe, Willem Ijsbrantsz. *Journael often gedenckwaerdige beschrijvinghe van de oost-indische reyse . . .* [1646]. Edited by G. J. Hoogewerff. The Hague, 1952.

Boston 1993
Sutton, Peter C., et al. *The Age of Rubens.* Exhib. cat., Museum of Fine Art, Boston; and Toledo Museum of Art. Boston, 1993.

Boxer 1965
Boxer, C. R. *The Dutch Seaborne Empire, 1600-1800.* New York, 1965.

Braunschweig 1978
de Jongh, Eddy, et al. *Die Sprache der Bilder: Realität und Bedeutung in der niederländischen Malerei des 17. Jahrhunderts.* Exhib. cat., Herzog Anton Ulrich-Museum, Braunschweig. Braunschweig, 1978.

Breck 1910
Breck, J. "L'Art Hollandais l'exposition Hudson-Fulton New York." *L'Art Flamand et Hollandais* 13 (1910): 3.

Brière-Misme 1927
Brière-Misme, Chotilde. "Tableaux inédits ou peu connus de Pieter de Hooch." *Gazette des Beaux-Arts* 16 (1927): 51-79, 258-96, 361-80.

Buchanen 1824
Buchanen, W. *Memoirs of Painting.* Two volumes. London, 1824.

Burke 1980
Burke, James D. "Dutch Paintings." *Bulletin of the St. Louis Art Museum* 15 (1980): 24.

Burnett 1969
Burnett, D. G. "Landscapes of Aelbert Cuyp." *Apollo* 89 (1969): 372-80.

Büttner and Unverfehrt 1993
Büttner, Emil, and Gerd Unverfehrt. *Jacob van Ruisdael in Bentheim: bein niederländischer Maler und die Burg Bentheim im 17. Jahrhundert.* Bielefeld, 1993.

Chong 1991
Chong, Alan. "New Dated Works from Aelbert Cuyp's Early Career." *Burlington Magazine* 133 (Sept. 1991): 606-12.

Collins 1930
Collins Baker, Charles Henry. "De Hooch or Not de Hooch." *Burlington Magazine* 57 (1930): 198.

Cox 1910
Cox, K. "Dutch Pictures in the Hudson-Fulton Exhibition." *Burlington Magazine* 16 (1910): 305.

Curtius 1948
Curtius, Ernst Robert. *Europäische Literatur und lateinische Mittelalter* [1948]. Translated by William R. Trask as *Euro-*

pean Literature and the Latin Middle Ages. New York and Evanston, 1963.

Davies 1962
Davies, D. W. A Primer of Dutch Seventeenth-Century Overseas Trade. The Hague, 1962.

Decamps 1872
Decamps, Louis. "Un musée Transatlantique." Gazette des Beaux Arts (1872): 437.

Delft 1988
Segal, Sam. A Prosperous Past: The Sumptuous Still Life in the Netherlands, 1600-1700. Exhib. cat., Stedelijke Museum Het Prinsenhof, Delft; Fogg Museum of Art, Cambridge, MA; and Kimball Art Museum, Fort Worth. The Hague, 1988.

Descamps 1753-64
Descamps, Jean-Baptiste. La Vie des peintres flamands, allemands et hollandais. Four volumes. Paris, 1753-64.

Detroit 1979
Detroit Institute of Arts, Selected Works from the Detroit Institute of Arts. Detroit, 1979.

Deursen 1978-81
Deursen, Arie Theodorus van. Het kopergeld van de Gouden Eeuw. Translated by Maarten Ultee as Plain Lives in a Golden Age: Popular Culture, Religion, and Society in Seventeenth-Century Holland. Cambridge, 1991.

Diekerhoff 1967
Diekerhoff, F. L. De oorlogsvloot in de zeventiende eeuw. Bussum, 1967.

Douglas 1966
Douglas, Mary. Purity and Danger: An Analysis of the Concepts of Pollution and Taboo. London and New York, 1966.

Duparc 1982
Duparc, Frits J. "Frans Post and Brazil." Burlington Magazine 124 (1982): 761-72.

Durantini 1983
Durantini, Mary Francis. The Child in Seventeenth-Century Dutch Painting. Ann Arbor, 1983.

Ekkart 1995
Ekkart, Rudolf E. O. Nederlandse portretten uit de 17e eeuw. Rotterdam, 1995.

Emmens 1963
Emmens, Jan A. "Natuur, onderwijzing en oefening; bij een drieluik van Gerrit Dou," pp. 125-63. In Album discipulorum aangeboden aan Professor J. G. van Gelder. Utrecht, 1963.

Emmens 1968
Emmens, Jan A. Rembrandt en de regels van de kunst. Utrecht, 1968.

Falkenburg 1988
Falkenburg, Reindert. Joachim Patinir: Lanscape as an Image of the Pilgrimage of Life. Translated by Michael Hoyle. Amsterdam, 1988.

Fell 1935
Fell, H. Granville. "A Recovered Franz Hals." Connoisseur 95 (1935): 105.

Fock 1973
Fock, C. W. "Willem van Mieris als ontwerper en boetseerder van tuinvazen." Oud Holland 87 (1973): 23-48.

Franits 1993
Franits, Wayne E. Paragons of Virtue: Women and Domesticity in Seventeenth-Century Dutch Art. Cambridge, 1993.

Franits 1994
Franits, Wayne E. "Between Positivism and Nihilism: Some Thoughts on the Interpretation of Seventeenth-Century Dutch Paintings." Theoretische geschiedenis 21 (1994): 129-34.

Franits 1997
Looking at Seventeeth-Century Dutch Art: Realism Reconsidered. Edited by Wayne Franits. Cambridge, 1997.

Freedberg 1980
Freedberg, David. Dutch Landscape Prints of the Seventeenth Century. London, 1980.

Fremantle 1962
Fremantle, Katharine. "The Open Vierschaar of Amsterdam's Seventeenth-Century Town Hall as a Setting for the City's Justice." Oud Holland 77 (1962): 216-34.

Fromentin 1876
Fromentin, Eugène. Les Maîtres d'autrefois [1876]. Translated as The Masters of Past Time: Dutch and Flemish Paintings from Van Eyck to Rembrandt. Edited by Horst Gerson. Oxford, 1948.

van Gelder 1972
van Gelder, J. G. "Doorzagen op Aelbert Cuyp." Nederlands Kunsthistorisch Jaarboek 23 (1972): 223-39.

van Gelder and Jost 1969
van Gelder, J. G., and Ingrid Jost. "Vroeg contact van Aelbert Cuyp met Utrecht." In Miscellanea I. Q. van Regerten-Altena. Amsterdam, 1969.

Gerson 1966
Gerson, Horst. "Pieter de Hooch." In Kindlers Malerei-Lexikon. Volume three. Zurich, 1966.

Goedde 1989
Goedde, Lawrence O. *Tempest and Shipwreck in Dutch and Flemish Art: Convention, Rhetoric, and Interpretation.* University Park, PA, 1989.

Goedde 1997
Goedde, Lawrence O. "Naturalism as Convention: Subject, Style, and Artistic Self-Consciousness in Dutch Landscape," pp. 129-43. In Franits 1997.

Goodman 1983
Goodman, Elise. "Poetic Interpretations of the "Lady at Her Toilette" Theme in Sixteenth-Century Painting." *Sixteenth Century Journal* 14 (1983): 426-42.

Gowing 1952
Gowing, Lawrence. *Vermeer.* London, 1952.

Griendl 1983
Griendl, Edith. *Les Peintures flamands de nature morte au XVIIe siècle.* Brussels, 1983.

Gudlaugssen 1959-60
Gudlaugssen, Sturla J. *Geraert ter Borch.* Two volumes. The Hague, 1959-60.

Gudlaugssen 1960
Gudlaugssen, Sturla J. "Kanttekeningen bij de ontwikkeling van Metsu." *Oud Holland* 83 (1960): 13-44.

Haak 1984
Haak, Bob. *Hollandse schilders in de Gouden Eeuw.* Translated by Elizabeth Willems-Treeman as *The Golden Age: Dutch Painters of the Seventeenth Century.* New York, 1984.

Haarlem 1962
Slive, Seymour. *Frans Hals: Exhibition on the Occasion of the Centenary of the Municipal Museum at Haarlem, 1862-1962.* Exhib. cat., Frans Halsmuseum. Haarlem, 1962.

The Hague 1974
Gudlaugssen, Sturla J. *Gerard ter Borch, Zwolle 1617–Deventer 1681.* Exhib. cat., Mauritshuis, The Hague; Münster, Landesmuseum. The Hague, 1974.

The Hague 1990
Broos, Ben P. J., et al. *The Great Dutch Paintings in America.* Exhib. cat., Mauritshuis, The Hague; Fine Arts Museum of San Francisco.) The Hague, 1990.

Hairs 1985
Hairs, Marie-Louise. *Les peintures flamands de fleurs au XVIIe siècle.* Translated by Eva Grzelak as *The Flemish Flower Painters in the XVIIth Century.* Brussels, 1985.

Hannema 1949
Hannema, D. *Catalogue of the D. G. van Beuningen Collection.* Amsterdam, 1949.

Haverkamp 1965
Haverkamp-Begemann, Egbert. "Terborch's 'Lady at Her Toilet.'" *The Art News* 64 (1965): 38-41, 62-63.

Hecht 1984
Hecht, Peter. "The *paragone* Debate: Ten Illustrations and a Comment." *Simiolus* 14 (1984): 125-36.

Hecht 1986
Hecht, Peter. "The Debate on Symbol and Meaning in Dutch Seventeenth Century Art: An Appeal to Common Sense." *Simiolus* 16 (1986): 173-87.

Heisner 1980
Heisner, B. "Mortality and Faith: The Figural Motifs within Emanuel de Witte's Dutch Church Interiors." *Studies in Iconography* 6 (1980): 107-21.

Heninger 1960
Heninger, S. K. *A Handbook of Renaissance Meteorology.* Durham, NC, 1960.

Heninger 1977
Heninger, S. K. *The Cosmographical Glass: Renaissance Drawings of the Universe.* San Marino, CA, 1977.

Hofstede de Groot 1907-28
Hofstede de Groot, Cornelis. *A Catalogue Raisonné of the Works of the Most Eminent Dutch Painters of the Seventeenth-Century.* Ten volumes. London, 1907-28.

Honour 1975
Honour, Hugh. *The New Golden Land: European Images of America from the Discoveries to the Present Time.* New York, 1975.

Houbraken 1753
Houbraken, Arnold. *De groote schouburgh der Nederlandsche konstschilders en schilderessen.* The Hague, 1753. Reprinted edition. Amsterdam, 1980.

Israel 1989
Israel, Jonathan. *Dutch Primacy in World Trade, 1585-1740.* Oxford, 1989.

Israel 1995
Israel, Jonathan. *The Dutch Republic: Its Rise, Greatness, and Fall, 1477-1806.* Oxford, 1995.

Janssen 1990
Janssen, Paul Huy. *Schilders in Utrecht 1600-1700.* Utrecht, 1990.

Jantzen 1979
Jantzen, H. *Das Niederländische Architekturbild,* 2. Auflage. Brunswick, 1979.

de Jongh 1971
Jongh, Eddy de. "Realisme en schijnrealisme in de Hollandse schilderkunst van de zeventiende eeuw," pp. 143-94. In *Rembrandt en zijn tijd.* Exhib. cat., Paleis voor Schone Kunsten. Brussels, 1971. Reprinted in English in Franits 1997, pp. 21-56.

de Jongh 1973
Jongh, Eddy de. "Vermommingen van Vrouw Wereld in de 17de eeuw," pp. 198-206. In *Album Amicorum J. G. van Gelder.* Edited by Josua Bruyn et al. The Hague, 1973.

de Jongh 1975-76
Jongh, Eddy de. "Grape Symbolism in Paintings of the Sixteenth and Seventeenth Centuries." *Simiolus* 8 (1975-76): 166-91.

Kansas City 1967
Paintings of Seventeenth-Century Dutch Interiors. Exhib. cat., Nelson-Atkins Museum, Kansas City. Kansas City, 1967.

Kettering 1983
Kettering, Alison McNeil. *The Dutch Arcadia: Pastoral Art and Its Audience in the Golden Age.* Montclair, NJ, 1983.

Kettering 1993
Kettering, Alison McNeil. "Ter Borch's Ladies in Satin." *Art History* 16 (March 1993): 95-124. Reprinted in Franits 1997, pp. 98-115.

Kuretsky 1974
Kuretsky, Susan D. "Rembrandt's Tree Stump: An Iconographic Attribute of St. Jerome." *Art Bulletin* 56 (1974): 571-80.

Lambert 1985
Lambert, Audrey M. *The Making of the Dutch Landscape: A Historical Geography of the Netherlands.* Second edition. London, 1985.

Larsen 1962
Larsen, Erik. *Frans Post, interprète du Brésil.* Amsterdam, 1962.

Lawrence 1991
Lawrence, Cynthia. *Gerrit Adriaensz. Berckheyde (1638-1698): Haarlem Cityscape Painter.* Doornspijk, 1991.

Lawrence 1992
Lawrence, Cynthia. "Hendrick de Keyser's Heemskerk Monument: The Origins of the Cult and Iconography of Dutch Marine Heroes." *Simiolus* 21 (1992): 265-95.

Leiden 1988
Sluijter, Eric J., et al. *Leidse fijnschilders: van Gerrit Dou tot Frans van Mieris de Jonge, 1630-1760.* Exhib. cat., De Lakenhal. Leiden, 1988.

Levesque 1994
Levesque, Catherine. *Journey through Landscape in Seventeenth-Century Holland: The Haarlem Print Series and Dutch Identity.* University Park, PA, 1994.

Liedtke 1971
Liedtke, Walter A. "Saenredam's Spaces." *Oud Holland* 86 (1971): 116-41.

Liedtke 1982
Liedtke, Walter A. *Architectural Painting in Delft: Gerard Houckgeest, Hendrick van Vliet, Emanuel de Witte.* Doornspijk, 1982.

Linschoten 1596
Linschoten, Jan Huygens van. *Itinerario* [1596]. Edited by H. Kern and H. Terpstra. The Hague, 1957.

Lokin 1996
Lokin, Danielle H. A. C., et al. *Delft Masters, Vermeer's Contemporaries.* Zwolle, 1996.

London 1960
MacLaren, Neil. *National Gallery Catalogues: The Dutch School.* London, 1960.

London 1986
Brown, Christopher, et al. *Dutch Landscape: The Early Years, Haarlem and Amsterdam, 1590-1650.* Exhib. cat., National Gallery of Art. London, 1986.

London 1980
Artemis Group. *Ten Paintings by Gerard Dou, 1613-1675.* Exhib. cat., Matthiessen Fine Art. London, 1980.

London 1991
MacLaren, Neil. *National Gallery Catalogues: The Dutch School.* London, 1960. Revised and expanded by Christopher Brown. London, 1991.

Los Angeles 1981
Walsh, John, Jr., and Cynthia P. Schneider. *A Mirror of Nature: Dutch Paintings from the Collection of Mr. and Mrs. Edward William Carter.* Exhib. cat., Los Angeles County Museum of Art; Museum of Fine Art, Boston; and Metropolitan Museum of Art, New York. New York, 1981.

Lowenthal 1986
Lowenthal, Anne W. "The Debate on Symbol and Meaning in Dutch Art: Response to Peter Hecht." *Simiolus* 16 (1986): 188-90.

Lowenthal 1996
Lowenthal, Anne W. "Contemplating Kalf," pp. 29-40. In *The Object as Subject: Studies in the Interpretation of Still Life*. Edited by Anne W. Lowenthal. Princeton, NJ, 1996.

Luttikhuizen 1997
Luttikhuizen, Henry M. "Late Medieval Piety and Geertgen tot Sint Jans' Altarpiece for the Haarlem Jansheren." Ph.D. diss., University of Virginia, 1997.

van Mander 1604
Mander, Karel van. *Het Schilderboeck*. Haarlem, 1604.

Manke 1963
Manke, Ilse. *Emanuel de Witte, 1617-92*. Amsterdam, 1963.

Martin 1902
Martin, Wilhelm. *Gerard Dou*. Translated by Clara Bell. London, 1902.

Martin 1911
Martin, Wilhelm. *Gérard Dou, sa vie et son œuvre: Etude sur la peinture hollandaise et les marchands au dix-septiéme siècle*. Paris, 1911.

Martin 1913
Martin, Wilhelm. *Gerard Dou: Des Meisters Gemälde in 247 Abbildungen*. Klassiker der Kunst in Gesamtausgaben. Band 24. Stuttgart and Berlin, 1913.

Martin 1936
Martin, Wilhelm. *De Hollandsche schilderkunst in de zeventiende eeuw. Rembrandt en zijn tijd*. Two volumes. Amsterdam, 1936.

Middelkoop and van Grevenstein 1993
Middelkoop, Norbert, and Anne van Grevenstein. *Frans Hals: leven, werk, restauratie*. Haarlem, 1993.

Minneapolis 1971
Mandle, Earl R., and J. W. Niemeijer. *Dutch Masterpieces from the Eighteenth Century: Paintings and Drawings 1700-1800*. Exhib. cat., Minneapolis Institute of the Arts; Toledo Museum of Art; and Philadelphia Museum of Art. Minneapolis, 1971.

Minneapolis 1990
Keyes, George S. *Mirror of Empire: Dutch Marine Art of the Seventeenth Century*. Exhib. cat., Minneapolis Institute of Arts; Toledo Museum of Art; Los Angeles County Museum of Art. Minneapolis, 1990.

Mirimonde 1966
de Mirimonde, A. P. "La Musique dans les allégories de l'amour." *Gazette des Beaux-Arts* 68 (1966): 265-90; 69 (1967): 319-46.

Morse 1979
Morse, John D. *Old Master Paintings in North America*. New York, 1979.

Naumann 1981
Naumann, Otto. *Frans van Mieris, the Elder (1635-1681)*. Two volumes. Doornspijk, 1981.

New Brunswick 1983
Hofrichter, Frima Fox. *Haarlem: The Seventeenth Century*. Exhib. cat., Jane Voorhees Zimmerli Art Museum, Rutgers University. New Brunswick, 1983.

New York 1958
Fifty Masterpieces from the City Art Museum of St. Louis. Exhib. cat., Wildenstein and Company, New York. New York, 1958.

New York 1980
Baetjer, C. *Summary Catalogue of European Paintings in the Metropolitan Museum*. Three volumes. New York, 1980.

Nicolson 1962
Nicolson, Majorie Hope. *The Breaking of the Circle*. Revised edition. New York and London, 1962.

Parker 1977
Parker, Geoffrey. *The Dutch Revolt*. Harmondsworth, 1977.

Pepys 1667
Pepys, Samuel. *The Diary of Samuel Pepys* [1667]. Edited by Robert Latham and William Matthews. Berkeley and Los Angeles, 1974.

Perth 1997
Middelkoop, Norbert. *The Golden Age of Dutch Art: Seventeenth-Century Paintings from the Rijksmuseum and Australian Collections*. Exhib. cat., Art Gallery of Western Australia, Perth. Perth, 1997.

Philadelphia 1984
Sutton, Peter C., and Jane Iandore Watkins. *Masters of Seventeenth-Century Dutch Genre Painting*. Exhib. cat., Philadelphia Museum of Art; Staatliche Museen, Berlin; and Royal Academy of Arts, London. Philadelphia, 1984.

Plenckers-Keyser and Streefkerk 1996
Plenckers-Keyser, G. I., and C. Streefkerk. "De Librije van Alkmaar." *Glans en Glorie van de Grote Kerk: Het interieur van de Alkmaarse Sint Laurens*. Alkmaarse historische reeks 10 (1996): 263-74.

Plietzch 1936
Plietzch, Eduard. "Gabriel Metsu." *Pantheon* 17 (1936): 1-13.

Plietzch 1944
Plietzch, Eduard. *Gerard ter Borch*. Vienna, 1944.

Pontanus 1611
Pontanus, Johannes. *Rerum et urbis Amsterlodamensium historia*. Amsterdam, 1611.

Preston 1974
Preston, Rupert. *The Seventeenth-Century Marine Painters of the Netherlands*. Leigh-on-Sea, 1974.

Price 1974
Price, J. L. *Culture and Society in the Dutch Republic during the Seventeenth Century*. London, 1974.

Rathbone 1951
Rathbone, Perry T. "'The Housekeeper' by Nicolaes Maes." *Bulletin of the City Art Museum of St. Louis* 36 (1951): 42-45.

Raupp 1983
Raupp, Hans-Joachim. "Ansätze zu einer Theorie der Genremalerei in den Niederlanden im 17. Jahrhundert," *Zeitschrift für Kunstgeschichte* 46 (1983): 401-18.

Reiss 1975
Reiss, Jonathan. *Aelbert Cuyp*. London, 1975.

Richardson 1941
Richardson, E. P. "A Canal Scene by Jacob van Ruisdael." *DIA Bulletin* 21 (1941): 22-23.

Robinson 1974
Robinson, Franklin W. *Gabriel Metsu (1629-1667): A Study of His Place in Dutch Genre Painting of the Golden Age*. New York, 1974.

Robinson 1958
Robinson, M. S. *Van de Velde Drawings: A Catalogue of Drawings in the National Maritime Museum*. Cambridge, 1958.

Robinson 1990
Robinson, M. S. *Van de Velde: A Catalogue of the Paintings of the Elder and the Younger Willem van de Velde*. Two volumes. London, 1990.

Rosenberg and Slive 1966
Jacob Rosenberg, Seymour Slive, and E. H. ter Kuile, *Dutch Art and Architecture, 1600-1800*. Harmondsworth, 1966. Third edition, 1977.

Rotterdam 1935
Vermeer: oorsprong en invloed: Fabritius, de Hooch, de Witte. Exhib. cat., Museum Boijmans van Beuningen, Rotterdam. Rotterdam, 1935.

Rotterdam 1991
Giltaij, Jeroen, and Guido Jansen. *Perspectives: Saenredam and the Architectural Painters of the Seventeenth Century*. Exhib. cat., Museum Boijmans van Beuningen, Rotterdam. Rotterdam, 1991.

Rotterdam 1996
Giltaij, Jeroen, and Jan Kelch. *Praise of Ships and the Sea: The Dutch Marine Painters of the Seventeenth Century*. Exhib. cat., Museum Boijmans van Beuningen, Rotterdam; and Staatliche Museen, Berlin. Rotterdam, 1996.

de Rudder 1913
de Rudder, Arthur. *Pieter de Hooch et son œuvre*. Brussels and Paris, 1913.

Russell 1983
Russell, Margarita. *Visions of the Sea: Hendrick C. Vroom and the Origins of Dutch Marine Painting*. Leiden, 1983.

Russell 1992
Russell, Margarita. *Willem van de Velde de Jonge: Het IJ voor Amsterdam met de Gouden Leeuw*. Bloemendaal, 1992.

Salomon 1998
Salomon, Nanette. *Jacob Duck and the Gentrification of Dutch Genre Painting*. Doornspijk, 1998.

Schama 1979
Schama, Simon. "The Unruly Realm: Appetite and Restraint in Seventeenth-Century Holland." *Daedalus* 108 (1979): 103-23.

Schama 1987
Schama, Simon. *The Embarrassment of Riches: An Interpretation of Dutch Culture in the Golden Age*. New York, 1987.

Schneede 1968
Schneede, Uwe M. "Gabriel Metsu und der holländische Realismus." *Oud Holland* 83 (1968): 45-61.

Schuler 1992
Schuler, Carol M. "The Seven Sorrows of the Virgin: Popular Culture and Cultic Images in Pre-Reformation Europe." *Simiolus* 21 (1992): 5-28.

Schwartz and Bok 1989
Schwartz, Gary, and Marten Jan Bok. *Pieter Saenredam: The Painter and His Times*. New York, 1989.

Slive 1970-74
Slive, Seymour. *Frans Hals*. Three volumes. London and New York, 1970-74.

Sluijter 1986
Sluijter, Eric J. *De 'Heydensche Fabulen' in de Noordnederlandse schilderkunst circa 1590-1670*. The Hague, 1986.

Sluijter 1991
Sluijter, Eric J. "Didactic and Disguised Meanings? Several Seventeenth-Century Texts on Painting and the Iconological Approach to Northern Dutch Paintings of This Period," pp. 175-207. In *Art in History, History in Art: Studies in Seventeenth-Century Dutch Culture.* Edited by David Freedberg and Jan de Vries. Santa Monica, CA, 1991. Reprinted with minor revisions in Franits 1996, pp. 78-87.

Smith 1829-42
Smith, John. *A Catalogue Raisonné of the Works of the Most Eminent Dutch, Flemish, and French Painters.* Nine volumes. London 1829-42.

Spicer 1983
Spicer, Joaneath. "*De Koe voor d'aerde statt:* The Origins of the Dutch Cattle Piece," pp. 251-56. In *Essays in Northern European Art Presented to Egbert Haverkamp-Begemann on His Sixtieth Birthday.* Edited by Anne-Marie Logan. Doornspijk, 1983.

Stechow 1939
Stechow, Wolfgang. "Salomon van Ruysdael in America," *Art Quarterly* 3 (1939): 251-63.

Stechow 1960
Stechow, Wolfgang. "Significant Dates on Some Seventeenth-Century Dutch Landscape Paintings." *Oud Holland* 75 (1960): 79-92.

Stechow 1966
Stechow, Wolfgang. *Dutch Landscape Painting of the Seventeenth Century.* London, 1966.

Stechow 1975
Stechow, Wolfgang. *Salomon van Ruysdael: Eine Einführung in seine Kunst.* Berlin, 1975.

Stone-Ferrier 1985
Stone-Ferrier, Linda. *Images of Textiles: The Weave of Seventeenth-Century Dutch Art and Society.* Ann Arbor, 1985.

Sutton 1980
Sutton, Peter C. *Pieter de Hooch: Complete Edition with a Catalogue Raisonné.* Oxford, 1980.

Sutton 1986
Sutton, Peter C. *Guide to Dutch Art in America.* Washington and Grand Rapids, 1986.

Swillens 1935
Swillens, P. T. A. *Pieter Jansz. Saenredam, schilder van Haarlem 1597-1665.* Amsterdam, 1935.

Taylor 1995
Taylor, Paul. *Dutch Flower Painting, 1600-1720.* New Haven, 1995.

van Thiel 1967-68
Thiel, Pieter J. J. van. "Marriage Symbolism in a Musical Company by Jan Miense Molenaar." *Simiolus* 2 (1967-68): 91-99.

van Thiel 1976
Thiel, Pieter J. J. van, et al. *All the Paintings of the Rijksmuseum of Amsterdam.* Amsterdam, 1976.

Thieme and Becker 1907-50
Thieme, Ulrich, and Felix Becker. *Allgemeines Lexikon der bildenden Künstler von der Antike bis zur Gegenwart.* Thirty-seven volumes. Leipzig, 1907-50.

Thomsen 1938
Thomsen, T. *Albert Eckhout: Ein niederländischer Maler.* Copenhagen, 1938.

Toledo 1976
Toledo Museum of Art. *The Toledo Museum of Art: European Paintings.* Toledo, 1976.

Utrecht 1961
Pieter Jansz. Saenredam. Exhib. cat., Centraal Museum, Utrecht. Utrecht, 1961.

Valentiner 1910
Valentiner, Wilhelm R. "Die Ausstellung holländischer Gemälde in New York." *Monatschefte für Kunstwissenschaft* 3 (1910): 5-12.

Valentiner 1921
Valentiner, Wilhelm R. *Frans Hals, des Meisters Gemälde.* Klassiker der Kunst in Gesamtausgaben. Band 28. Stuttgart and Berlin, 1921.

Valentiner 1926
Valentiner, Wilhelm R. "Pieter de Hooch, Part One." *Art in America* 15 (1926): 45-64.

Valentiner 1927
Valentiner, Wilhelm R. "Pieter de Hooch, Part Two." *Art in America* 15 (1927): 76-77.

Valentiner 1932
Valentiner, Wilhelm R. "Zum 300. Geburtstag Jan Vermeers, Oktober 1932: Vermeer und die Meister der holländischen Genremalerei." *Pantheon* 10 (1932): 305-24.

Valentiner 1935
Valentiner Wilhelm R. "New Additions to the Work of Frans Hals." *Art in America* 23 (1935): 85-103.

Vancouver 1986
Schwartz, Gary. *The Dutch World of Painting.* Exhib. cat., Vancouver Art Museum. Vancouver, 1986.

de Vries 1974
Vries, Jan de. *The Dutch Rural Economy of the Golden Age.* New Haven, 1974.

de Vries 1981
Vries, Jan de. *Barges and Capitalism: Passenger Transportation in the Dutch Economy, 1632-1839.* Utrecht, 1981.

Waagen 1854-57
Waagen, Gustav Friedrich. *Treasures of Art in Great Britain: Being an Account of the Chief Collection of Paintings, Drawings, Sculptures, and Illuminated Manuscripts.* Three volumes. London, 1854-57.

Waal 1974
Waal, Henri van de. *Steps Towards Rembrandt: Collected Articles 1937-1972.* Edited by R. H. Fuchs. Amsterdam and London, 1974.

Walford 1991
Walford, E. John. *Jacob van Ruisdael and the Perception of Landscape.* New Haven, 1991.

Washington 1985
Jackson-Stops, Gervase. *The Treasure Houses of Britain: Five Hundred Years of Private Patronage and Art Collecting.* Exhib. cat., National Gallery of Art, Washington. Washington, 1985.

Washington 1989a
Wheelock, Arthur K., Jr. *Still Lifes of the Golden Age: Northern European Paintings from the Heinz Family Collection.* Exhib. cat., National Gallery of Art, Washington; and Museum of Fine Arts, Boston. Washington, 1989.

Washington 1989b
Slive, Seymour, et al. *Frans Hals.* Exhib. cat., National Gallery of Art, Washington; Royal Academy of Arts, London; and Frans Halsmuseum, Haarlem. Washington, 1989.

Washington 1990
Clayton, Virginia Tuttle. *Gardens on Paper: Prints and Drawings, 1200-1900.* Exhib. cat., National Gallery of Art. Washington, 1990.

Washington 1998
Wheelock, Arthur K., Jr. *A Collector's Cabinet.* Exhib. cat., National Gallery of Art. Washington, 1998.

Weber 1904-5
Weber, Max. *Die protestantische Ethik und der Geist des Kapitalisme* [1904-5]. Translated by Talcott Parsons as *The Protestant Ethic and the Spirit of Capitalism.* London, 1930.

Welcker 1979
Welcker, Clara J. *Hendrick Averkamp (1585-1634), bijgenaamd "De Stomme van Campen" en Barent Averkamp (1612-1679), "Schilders tot Campen."* Zwolle, 1933. Revised edition by D. J. Henbroek-van der Poel. Doornspijk, 1979.

Welu 1975
Welu, James A. "Card Players and Merrymakers: A Moral Lesson." *Worchester Art Museum Bulletin* 4 (1975): 8-16.

Welu 1977
Welu, James A. "Vermeer and Cartography." Ph.D. diss., Boston University, 1977.

Westermann 1996
Westermann, Mariët. *A Worldly Art: The Dutch Republic 1585-1718.* New York, 1996.

Wheelock 1975-76
Wheelock, Arthur K., Jr. "Gerard Houckgeest and Emanuel de Witte: Architectural Painting in Delft around 1650." *Simiolus* 8 (1975-76): 167-85.

Wheelock 1976
Wheelock, Arthur K., Jr. "Review of Robinson's *Gabriel Metsu*." *Art Bulletin* 58 (1976): 456-59.

Wheelock 1995
Wheelock, Arthur K., Jr. *Dutch Paintings of the Seventeenth Century: The Collections of the National Gallery of Art.* Washington, 1995.

Wiegand 1971
Wiegand, Wilfred. "Ruisdael-Studien: Ein Versuch zur Ikonologie der Landschaftsmalerei." Ph.D. diss., Hamburg University, 1971.

Witsen 1671
Witsen, Nicolaes. *Aeloude en hedendaegsche scheeps-bouw en bestier.* Amsterdam, 1671.

Yamey 1986
Yamey, Basil. *Arte e Contrabilité.* Bologna, 1986.

PHOTOGRAPHY CREDITS